LA Artland

LA Artland

Contemporary Art from Los Angeles

Black Dog Publishing

Contents

Chris Kraus

A Walk Around the Neighborhood

LA is not so much a city full of alternative spaces, but an alternative space in itself, a perpetual frontier, peripheral to the financial and museological center of the US artworld, New York, but still possessing a vitality that would be embarrassing to ignore. There are bursts of lexical enthusiasm for 'LA art' in the form of emotionally sincere and deliriously subjective marketing literatures, almost identical in their perspectives, appearing every five years or so, almost like clockwork,

as the late New Zealand artist-turned-curator Giovanni Intra observed, in an essay written for ZKM's 2002 show, *Circles*.[1]

Intra moved to LA in 1996, and rightly sensed the city's possibilities. As provincial as his native Auckland, LA was also as diverse and vibrant as New York or London. After putting in an obligatory three years at Art Center College of Art and Design's graduate program, he co-founded China Art Objects, the renegade commercial gallery that spawned a micro-revolution. After China's first year in business, new galleries opened in the adjacent storefronts by the week. Until then, almost all LA's commercial galleries were located on the west side of the city, in upscale neighborhoods like Santa Monica and Brentwood. Finally, the art scene was about to move to where the artists actually lived. The instant success of China Art Objects signaled downtown LA's first wave of gentrification—an "economic miracle" that had eluded its developers for two decades.

"Of course we will take advantage of this in whichever way seems appropriate or possible at the time, but it's not exactly riding the jock of genius," Intra concluded with his characteristic deadpan realism.[2]

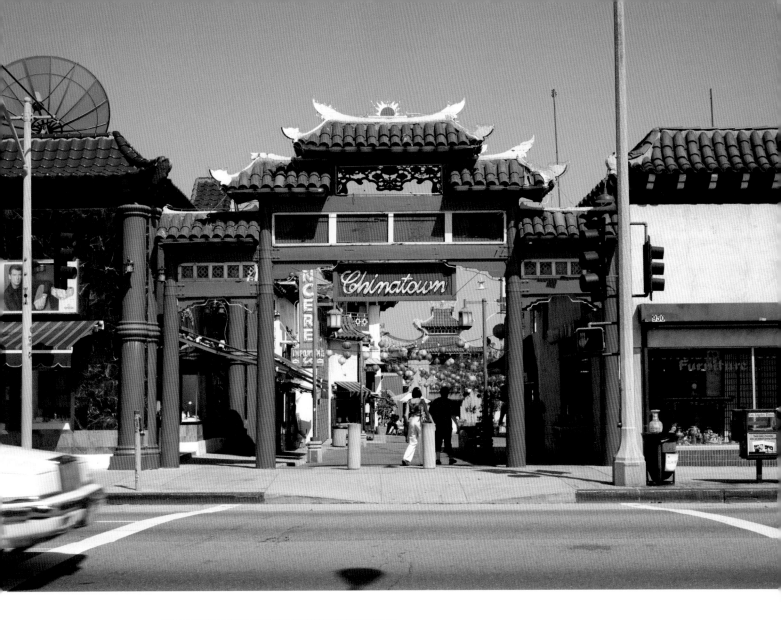

I moved to LA ten years ago to teach writing in Art Center College's high-profile graduate program. Fresh from the East Village of New York City, I was amazed by the hegemony graduate art education held over the Los Angeles artworld. LA was, after all, America's second largest city. Routinely touted as the "first twenty-first century city," it was, and remains, one of the great immigrant capitals of the world. Yet, in the mid 1990s, there was only one port of entry to the commercial gallery system, and that was attendance at one of three or four high-profile graduate programs. Usually, about a quarter of these graduates attained A or B list gallery representation upon leaving school. Alternative spaces had no credibility. Leaving school with as much as $100,000 in debt, it behooved younger artists to make saleable work as soon as they could. Yet the very success of this system changed it, at times unpredictably. Thousands of talented artists flocked to attend schools in LA, and they stayed. Artists have opened their own galleries, boutiques and bars. The look is less uniform, "success"—defined as the ability to keep making art—is now achieved here in numerous ways.

As a writer, I never knew much about art. Nevertheless, I was invited to write a column between 1998 and 2001 about Los Angeles art for *Artext* magazine. I studied the Los Angeles artworld as an anthropologist studies primitive tribes. I liked a lot of the people I met; I tried to keep an open mind. The artists I talked to for this essay have one thing in common: all are committed to pursuing original work on their own terms. Some, like Henry Taylor, are on the verge of international careers. Others, like Eugenia Butler, have continued working in ebbs of fame and obscurity over decades. To my mind, all have succeeded in channeling the possibility and freedom this city affords. Are they representative? Yes and no. As Walter Mosley, the author of more than a dozen philosophical-sleuth novels set in LA's notorious South Central "ghetto," observed: "my father said: 'Los Angeles already had a structure. As people came here, they brought another structure. As they came together, it made a city that was impossible to know.'"[3]

There are many LAs.

Chinatown, 2005
photo: M. Paige Taylor

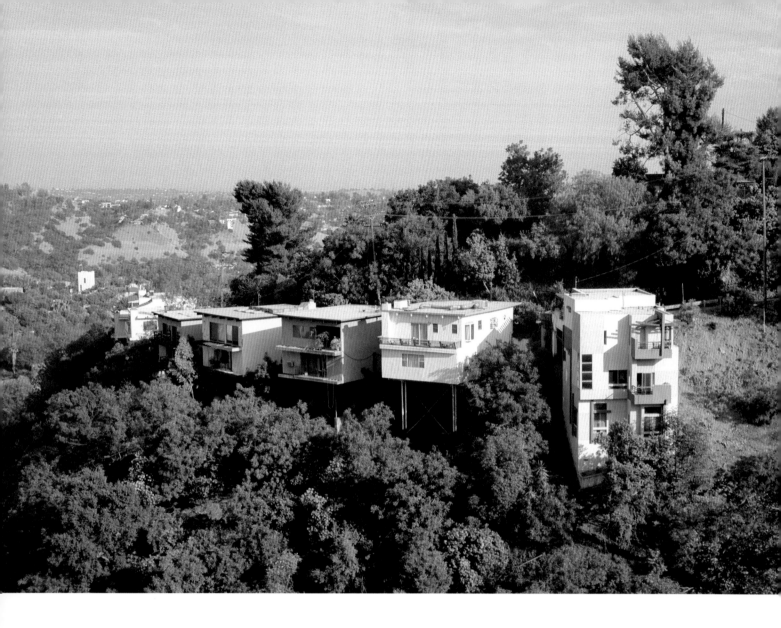

Northeast Los Angeles, sometime in 2002: we're in a spacious California Craftsman bungalow, the kind of classic Mission-style house featured in architectural magazines. The house is discreetly tucked into a hill known as Mt. Washington, and we are being guided around it by Delia Brown's trancey, transcendent steadicam. Five minutes (without traffic) from downtown, Mt. Washington sits above the northeast LA neighborhood of Highland Park. With its green belt of Santa Monica Conservancy tracts and winding streets named after birds, Mt. Washington was once quaintly known as "the Brentwood of the ghetto." Blacklisted during the McCarthy era, the writer Dalton Trumbo holed up in a cabin here to write the movie *Spartacus*. Now, the neighborhood is decidedly more upscale, home to attorneys, movie producers, City Council officials and prominent artists like Shirley Tse and Jorge Pardo.

This particular Craftsman house is halfway up the hill, and we're at a gathering of friends on what seems to be a gentle Sunday afternoon. The camera floats around the party in one long take that lasts four minutes. The party feels like it could go on forever. It might still be going on right now. Goapele, the exquisitely beautiful, young Oakland-based R&B singer whose independently produced debut LP recently hit the Billboard's top 100 chart, sits on one of the couches, gazing into her diary. A community activist since her teens, Goapele's name means "to move forward" in Sitswana, a South African dialect. She's wearing a light-as-air summer dress, and lip-syncing the lyrics to her hit single "Closer":

> *I'm getting higher*
> *Closer to my dreams*
> *Feel it in my sleep*

Mt. Washington, 2005
photo: M. Paige Taylor

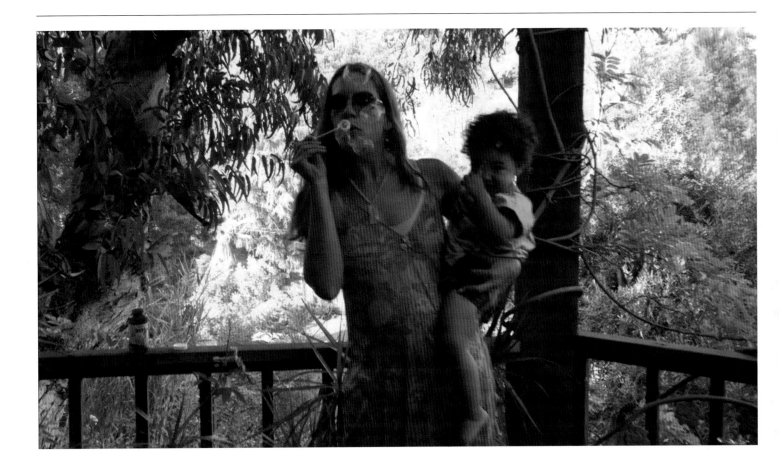

The camera's getting closer too, but not *too* close: just close enough to show the house, and those who on this afternoon inhabit it. The multi-colored angel fish in the aquarium, the stocky white guy and his girlfriend kissing in the hallway on a cushioned Mission bench. A tranced-out Bathsheba dances on an oriental carpet in the living room; she wears a purple jersey dress.

> *Sometimes it feels like I'll never go past here*
> *Sometimes it feels like I'm stuck, forever*

sings Goapele, but if she's stuck, there are worse places than this to be. Here, suspended in this light, among the wood and glass and outdoor bougainvillea, a black couple lean against the railing of a redwood balcony, deep in conversation. Two white girls walk down to the koi-pond, put their sandals on a ledge. Back in the living room, a gold-leafed Buddha gazes tranquilly at champagne mimosas on the table. A woman lying on the floor leafs through a magazine. Red wine and Tiffany lamps. Books everywhere, a guitar thrown casually on the sofa, framed works of art.

The day is mellow, smooth, but not without a little tension. Seen through the open kitchen doorway, a man and woman lean against the kitchen counters exchanging words. She frowns, she gestures with her hands. Crossed, he gazes at the floor, stiffens, then pulls back. Still, the tension here is like the backbone of the lizard: there's just enough to give the afternoon some shape. Out on the deck, a white woman in a neo-psychedelic caftan blows bubbles from a wand and rocks her toddler gently to the beat.

Staged by LA-born artist Delia Brown, the film, called *Pastorale*, 2002, enacts a kind of paradise. The kind of multi-racial paradise of informed, discreet consumption that LA could maybe be; a collective cumulative fantasy dreamt by millions, perfected by a steadicam, and shown, without the dreary plots and dialogue, on afternoon TV. Writing in *The New York Times*, reviewer Ken Johnson pointed out that *Pastorale* "would seem to mock the infantile complacency of people protected by unearned privilege."[4] But when I saw the work in San Francisco at the knockout *Baja to Vancouver West Coast* show mounted in 2004 at The Wattis Institute, the first thing that I thought was, "I want to live in this world, too."

Delia Brown
Pastorale, 2002
video, 4:57 minutes
courtesy D'Amelio
Terras, New York

Months later, when we meet for drinks at The Arsenal, a reconstructed dive bar in Santa Monica, Brown talks about the curious response that she initially received to *Pastorale*:

> *People who knew my work said* Pastorale *was a departure. They said: we don't see the cynicism, where's the irony? And I was like, yeah—that's true. Because I don't like to see my work in terms of irony, I like to move in and out. I never wanted to paint myself into this ironic corner.*
>
> *People talked about the song as music for boutiques and bubble baths, and this seemed so degrading. Maybe the piece got away from me in the process of making it, but originally I meant it as an ode to Goapele... she is an intensely strong soul, and to me 'Closer' was a very uplifting song, a contemporary spiritual.*

Brown is a compact, energetic woman in her mid 30s. Before attending UCLA she'd almost made a go of a career in rap, being mentored by the manager of the illustrious Wutang Clan. She's white. Given *Pastorale*'s graceful, effortless bi-racial casting (and the almost total absence of black subjects in white, post-art school LA art), I'd just assumed that Brown was black.

> *I was feeling frustrated by the way you're often bound, as a visual artist, to create a critical practice. I'm happy to have my work be critical, as much as possible. But I want to also feel the potential for making work that creates a transcendent experience for the viewer. So often with visual art you have to penetrate its conceptual strategies and its history to feel anything at all. Music is more giving to the receiver. So a part of this came out of a major envy of Goapele: here she was, ten years younger than me, with this extraordinary gift, and working in an art form that I'm jealous of.*

Brown, who graduated from UCLA's MFA Studio Art program in 2000, approaches art as an opportunity to probe the triggers of desire, and in the process, make them true. Her debut show featured mother-daughter paintings of herself with her LA gallerist, Margo Leavin. "All artists," Brown explains,

> *have some sort of parent/child relation to their dealers. And Margot personified the kind of mother that I'd fantasized having in my teens: she was single, cultured, very glamorous. My parents are in the healthcare field, so I always fantasized having a mom who smoked cigarettes and wore red Chanel lipstick and partied with her friends.*

Critics saw the image differently. Was Brown a social climber, thrusting herself into the arms of this powerful artworld woman? Well, yes and no. "When I was growing up I had to buy all my clothes at JC Penney," Brown recalls. "My friend from Beverly Hills bought all of hers at Neiman Marcus. Her mom was single, and I imagined her with this fabulous lifestyle, smoking a joint in the evening. Margot embodied that to me."

Shades of resentment. I think that Brown's a bold and brilliant artist, playing with a fuller deck than most. Still: it is these small differences, between JC Penney and Neiman Marcus; between outright wealth and lower-middle class, that fuel LA's most bitter feuds.

> *... a vertiginous hump of residential bleakness... a yawning blackness sprinkled here and there with streetlamps... the air fraught with the howling of dogs, a regular keening that carries on half the night and sometimes all night... myriad agitated semiferal dogs chained in myriad desolate dustridden yards choked with cinder blocks piled under flapping tarpaper....*

is how Gary Indiana described the neighborhood that stretches at the bottom of Brown's paradisiacal hill in his great 1997 LA book, *Resentment*.[5]

What struck many visitors about Los Angeles in the wake of the 1994 South Central riots was just how *nice* the ghetto was. At least, from the outside. The same bougainvillea that twists around the redwood deck in *Pastorale* blooms in Watts outside tidy single-family brick and wood-frame homes. Watts, scene of the cataclysmic riots of the mid 60s, and home of the Watts Towers, one of the most extraordinary constructions within American outsider art, embodies LA's wild contradictions. As Lynell George noted recently in *The Los Angeles Times*:

> *... on this short stretch of 107th street, small bungalows painted the cheerful pastels of Easter eggs sit behind flowerbeds bearing succulents; grandmothers chat across the fence in dancing Spanish; kids zip by on bikes. But just an echo away, a police cruiser has pulled up alongside a purring and primered sedan; a teenage boy missing one leg rolls by in a wheelchair; a weathered old guy wheels by a block away, missing both.*[6]

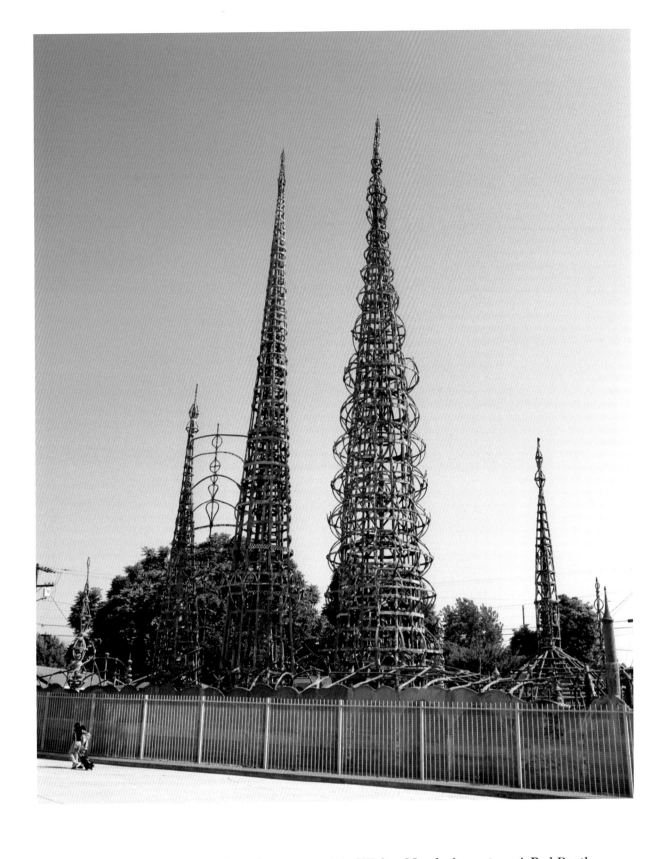

I'm reminded of how Easy Rawlins, the protagonist of Walter Moseley's mystery *A Red Death*, describes his Watts house on 116th street, circa 1954:

> I had a small house, but that made for a large front lawn. In recent years I had taken to gardening. I had daylilies and wild roses against the fence, and strawberries and potatoes in large rectangular plots at the center of the yard. There was a trellis that enclosed my porch, and I always had flowering vines growing there...
>
> But what I loved most was my avocado tree. It was 40 feet high with leaves so thick and dark that it was always cool under its shade.... When things got really hard, I'd sit down there to watch the birds chase insects through the grass.[7]

The artist Daniel Mendel-Black lives and works in a Figueroa Boulevard storefront down the hill in Highland Park, just two miles south of Brown's *Pastorale* locale. It's very urban here: a payphone on the sidewalk, pre-dating the omniscience of cell phones; a blue graffiti'd canvas awning gracing the facade of Daniel's low-slung white-washed stucco building. And, in fact, the history of this generic structure, with its fluted deco-modern porticos slapped on the roofline in a passing nod to architecture, encapsulates the history of the neighborhood of Highland Park. Originally a Mexican dancehall bar, it served later as a sweatshop until the garment industry moved south. When Mendel-Black moved in, he had to rip out vats of toxic chemicals left behind by the fly-by-night methamphetamine operation that had holed up there for a while.

Across the street, the El Recreo Social Club stays open until 4 a.m., shuttling patrons back and forth between a nearby brothel. Mendel-Black's Russian neighbor deals in carpet remnants, vinyl tiles. With a Home Depot just three blocks away, Color Carpet does very little trade in home improvement, but the owner's on the phone all day. The storefront Daniel occupies is cheap, and huge. Its plate glass windows looking out on Figueroa Boulevard are draped in rice-paper and everything inside is washed diffusely in pearlescent light. Books on Gilles de Rais and Jewish mysticism vie for space with horror comics on the artist's thrift-store couch.

Works in varied stages of completion are scattered all around the loft. There's a sheaf of gorgeous black and white ink drawings near the window: stalactites of spider webs melting in the dark. For the past two years, Mendel-Black has pursued a heady mix of minimalist grids gone horribly and biomorphically wrong. His works—which take the form of paintings, sculptures, drawings—are like a gross-out artist's ode to Agnes Martin. In *Diseased Love*, 2004, organic tubes curl up into rectangles, white squares light up darkened cubes like so many office windows, and spray-painted circles radiate in whiteness from the center of Matisse-like melted forms. "The tissue of the brain and the intestine are identical," the artist notes.

The son of two artists based in Washington DC, Mendel-Black arrived in LA in 1994 to do an MFA at Art Center College of Design. In the early 90s, Mendel-Black worked a short stint as a studio assistant for Peter Halley in New York, then took a more regular job as an editorial assistant at *The Washington Post* in DC before moving out to California. He chose Art Center for its emphasis on intellectual rigor, and spent two years reading back into the experiments of mid century artists such as Robert Ryman, who gleefully trashed the expressionist impulse by devising ways of making paintings according to arithmetic formulae and mechanical means.

> *When I came out here in 94, it wasn't about being in the LA art scene. It was about going to school, where there was an environment based on working out certain issues in contemporary art—it was almost an intellectual merit system—but when I graduated it was a shock to find that in the LA artworld, that wasn't actually what was happening at all. I thought there'd be an openness and freedom, a large-scale experiment going on, but instead there was this kind of false professionalism, everybody acting as if there was all this money to be made.*

Perhaps a little naively, Mendel-Black believed that these schools were preparing people for lives of artistic reflection, rather than fast-paced commercial careers.

> *For years it was a very lonely activity to be an artist here, though that might seem strange, considering the schools are pumping out hundreds of kids a year. But really the schools produced a lot of artists who were made entirely reliant on institutional structures. I was shocked, given the paucity of what the commercial gallery system has to offer, that people started putting so much faith in these institutions. They lost sight of the fact that art should be based on whatever it was the artist wants to do.*
>
> *This produced a kind of sadness. It became clear that a lot of artists just wanted to get their seat on the bus as quickly as possible and not think about other things.*

Stranded in the maximal environment of Highland Park, Mendel-Black soon began working on his own projects, trying to provide alternative outlets for his friends. In 1999, he started *Spring Journal*—the title an ironic nod to German romanticism, but also the much less ironic belief it might be possible for artists to rely upon each other, and in so doing, make a fresh start.

In subsequent issues, the journal has published articles questioning contemporary nostalgic attitudes, and exposing the myth of willed naiveté and unself-consciousness in art and literature from eighteenth century Germany to twenty-first century LA. Contributors have included such distinguished artists and writers as John Miller, Larry Rickles, Andre Butzer, Martin Prinzhorn and Benjamin Peret.

Daniel Mendel-Black
Diseased Love No. 3,
2004
acrylic on polyflax,
45" × 30"

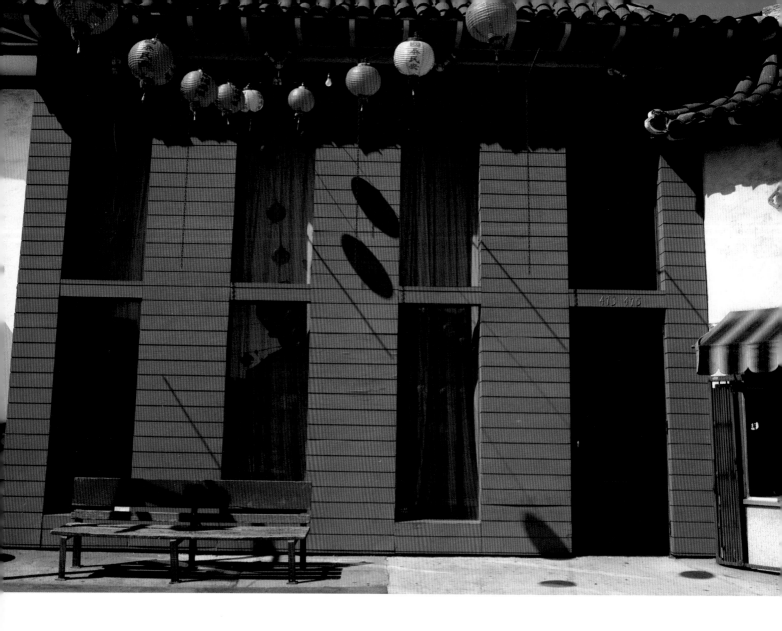

Recently, the journal has attracted German collaborators who, like Mendel-Black and his friends, are prepared to challenge all received ideas. "The rebellion we inherited," Mendel-Black says of his generation,

> wasn't Expressionism or Situationism like the Europeans. Our history is more based on an irrational suspicion of the inside world. What makes it so neurotic is its equally cynical Romanticism of the outside world—hi-tech, consumer culture, the desert landscape, etc.. The Europeans equate American minimalism with a Punk Rock militancy towards visual culture. For me it is not the one over the other. It is the combination of these and other attitudes that by all accounts are supposed to ideologically oppose each other that can really open a discussion up again.

Recently, with his friends from Germany, LA based sci-fi writer Mark Von Schlegell, and Chinatown gallerist Joel Mesler, Mendel-Black mounted the "Ten Thousand Fair Afflictions: The First Annual Extremist Conference" at The Mountain, artist Jorge Pardo's avant-upscale bar. Among the many high points of the event was Andre Butzer's primal scream delivery of psychoanalytic fragments from Lacan while his friend, Professor Winkler, played sugar-sweet acoustic pop songs on the guitar.

**Mountain Bar,
Chinatown, 2005**
photo: M. Paige Taylor

A gray Saturday in late February, I'm sitting around the Pruess Press gallery with owner Joel Mesler, the writer Mark von Schlegell, and my friend Goody B. Wiseman, an artist who's recently moved down here from San Francisco. It's early morning here on Bernard Street in Chinatown, and by 11 a.m. we've all more or less haphazardly arrived.

Pruess Press presently revolves around a huge dual etching litho press that Mesler bought from an old-school pressman in the San Fernando Valley. Used since the 1930s to print trade union pamphlets, supermarket flyers and suburban newspapers, the press is presently deployed in cranking out commemorative cartoons for a famous hip-hop artist, inspired by his lyrics. With their big-titted blondes and midget pimps, the drawings look like dirty cocktail napkins from a 1960s adult store.

"Our general theoretical concept," Mesner explains, "is that young people of our generation are really interested in high-end success—which is great, but they've left this *wide open field* for the low-end, middle ground."

"It's like, niche-marketing," von Schlegell adds.

Mesler moved Pruess Press here to Bernard Street in October 2003, from a space on Chung King Road to a building shared with Daniel Hug and David Kordansky Galleries. Their expansion onto Bernard Street marked the last wave of pre-discovered Chinatown. Launched in 1999 when Giovanni Intra and Steve Hanson founded China Art Objects, the Chinatown phenomenon had already peaked by 2001, with adulatory press in mainstream magazines. Recalling one of China's early shows—a videotape by Frances Stark of her cat listening to Black Flag in her apartment—the artist Laura Owen gushed with faux-naiveté to *W* magazine, "It was incredibly compelling, but you didn't know whether it was art or not, and that was so exciting; it hadn't been defined yet."[8]

Mesler and his friends are more relentlessly hardcore. They christened the space by summoning Art Bell, high priest of conspiracy theorists and flying saucer aficionados, who for many years helped his insomniac fans make it through the night with "Coast to Coast A.M.," his radio talk show. The spirit of Bell spelled out the following message on Mesler's old Ouija board: "I'm here." After wasting two years at the San Francisco Art Institute pursuing an art career in "Jewish Expressionism," Mesler moved to Chinatown in 2000 and opened his first gallery. "I never wanted to represent artists," Mesler says.

> *I had so many friends who weren't showing, I just thought I could help facilitate some projects. Because it was so cheap, I could exist without selling anything. People came to Pruess who weren't in the LA art school orbit at all. We'd just hang out and play guitar.*

In collusion with his friend, the sci-fi genius Mark von Schlegell (who edits *The Rambler*, an anonymous collaborative deep-dish LA zine inspired by Samuel Johnson's daily newspaper, self-published by the writer in the eighteenth century) Mesler's program has become increasingly *programmatic*. "I started to realize," Mesler says, "I didn't like the idea of artists going alone into their studios to make their work—it's just so sterile. We wanted the energy of the production house, where the studio could be the marketplace." And so Pruess Press, pruesspress.com, and their filmmaking wing, 2/3/2 Studios, was born.

"Our theory," Mesler says, "is—we came here to work, we didn't come to hang around." Citing one of his artists, Rabbi Milkblood, Mesler adds, "If you shoot yourself in the left foot, the right foot gets strong." What else, I ask, does Rabbi Milkblood say? "Don't fuck with our orgasm." "We object," von Schlegell adds, "to things being made for consumption, not for use." Pruess Press produces artist multiples and books; Pruess Studios records music produced by Mesler, Von Schlegell and their many friends. Recently, Pruess produced a series of collaborative monoprints by artists Henry Taylor, Andrew Hahn and Jason Meadows (Meadows makes a cameo appearance in Brown's *Pastorale* kissing Katie Brennan, who is Taylor's gallerist at ACME's Chinatown offshoot gallery, Sister. Sometimes, the artworld in Los Angeles seems very small.) Spontaneous and improvised, their music defines a new genre that they call Reality Rock. "We discovered everybody is a rock star when you treat them like one," von Schlegell says.

> *Music offers another level of anonymity. Last night, John Pylypchuck and his wife Annette were playing music with us. She is a Mennonite, and at one point she made him go and get a hymnal. She was reading things from this hymnal, tearing up while we just played music to accompany her.*

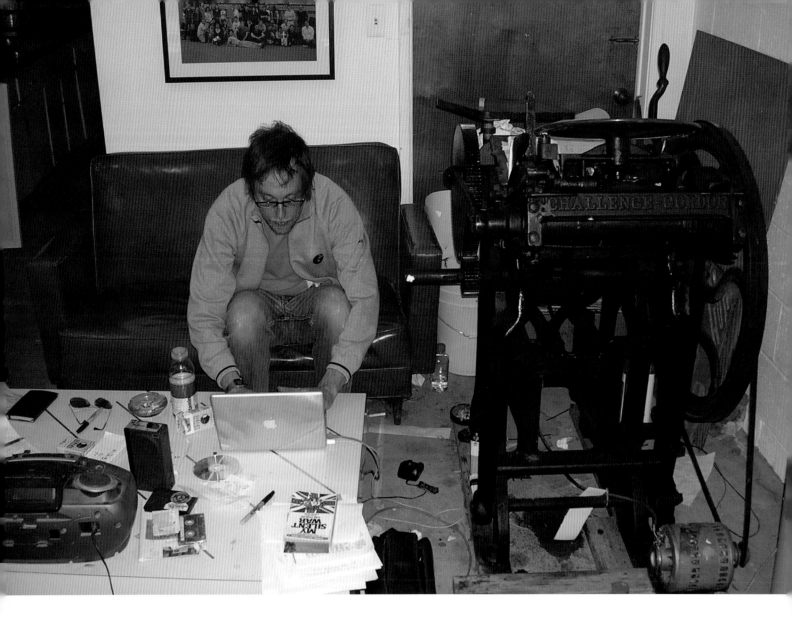

The songs—including freestyle soul sung by Henry Taylor—are broadcast on the gallery's website, pruesspress.com.

Not surprisingly, the guiding principal of Pruess' 2/3/2 Studios is: fast and cheap. The group is shooting their first feature, *My Dinner with Merlin* directed by the German artist Frances Scholtz. Written in two weeks, shot in three, edited in two more, the film features cameo appearances by Dan Graham, Joan Jonas, the writers Denzy Senna, Fanny Howe and Norman Klein in an epic inspired by the King Arthur legend.

Perhaps as a response to the incessant branding of the art market, a spate of ambulatory, anonymous art "collectives" have sprung up across the world in the last decade, though I can't think of any who pursue their mission with such fluidity and wit as Pruess. They've added the seriousness and professionalism that, till recently, was sadly lacking in LA among those who tried to forge alternatives to the hegemony of the artworld's "studio system"—the high-profile MFA.

Although not wanting to be left out of this lucrative market, Pruess has also opened up a school. "We call it SCA," Mesler explains, "because we had all this leftover stationary, certificates and awards that said Southern Cantonese Association, so we figured, we won't have to make new ones." "There's an excellent student teacher ratio," Von Schlegell says. "We have two students, and we have a lot of teachers…." Since the school's inception, the SCA faculty has included Frances Stark, Dennis Hollingsworth, and the late Giovanni Intra. "We put Thomas Pynchon on the faculty list, thinking if we did, he might show up," von Schlegell says. "Yeah," adds Mesler. "Is Pynchon still alive?"

Joel Mesler at work in the Pruess Press Studio, 2005
courtesy Joel Mesler and Pruess Press

"I like," says Marnie Weber, "to think about things beyond what you can see." We're sitting in her upstairs studio in front of *Woodland Creatures*, her extraordinary collage. *Woodland Creatures* and its companion *Tree House*, on the floor, are part of *Spirit Girls*, 2005, her new image suite. In *Woodland Creatures*, a woman in a long white dress reclines with both arms raised on a flower-laden funeral bier. The girl is haunted and protected by companion animals, some of whom appear to be half-human: a flying owl, an aproned bear, a sexy, high-heeled sheep. The moonlit night is violet-tinged like deadly nightshade, that most delicious poison.

Weber is an artist's artist. Collaborating with friends from Sonic Youth and Destroy All Monsters, Mike Kelley's and Jim Shaw's LA art rock band, she's been around the LA scene since the late 1980s, when she staged gallery performances and sang. Too original and singular to ever hit as LA art's "next big thing," she has exhibited and worked continually for nearly 20 years. Claiming for herself the freedom of the French Surrealists (whose work she naturally adores), Weber's work, with its constantly evolving lexicon of images, refers more richly to itself than to art criticism, philosophy or other art.

During the late 1990s, she successfully collaged pornographic images into pastoral landscapes. "[The models] carry the stigma of their past, but I'm trying to give them a new life—it's like saving a lost puppy," she told Darcey Steinke in *Spin* magazine.[9] Lately she's decided to stop using found images in her work. Pornography got old, particularly once she had a daughter of her own. "Once I became a mother," Weber says, "I couldn't see the girls as figures anymore. I'd always seen them in a figurative, art historical sense—figures in a landscape. But once I had a little girl, I started seeing them as grown up little girls. And that was the end. It stopped." Harking back to her performance days, she plays many of the characters herself. The rest of them, she costumes, poses, casts, directs. With a 5,000 square foot studio/sound stage out in Glendale that she shares with artist husband Jim Shaw, two costume rooms and a retinue of girl assistants, Weber's production apparatus is reminiscent of the silent movie studio days.

"I thought," she says of *Spirit Girls*,

> it would be a nice idea to do a series about girls who've died and come back to put on a musical. No, they aren't hungry ghosts. They've come back to spread a message. They're communicating, putting out. The spirit girls are all fictitious characters. I play the lead.

But what about the animals in *Woodland*?

> I like the role of animals because they're always protecting. They're always gathering around. A girl is being guided into different situations. The animals create a male alter-ego, without using an actual man. That's their primary function. They're idealized men.

I ask about the chubby gremlin in the foreground, hips jutting out, grasping a long pearl necklace made of eggs. "Ah, he's the egg stealer. He steals eggs, which is kind of funny, but also tragic. All women come across the egg stealer at some point in their lives. The passing of time, loss of fertility, miscarriage, getting older—there are many ways."

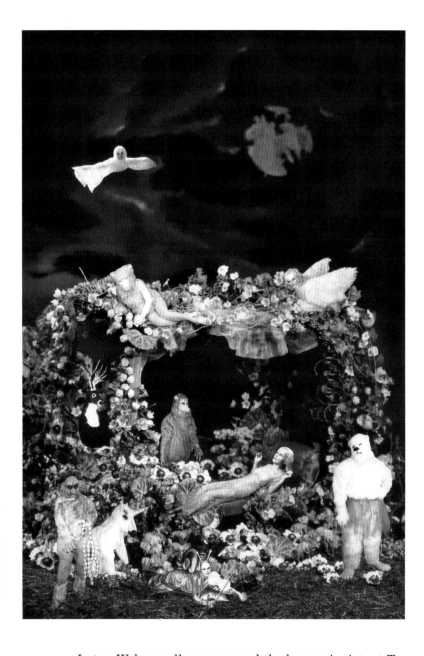

Later, Weber walks me around the house. Assistant Tamara Sussman is busy in the living room, cutting red roses out of colored contact sheets. Stuffed horses prance across the keyboard of an old piano; Barbies of all eras laid out on a wrought-iron coffee table sunbathe on the deck. Down in the basement, there's a witchy-looking metal soup bowl full of cut out butterflies and women's faces. "Oh," laughs Weber, "that's my next series there."

Driving down from Weber's house through Highland Park, a mural of enormous Toucan parrots graces Birdman Pet Supplies' concrete block wall. Behind the counter of El Pavo Bakery, there's a half-moon-shaped painting of a peacock, whose enormous half-spread tail threatens to eclipse the mountain in the background. The sign reads: Monterrey. Outside again, I start to see the Figueroa Boulevard storefront windows, with their infant shoes and christening dress displays, in a new way.

Later on that night, returning from my friend Matias Viegener's house in Silver Lake, I see a guy step out the passenger side door of a silver BMW on Sunset Boulevard. A girl is waiting for him on the sidewalk. She wears a shiny silver rayon blouse. He kisses her. The light turns green. In front of me, the car turns right on Parkman, then right again and disappears down the alleyway behind the Tropical. In certain frames of mind, each passing thing becomes apocryphal, and I think sometimes that the great difference between LA and London or New York is that less of it has been mythologized by poets and writers. Beyond the treacherous film-noir curves of Mulholland Canyon and the gaping immaculate suburbs of daytime TV, what do we know of LA? Whereas no mid twentieth century New York City cobblestone was left unturned by the thousands of writers who lived there, the chronicling of LA is much sparser. There is little left to remind us of the vibrant boarding house scene in downtown LA's Bunker Hill (long ago bulldozed to make way for the city's new high-rises) beyond the stories of John Fante, and most of them are out of print now.

Marnie Weber
Woodland Creatures,
2005
collage on photograph,
40" × 27"
courtesy the artist and
Rosamund Felsen Gallery, Santa Monica

Still, often, when I'm driving around LA I'm struck by the slight artifacts of what I imagine as LA's utopian future. An otherwise generic office building in mid Wilshire boasts three limestone friezes depicting human hands turning the earth, wielding a pickaxe, pouring medicine into a beaker. Low water washes between rocks and branches in an enormous (and anonymous) mural at the Wilshire Colonnades. Seals perch on rocky ledges, a flock of doves flies overhead. Two women and two men lounge among dry branches with their children. One man plays guitar. They're immigrants—Mexican and Scandinavian—the women have round breasts and shoulders; the men are slightly built: not uber-proles, but quiet urban workers. It is another kind of heaven, dreamt of by trade union and social reformers who flocked here between the wars from harsh northeastern industrial cities, as compelling to them as Delia Brown's *Pastorale* seems to us now.

Public artworks like this summon a vision of a radiant city where working people dwelt in grace, urbanity, and leisure. Who put them here? "The myth of Los Angeles during the 1920s was that it could be a worker's paradise," says Norman Klein, the urban archeologist and writer. "It was the last city where you could work and buy a house. There was no labor movement here to speak of, but the promise LA made was that workers might enjoy an elegance and stability unknown in other cities."

During the 1930s, Los Angeles pioneered one of the largest educational infrastructures in the country. The verdant, sprawling campuses of junior and community colleges, built when land was cheap, are reminders of a time when public education functioned as a new religion. Klein has made a study of LA's "history of forgetting." The city, he says, is characterized by:

> *moments of manic anxiety among its elite and policy makers. Like a house badly cleaned by a manic depressive, this city—its fantastic architecture, its lopsided infrastructure—is filled with half-completed episodes, lots of unwrapped junk that are clues to a larger emotional, collective confusion. LA is a neurotic's version of the planned city that keeps losing its way.*

"It's flattering to kind of keep that hope alive," the painter Henry Taylor says. We're sitting in his live/work studio in Chinatown on Hill Street, and he's talking about the monoprints he did last week at Pruess Press. "Joel is so encouraging, so positive. We're drawing late into the night. It makes you feel you're living a fuller life, the kind of life you've always wanted to be living."

Taylor, whose recent New York show at Daniel Reich in Chelsea sold out before the opening, has lived in Chinatown for 15 months. Before that, he was "kind of floating" between Culver City, Santa Cruz and Thousand Oaks, making paintings on the backs of cigarette packs when his studio was a kitchen table. Like all his larger works, they're sharp and sweet, blatant, simple narrative images that conjure up more complex histories.

While Taylor talks a mile a minute, my eyes are wandering around the 40 to 50 finished works around his studio. Like the painter R.B. Kitaj, many of his paintings are compositionally disjunctive narratives, but Taylor packs a more aggressive visual punch. Painted in deep colors, his people practically burst through the frame. The first one that sucks me in is a painting of a young black man in a T-shirt standing in front of a long, low WalMart building. Underneath the figure, a soldier crouches in a tunnel. It's any-urban-neighborhood, USA. "Yeah," says Taylor,

> *it's just kind of projects and stores. My brother was what they called a 'tunnel rat' in Vietnam—he was shot in the leg, and he was in a ditch. I used to read his letters to my mother because she couldn't read, and he'd write things like 'Mom, I'm really scared, I can't let the others know how scared I am.' And I was like, How could you be a damned soldier? I had two brothers who went to Nam. My other brother, Herschel, was shot there three times, he was shot on his birthday.... He said he was scared but dared not say it to the other younger soldiers he was in charge of. When I did my last show in New York, it was really like bringing my family with me. I was just thinking of him....*

While still a student at CalArts during the mid 90s, Taylor made a series of paintings inspired by the labels on bulk foods distributed to welfare clients: *US Dept. Of Agriculture—Not To Be Sold or Exchanged.* Growing up in Oxnard, California in a family of eight children, he met a teacher at his junior college who'd graduated from CalArts, and convinced Taylor he should go there, too. "I didn't know what they were talking about at art school," Taylor recalls of CalArt's theory-rich syllabus. "I was like, did everybody read this shit?" It's a sentiment shared by many of CalArt's most illustrious graduates, including Julie Becker and Andrea Bowers. Taylor paints cars and hairstyles, Old English beer cans, fat women, birds and smiling Arabs. "I work intuitively," Taylor says, "just moving shit around."

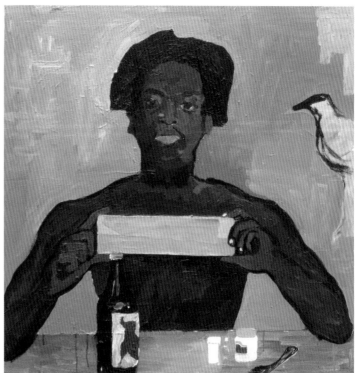

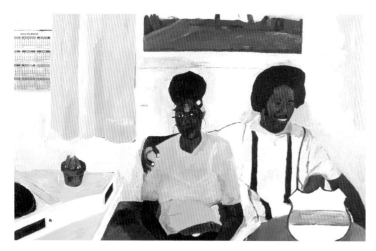

We walk around the room to a painting of a thin man sitting in a Queen Anne chair. White shirt, black tie. A black horse behind him, and two guns on the table as if on court exhibit. "This is my grandfather," Taylor says.

> He was a horse trainer, his name is Ardmore. He was shot and killed at 33, ambushed in Naples in East Texas. My dad, whenever he got drunk, he would act out the scene: my dad was nine years old, and he went and picked up the body with my grandmother. His horse would not leave him. The horse was trying to protect him.

In between attending international art fairs, Taylor's recently begun a series of paintings of former Black Panther leaders. There's a blow-up of the cover of George Jackson's book, *Soledad Brother*. A painting of Malcolm X gazing straight ahead and measuring the string of a cat's cradle. "Neighborhood Watch," the painting says, in black letters above Malcolm's head. As a child, he'd seen one of his brothers gravitate towards the Black Panther movement in Oakland. Taylor comments:

> I was too young to be a participant, but my brother was. He was involved in the 'struggle'. Driving past Soledad Prison when I was in Santa Cruz got me thinking about Jackson. I re-read the book and realized little has changed, if not gotten worse. I was just thinking, about what people's priorities are now, compared to those days. I'm still just curious, and I try to be sincere about learning.

25 blocks north at an artist's complex called The Brewery, Eugenia Butler is reinventing the kind of process art that she grew up with. Daughter of the well-known gallerist (also named Eugenia Butler) who introduced Fluxus to LA, she was born to art, and recalls the late 1960s art scene she engaged with in her teens: "There was this flow of electricity. Everything happened in the studio. We had the sensibility that we could change the world. That ideas were incredibly important." At that time, Butler and her friends—the artists James Lee Byars, Grant Cooper, Eric Orr—were experimenting with light, and body sounds, and absence. Staging impromptu happenings with ruby lasers on abandoned boulevards, inserting plaques bearing the description "A Congurent Reality" into public spaces, Butler's group opposed the static nature of minimalism. "I was interested," Butler says, "in how you could make work without that lugubrious materiality."

top left:
Henry Taylor
Untitled, 2004
mixed media on
cigarette boxes,
2 ½" × 7" × 1"

bottom left:
Henry Taylor
Sis and Bra, 2004
mixed media on canvas,
47" × 77"

right:
Henry Taylor
Untitled, 2004
mixed media on canvas,
36" × 36"

courtesy Sister Gallery,
Los Angeles

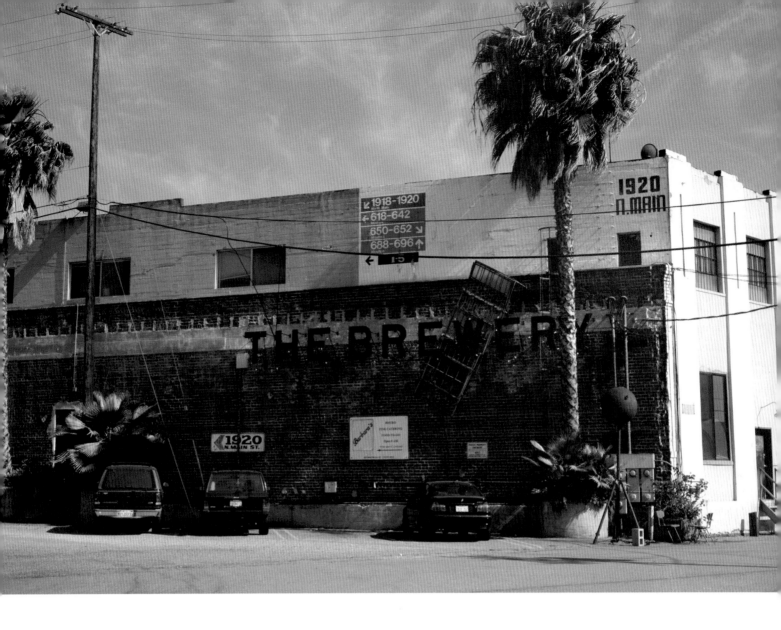

Life eventually intervened. Butler had a child, moved to South America, and studied shamanism. In the late 1970s she came back to LA and lived for a short time in Beverly Hills designing furniture. Now, she occupies a live/work space and spends her time thinking about the future. In 1993, Butler began an extraordinary ongoing work called *Fire in the Library*, staging conversations between scientists, philosophers, writers, activists, psychiatrists and film people. In 2004, she launched *A Laboratory With Velocity—First of a Series of Conversations on Envisioning the Future*. The projects are an extraordinary mix of Fluxus-style art happenings, think tanks, and academic panels pursued with intellectual passion.

Dialogue is a living thing; it's also immaterial. "Why am I so interested in dialogue?" she asks

> *Dialogue was such a formative element of how I learned about making art. I could see this really beautiful transmission of ideas between one human being and another, and I noticed the way these ideas would morph and change, become something else through that person's interior dialogue. I never felt territorial about any of this. I did not believe in it.*

In *Laboratory with Velocity*, she hopes to get 250,000 people in LA thinking about the future. "When we think about the future in concrete terms," she says,

> *our reptile brains begin to work. It's a piece that's socially ambitious as well as artistically ambitious. Because I realized, now, that no one feels they have a right to think about the future, in some terrifying way. A dying body doesn't think about the future. But the Enrons and the Halliburtons are thinking about the future. What is our heart's desire? If we are going to hand on a future that's going to be livable to the next generation, we have to think about it now.*

The Brewery, 2005
photo: M. Paige Taylor

Butler thinks primarily as a visual artist. The walls of her large studio are strewn with drawings of ideas. "Drawings," she says, "are how I *move* the work, the way I gather my ideas."

I get up and walk around the room among Butler's many drawings. Like placards from a high-school science fair, they're written and painted on posterboard and oaktag. Swirls of paint, newsprint cut-outs, collaged photographs of animals, organized within mismatched hierarchies into diagrams. I read a list of "five conditions":

1. *seemingly ineradicable danger*
2. *ongoing threat*
3. *seeing our way to a healthier habitat*
4. *need to act*
5. *seeing the next step*

One poster features the word "Mystery" in luxurious scroll next to a painting of a laboratory beaker. "Intrigue," the work states, "story, romance, political, mystical, piecing together solutions." There are spirals and flowers and rainbow swirls, puce-green magic marker drawings. Moon craters, and above them she writes the words: "fecund emptiness."

Since the first *Velocity* event staged in November 2004, Butler has produced a short film, a DVD, 20 videotaped interviews, and a series of ten smaller dinners in which participants and those she calls "The Audience of Active Listeners" converse informally. It is an all-consuming process. Dozens of small events occur. They multiply. And somehow, they inform each other. Sensitive to the intangible value of the fleeting daily exchanges that comprise the life of a city, Eugenia Butler has transformed civic discourse into conceptual artwork.

Eugenia Butler's Studio, 2004 wall of "idea holding" drawings for *A Laboratory with Velocity*

The people that I visited on this short walk are only seven among thousands of artists now living in Los Angeles. Their lives make me believe that in the mythic isolation of the city, people are devising not just the artifacts that we call "art," but also something more elusive: a community of shared references, jokes and indiscriminately wasted time, that thing that in past centuries was known as "culture." But each walk a person takes yields something new, and I hope that in this book you'll find your own "Los Angeles."

All quotes were from conversations with the author for this essay unless otherwise attributed.

1 Intra, Giovanni, "LA Politics," *Circles*, Karlsruhe: ZKM, 2002, pp. 117–118. Giovanni Intra 1968–2002.
2 Intra, "LA Politics."
3 Mosley, Walter, *A Red Death*, New York: Pocket Books, 2002, p. 54.
4 Johnson, Ken, "Delia Brown," *The New York Times*, June 12, 2002.
5 Indiana, Gary, *Resentment*, New York: Doubleday, 1997, p. 303. *Resentment* is a social comedy inspired by events surrounding the Carlos and Felix Menendez murder trial. 6 George, Lynell, "Easy Writer," *LA Times*, April 13, 2005.
7 Mosley, Walter, *A Red Death*, New York: Pocket Books, 2002, p. 312.
8 Cutter, Kimberly, "East Side Story," *W* magazine, September, 2001.
9 Steinke, Darcey, "Malice in Wonderland," *Spin*, June, 1997, p. 40.

Eugenia Butler
A Laboratory With
Velocity, **2004**
conference/performance

Jan Tumlir

Lessons of the Class of 90: Siting Recent Art in Los Angeles

The generation of Los Angeles artists that rose to prominence in the early 90s is well on its way to becoming the most successful and influential that this city has ever known. On this point about the "Class of 90" there is a developing consensus, though not on much else. Contemporary art is characterized by a wanton multi-media amorphousness that exceeds even the 70s in its scope and grasp, and nowhere is this more true than on the West Coast where we can now say in earnest that "anything goes." Any sort of analysis concentrating on media, materials, techniques and so on is thereby doomed from the start to irrelevance. Neither is there much to be said on the question of style, or even general sensibility. Any attempt to deal with this work as an isolated phenomenon— as in the "sweet neglect" theory advanced by Lari Pittman and Terry R. Myers, which has LA art flourishing not just in spite of a dearth of local collectors or any established system of critical appraisal, but precisely because of it—will progress swiftly from the general to the specific, bypassing most historical, social and economic factors in favor of the object, once again, "in and for itself."[1] However, should we choose instead to work our way backward so as to consider the object an outgrowth of its particular context—that is to say the context it is ostensibly produced for, the context it aims to fill—then certain points of consistency will become at once evident.

In this light, the litany of shortcomings that was once invoked to account for the failure of LA art can be seen more as a positive incentive. Yet it is not neglect *per se* that benefits local artists, allowing them to concentrate on "the essential" within a system of ever-greater atomization and anomie, but neglect as a rallying point, binding disparate segments of the artworld around the common goal of building up an infrastructure from scratch. As much as the critical establishment—those (like Dave Hickey, David Pagel and Christopher Knight) who once made the pages of the local journal *Art Issues* into their united front—wants to dress up the new in the guise of the old, returning like something repressed in the intervening two or three decades of conceptualist dominance (and thereby effectively repressing conceptualism instead), their brand of hard and fast revisionism is ultimately way out of synch with the fluid, protean nature of the art in this town. It is no longer theoretically feasible to bracket the realm of practical endeavor off from the other "creative" one.

No matter how far and wide contemporary artists may search for inspiration—and the LA school is known to search farther and wider than most—the first concern of production remains context, and the same goes for reception. The first, the context of production, is the more "ideal" (in the Platonic sense) of the two, being the ground zero of the artistic process, but it is not without its own material determinants. For instance, an expansive warehouse studio may yield heroically-scaled artworks, while a converted garage workshop will tend toward a more modest sort of output. Moreover, we may want to distinguish between the urban and suburban attitudes that inhere to these different locales, and their attendant bohemian and/or "bougie" connotations. The movement of capital through the physical fabric of the city impacts artists directly, and is directly impacted by them. The search for affordable workspace compels a migration toward the economic hinterlands, whatever they may be at any given time, which touches off the inevitable cycles of real-estate redevelopment and gentrification, eviction and relocation, and so on. It is a familiar story, one that describes the artist's spiraling trajectory throughout just about any big city, although here in LA where the borders between city and suburb, public and private, are subject to constant revision, we have our own special version of it. A famous TV ad for *The Los Angeles Times*, run at the start of the new millennium, sums up this uniquely conflicted sense of place in a succinct montage that opens on the neighborhood idyll of a blissfully oblivious homeowner watering her front lawn, and then follows the spray to what looks like the flashpoint of an inner city riot.

Kerry Tribe
Here and Elsewhere,
2004
video stills from an installation with 2 channel DVD projections, 10:30 minutes

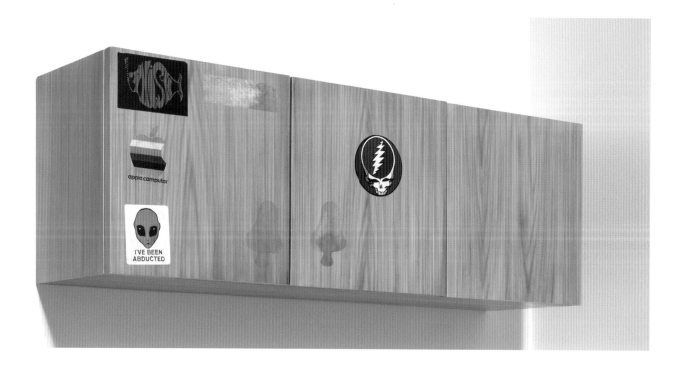

The city lies between the studio and the gallery, surrounding them both as a common denominator, a general framework that is then subdivided into ever smaller and more specific frames. The context of reception seeks to insulate itself against this overarching influence with a "white cube" aesthetic, and a persistent logic of autonomy or "art for art's sake." There is nothing implicitly wrong with this, of course; it is just an attempt to extend the open-ended conditions of the work's conception into the realm of display and exchange. Yet, if conceptualism has taught us anything, it is that this "secondary" context is just as vivid and demanding as the first, and that its hold over production is all the more pervasive the more it is ignored. Rejecting the various emancipatory paradigms that defined the course of progressive art throughout the modern era as utopian, mythic and basically oblivious to their own material realities, the "idea artists" would instead try to simply narrow the gap between intentional cause and objective effect within a conventional gallery and/or museum context. Of course, conceptualism's aspiration toward a 100 percent context-appropriate modus could only yield an aesthetic that was cryptic and bureaucratic in the extreme. This much is by now well established: the object of art was modeled directly upon the institution of art, which was in turn modeled directly upon the archive. Hence, a new art of information whose only concession to the art of the past is a certain residual self-reflexivity, that it be not only "of," but also "about," information as such.

This general game-plan remains vital for the generations that follow, disseminated as it is through the network of colleges, universities and art schools that dominates the area, and where the conceptual credo holds firm. Frequently described as "post-conceptual" (a label that backhandedly attests to the staying power of whatever has supposedly been superseded), recent art from LA is above all hyper-educated. If it nevertheless appears to be colored by an incipient intellectual sloth (rock on!) this should probably be seen as a reaction to an excess of learning rather than the lack thereof; the more educated it becomes, the more it adopts a posture of "dumbness." Likewise, the recent so-called "turn to beauty" (of Hickey, Pagel and Knight) hardly marks a point of authentic rupture with anything that has gone on before; to treat it as such smacks of rhetorical jockeying. The generation currently ascending cultivates the same practices of inclusivity and hybridization that have always been part of LA art, and to an even more delirious degree. The 2004 California Biennial, for instance, was full of interdisciplinary, cross-cultural offerings that extended the reach of art into such outlying fields as architecture and urban design (Peter Zellner and Jeffrey Inaba's VALDES project), internet design (Amy Franceschini/Futurefarmers), product design (Michelle Lopez), popular music (Mads Lynnerup), documentary film (Kerry Tribe), animation (Koto Ezawa), and so on, all the while resuscitating the full range of prior postmodern strategies that have characterized West Coast production over the past 40 years—everything from kustom kar kulture (Rueben Ochoa) to finish fetish (Kaz Oshiro), via Bay Area funk (Simon Evans) and assemblage (Mark Bradford). On the one hand, then, the scene can be summed up by those famous words of E.M. Forster: "only connect." One must always try to bear in mind the intricate web of references and citations, of historical continuities and working-throughs, that subtends every new cultural development in this town. On the other hand, however, one must also acknowledge the impact of environment in a more basic and immediate sense; that is to say the material environment of Los Angeles, which, to confirm a cliché, often seems anything but material.

Kaz Oshiro
Wall Cabinet 1 (I've been abducted), 2003–2004
acrylic on stretched canvas, 15" × 45 ½" × 12"
photo: Douglas M. Parker
courtesy Rosamund Felsen Gallery, Santa Monica

Mark Bradford
Backward C, 2005
mixed media collage
on canvas, 84" × 120"
courtesy Brent Sikkema,
New York

Outwardly, that is, history does not seem to count for much in Los Angeles. No pride of place reserved for the old, the patinated, the palimpsested. Out-of-towners are frequently shocked by the open disregard we show our historical landmarks, any of which can be sacrificed at a moment's notice to make way for a new parking lot, a few more lanes of freeway. Nothing here stands in the way of economic movement and mobility. No wonder, then, that Norman Klein has dubbed this city the very capital of forgetting.[2] The boulevards and streets cut right through the built environment, eroding history on every side and laying it to waste, like the mythical river Lethe.

Whether or not one agrees with the characterization of Los Angeles as the first truly post-historical city, there can be no doubt that this is in effect what most of the world sees, making it the model for every other flickering way-station on the newly globalized circuit of art. London, Paris, Cologne, Havana, Johannesburg, Istanbul—the overriding perception is of the sameness of things, a wearing away of cultural difference so insidious and totalizing that any mention of vernaculars should at once strike us as hopelessly nostalgic. A vernacular implies a certain formal resilience, and form does not last in LA. The ultra-pragmatic policy of this city's original planning commission, 1920, still seems entirely relevant in this regard: "A city plan should be prepared from the economic standpoint first, the social or human standpoint second, and the aesthetic viewpoint last."[3] Here, where buildings sometimes seem like merely bumps in the road, the fate of architecture is precarious at best, and yet it is precisely architecture that is on everyone's minds these days. On a recent trip to New York it was noted by more than one observer that LA's young artists are, for the most part, surprisingly well versed in this subject. They think a great deal about architecture and urban design, particularly as these apply to the city they live in, and perhaps most surprising of all, to its history. To those on the East Coast, who see LA as the antithesis to their own longer lasting urbanism, where architecture stands as a palpable crystallization of time, this seems like a paradox. It is worth recalling, however, that there are probably more historians per square foot here than in any other city in the world, and if form does not last in this climate, some record of it surely will.

Perhaps the point is precisely to do away with the thing so as to make way for the idea—a distinctly anti-materialist tendency that seems to fly in the face of the commonly-held description of Los Angeles as a plastic paradise of rampant consumerism and idolatry. In general one could say that Angelenos have an enormously conflicted and paradoxical relation to things (to the determined "thing-ness" of things) and its artists perhaps even more so. A representative instance is provided by John Baldessari, who decided in 1970 to send the entirety of his painterly corpus up in flames, exhibiting the outcome in a modest urn as though to commemorate his phoenix-like rebirth as a post-studio idea artist. Outwardly drastic, this gesture can also be read in purely practical terms; it is not compelled by a logic of vandalism so much as recycling. For starters, we can comfortably assume that the paintings he torched were not exactly "hot" to begin with. Economically speaking, at least, the urn simply suggests a more efficient use of space and personal resources. Bearing in mind its particular time-frame, poised between the lavish vista-visions of US art circa 1950–1960 and the leaner years to follow, it makes perfect sense.

Interestingly, however, Baldessari ultimately chose to override conceptualism's anti-painting *diktat*. More, many more, paintings would follow in the wake of his ostensibly definitive gesture, but it would be too easy to put this down to a maverick (or better yet, mercenary) tendency. Clearly one cannot simply return to "business as usual" after a shakeup of this magnitude, since Baldessari had managed to erase not only a good part of his own artistic history, but the history that generally inheres to the medium. In effect, painting could no longer be counted on to provide a secure space or surface of inscription, at least not within this particular body of work. Its archival status had been violated, as it were, for good.

John Baldesarri
Cremation Project,
1970

David Bunn
Aleister Crowley, 2003
installation detail from
Subliminal Messages
LA Central Library
catalog card, 3" × 5"
courtesy the artist and
Angles Gallery, Santa
Monica

That the subsequent paintings would play upon language—and moreover, upon lettering, signage—in such a way as to highlight a zone of indeterminacy between handicraft and commercial fabrication is telling, and sets a crucial precedent, I believe, for a whole LA school of artist/scribes. The lines of influence can easily be traced from Baldessari and such figures as Ed Ruscha and Allan Ruppersberg to the second generation conceptualists David Bunn, Stephen Prina and Larry Johnson, all of whom perform their own variations on the general theme of privatizing the public archive.[4] Bunn, who continues to work with the card files of the Los Angeles Central Library that he "inherited" in 1993, on the eve of this institution's digital turn, provides the most literal instance of this incentive. His ongoing attempt to derive from this largely bureaucratic source material a kind of concrete poetry, however, is shared by both Prina and Johnson. For example, Prina has done much the same by appropriating the archival holdings of his Cologne gallery, Galerie Max Hetzler, 1991, just as Johnson, for his part, continues to appropriate those telling snippets of industrial signage and promotional verbiage that form the chattering backdrop of everyday life in LA. This practice continues in the work of Frances Stark, Dave Muller and Mungo Thomson, among many others; its meaning and purpose altered as much by their distinct sensibilities as the times they inhabit.[5] Especially revealing in the case of this last group is the emergence, alongside the poetic sensibility already noted, of an increasingly "personalized," or at least "physicalized," aesthetic. Stark, Muller and Thomson have all nurtured a distinct mode of *écriture,* once more prioritizing the work of the hand as a viable means of transcription.

Time is indeed of the essence in the work of all the above artists. The question that inevitably arises—why bother to physically render mechanically or electronically generated information?—will not accept a single, final answer. From a present-day vantage, it has already lost its explicitly pop or conceptual connotations. The original moment of collision between artisanal and industrial cultures is here distantly echoed, but it is no longer the main event. Somewhere along the line as pluralism and sheer heterogeneity reaches critical mass, annexing every last enclave or holdout of consistency to its own fractured scheme, there begins a vast process of cultural reassessment. Even the simplest statements must now be broken down and sounded out, their meanings reestablished, as it were, from the ground up. Within the text drawings and paintings of Stark, Muller and Thomson, for instance, one gets the distinct impression that something is being built. One letter, word, sentence after another, text layers the available surface like bricks; an edifice of information is raised up incrementally as if to immediately undergo an equally incremental dismantling.

Baldessari's late paintings emerge from the urn and never stop pointing back toward it as a potential fate. It is the emblem of their ultimate eradication and an archive in itself. The urn contains, and thereby also becomes, art: an idea of art-as-container. This idea resembles the one advanced by conceptual art, except for the fact that the container in this case is a common household item, belonging more to the mantle and hearth than the bureaucratic crypt. Of course, Baldessari could not possibly have foreseen the conditions that would extend his gesture from the Situationist 60s into the simulationist 80s, and then further, augmenting its appropriateness every step of the way. No doubt it is significant that both decades close on a bum note as recession takes hold, both times stifling this city's potential to develop a "world-class" art scene just as it was about to happen. As the "ultimate commodity," in Adorno's estimation, art is also the first item to get crossed off the list of basic necessities when times get tough. And the artworld follows suit: inasmuch as it can serve as a barometer of financial speculation on the very frontier of real-estate redevelopment, so too does it sound the first warning of economic downturn. When an area nurtured on a rich cultural regime expands to a point where it can no longer sustain its founding bohemia, and artists begin losing their lofts to design offices and pricey boutiques, that is the first sign. The second arrives close behind as, one after another, galleries begin to shut their doors to the public; at this point, all but the most deeply entrenched will be advised to seek cover. In the 70s, such a state of affairs encouraged a "return to authenticity." In the absence of any viable system of distribution, artists could safely dispense with the commercial posturing that was so characteristic of an earlier pop moment, and resume whatever it was that got them involved in this business to start with. Work became so easy or difficult that its only chance for exposure would have to be state-subsidized: either through the not-for-profit artist-run spaces like LACE, or the museum system as such. Within this climate of mounting economic indifference, it is easy to see how conceptualism developed its sullen bureaucratic biases.

As noted, the generations that follow revisit this experience in the somewhat attenuated form of their schooling. CalArts is known to this day for training artists to enter into immediate conflict with the institutional hand-that-feeds (which it did ever more lavishly throughout the "boom-times" of the 80s). When this system collapsed in turn (for the Class of 90, to whom I will now turn, this happened right on time for graduation), "authenticity" was pretty much out of the question—there were massive student debts to repay.

Mike Kelley,
***Matriculation*, 1997**
mixed media on paper,
20" × 26"

This situation is unprecedented. The sense of having been conned, somehow, was pervasive and devastating and yet, just like a hangover, it could not be articulated, and would find no sympathetic audience anywhere anyway that was not inclined to write it off as privileged whining. Following Ralph Rugoff's ultra-chic "exposé" of CalArts celebrating the art school as a happening "scene" in a 1989 issue of *Vogue*, the magazine articles kept coming: Dennis Cooper's "Too Cool for School" in *Spin*, 1997, Andrew Hultkrans' "Surf and Turf" in *Artforum*, 1998, Deborah Solomon's "How to Succeed in Art" in *The New York Times Magazine*, 1999. On the one hand, these raised the prospect of graduate education, for West Coast artists, to an indispensable rite of passage, while on the other hand, lambasting the whole idea with ever-increasing venom. A gradual souring of the editorial tone can be traced from the first of these articles, which could easily pass for art school advertising, to the last, which indicts art school careerism as the simultaneous cause and effect of the utter corruption of US culture overall. For those who experienced this turn as a kind of "bait and switch" strategy, having bought the art school rap at a premium without preparing for the inevitable payback time, ambivalence is the only answer. If there is any sort of consistent psychological tenor to be discerned in the art that results—stoic, guarded, but underneath almost hysterically sensitive—it might have something to do with these very real economic pressures. The Class of 90 turn inward in public, which is to say that they never really let down their guard. The air of confrontation and critique hangs heavy—another legacy of the intellectualism of the 70s and 80s—but its purpose is oddly dispersed, so that while it seems to touch everything and everyone in its midst, it does this so lightly that it might as well be touching no one and nothing at all.

Dave Muller
various images from
Three Day Weekend,
1995–2002

top left:
Jory Felice
Corolla Over 94, **1995**
installation view at solo
show in Los Angeles
photo: Dave Muller

top right:
Mari Eastman
***Reclining Chewbacca*,
2000**
installation view from
exhibition of Amy
Wheeler, Mari Eastman,
and Rebecca Morris in
Los Angeles
photo: Dave Muller

bottom left:
of related interest...,
2001
installation view of
an exhibition of Dave
Muller drawings related
to *Three Day Weekend*
and LACMA Lab, Los
Angeles
photo: Dave Muller

bottom right:
***Monochrome No. 15*,
2002**
acrylic on paper, 6" × 8"

courtesy Dave Muller
and Blum & Poe, Los
Angeles

This attitude is perplexing, and all the more so when one considers how long it has survived in the absence of any distinct *doxa*. The "institution of art" that previous generations had the privilege to critically undermine was now truly in shambles. This new generation—the Class of 90 —basically had to develop their work "from either end," production and reception at once. They had to concentrate not just on the object, that is, but the context as well—the space of display, the announcements and ads, the opening, the drinks, and so on. This is the culture that Dave Muller's work commemorates even as it participates within it; a culture already well underway when *Three Day Weekend*, his convivial party/showspace, first opened its doors in 1994. Much like the gallery he mounted while still a student in his CalArts studio, *Three Day Weekend* is an exercise in casual curation, responding more to social connection and community building than any strict thematic agenda. Accordingly, its gradually evolving, hyper-intuitive program also provides, at any given moment, a partial glimpse of the new court taking shape around the artist while simultaneously shaping him. Tracking Muller's "rake's progress" through the world, *Three Day Weekend* has cropped up in a succession of downtown lofts and, more recently, his Highland Park home (as well as, via home and gallery exchange, in Houston, Vienna, Tokyo, Malmö, London and Berlin). Throughout it all, the artist has maintained the role of a beatific host, MC and DJ in one, while always generating a hand-made poster for the affair, this being simultaneously a "gift" to all involved and a unique instance of his own work. With the quick rise up the artworld ladder of Muller and his numerous friends and colleagues, the liberal-democratic interpretations that clung to this practice at the outset have come to include murmurs of careerism and in-club exclusivity—but this only makes it more interesting. In effect, the argument concerning the asymmetry of these two realms of production and reception, which was precisely the critical starting point for conceptual art, was rendered close to moot by the end of the 80s. Increasingly, that is, both would be domesticated.[6]

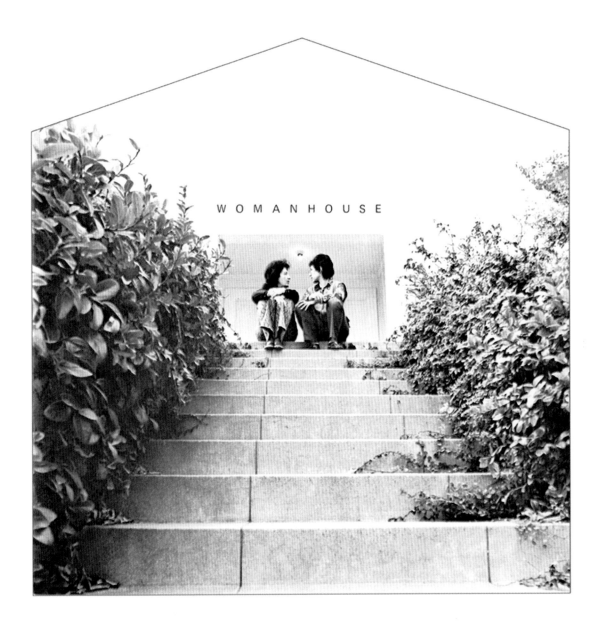

WOMANHOUSE

Tidy up a warehouse loft, apply a fresh coat of paint, and it can easily pass for gallery space —not so a garage, and still less the living or bedroom of a regular apartment or house. But in the late 80s and early 90s this is exactly what happened: artists who had moved out of the urban industrial sector (which now enfolded their dwindling production schedules in the logic of a cruel joke) and back into the suburbs, began to show their own work and that of their friends, _in situ_, so to speak. There are of course precedents for this move, notably the feminist collective _Womanhouse_, an off-shoot of the CalArts Feminist Art Program spearheaded by Judy Chicago and Miriam Schapiro in 1972. Located in an abandoned residential building, this space provided a context-specific backdrop for a series of performances dealing with subjects such as domesticity and "women's work" that the more conventional artworld tended, at the time, to pointedly overlook. _Womanhouse_ was a response to an experience of marginalization, which might also be said for these latter instances, except that here it no longer touches on any specific gender, race or class—here it is the economic marginalization of an entire artistic community that is at stake. Artists from the San Fernando Valley to Silverlake dusted off their old volumes of Bachelard, and turned to the appropriate sections—what, for instance, might it mean to exhibit in a kitchen, a bathroom? All at once these spaces became options, and not just for a minimalist "white cube" style makeover, but rather, right from the start, this turn was seized as an opportunity to generate some auspicious confusion.

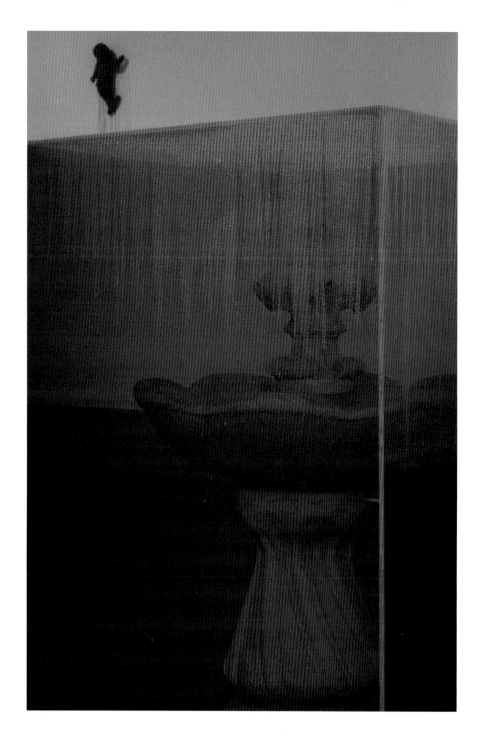

This certainly was the idea behind Bliss, a modest Craftsman house in South Pasadena that was opened to the public in late 1987 as an on and off exhibition space by three Art Center alumni —Kenneth Riddle, Gayle Barklie and Jorge Pardo. Although their earliest shows had been casual, impromptu affairs, mostly confined to the garage, the gauntlet was officially thrown down with *The Neighborhood Art Show*, 1987, which featured the work of some art school colleagues juxtaposed with a motley assortment of items gathered from the neighbors "within a one block radius of Bliss (who had been invited) to include anything they had made or that was important to them."[7] Of course, a fair number of the exhibitions mounted at Bliss could just as easily have been shown in a conventional gallery, but the ones that counted took the specificity of the space firmly into account. Jorge Pardo's first solo outing, for instance, included a table that had been routed out to accommodate several small handmade cameras, in effect allowing it to photograph itself. The resulting images were displayed on the walls surrounding the table in question, thereby "joining the subject and object of photography," in Pardo's words.[8] The notion of an everyday, utilitarian object acquiring an arty interiority via the photograph is of course integral to just about every piece of his that would follow. Moreover, the use of a photo-mechanical paradigm to revisit, in a virtual sense, a range of sculptural issues, formerly the domain of the solid and real, would prove enormously productive, and not just for Pardo, but for the whole school of West Coast "neo-constructivism" (for lack of a better term) that was emerging around him.

Pae White
Untitled, 1989
plexiglas, concrete
fountain and water,
dimensions vary

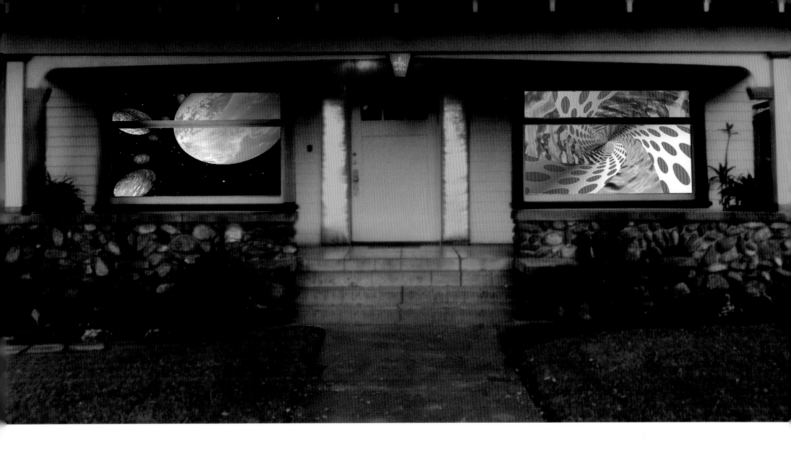

Questions of utility, design for life and/or lifestyle, have long served to shape the evolution of Los Angeles art. For instance, the marriage of painterly concerns and industrial materials and techniques that yielded some seminal examples of Light and Space and finish fetish work in the 60s would have been (and no doubt was) right at home in any number of space-age bachelor pads. This work branched out to other forms of production, and occasionally wound up "out on a limb," the results verging on kitsch eye-candy, the art equivalent of the lava lamp, but those were the stakes in this particular game. If the 90s generation has nurtured a fetish for this period and all its inflated biomorphic accoutrements, it goes beyond aestheticist nostalgia; no doubt the look is cool and fashionable, but more importantly it represents a genuine hybrid potential that once more seems ripe for exploitation. Another Bliss artist to take advantage of this state of affairs was Pae White, who transformed the space into a "virtual garden," colliding her organic, planting materials (bonsai trees, sunflowers, etc.) with elements of patently artificial "hardscaping," most notably a DeWain Valentine/Craig Kaufman-style Plexiglas cube, tinted a hot, fluorescent pink, enclosing a working fountain.[9] A collection of humidifiers sculpturally mounted on pedestals completed the convulsive makeover of this monument to American domesticity into a psycho-sexual hothouse, while also inaugurating White's own ongoing exploration of the categories of interior and exterior, private and public, in regard to the self as well as the various structures that surround and contain it. The reversal and conflation of qualities inherent to either side continued apace in the contributions of Jennifer Steinkamp and, even more explicitly, Diana Thater, whose 1992 piece *Up to the Lintel* included a video projection of the house's interior upon its facing windows, and thereby served to turn it literally inside-out.[10]

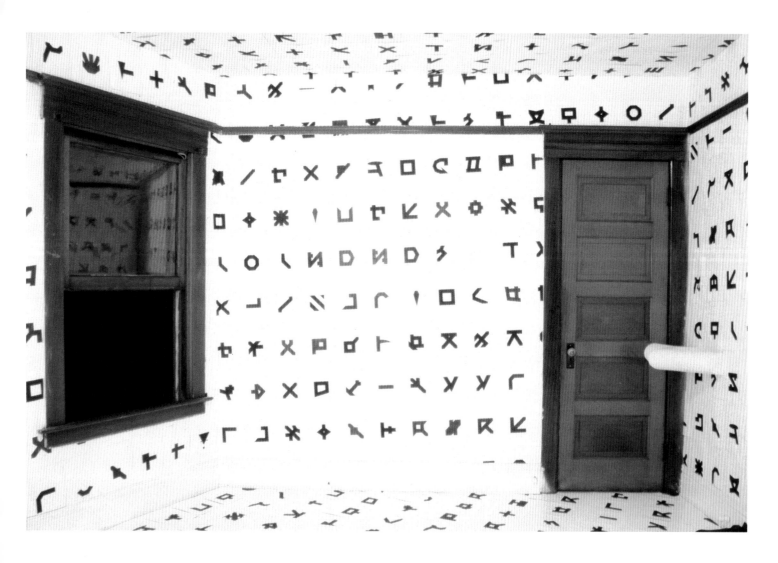

It can be safely assumed that the unique conditions of display that Bliss foisted upon its visiting artists, many of them just out of school, helped to determine the particular set of concerns that are at the crux of what is presently known as the Art Center aesthetic. Providing an invaluable testing ground for the sort of interdisciplinary art and design merger that is promised in that school's brochure, but so rarely in fact delivered upon, Bliss no doubt played a key role in promoting the Art Center cause throughout the 90s, and securing its artworld rep to this day. The results are wide-ranging, touching upon all areas of current practice: sculpture, video, photography, as mentioned, but also painting, where a certain 60s/70s period style has become almost *de rigueur*. In the work of Fandra Chang, Linda Bessemer, Habib Kherdyar, Adam Ross, Carl Bronson, Michael Gonzales, among others, a streamlined minimalist aesthetic is revisited DIY-style, with materials straight from the local home improvement outlet. A marriage made in heaven, apparently, it quickly developed into a style in its own right, claiming new adherents to this day. However, here again, we find that it is a marriage of necessity first, one that is directly conditioned by a new suburban/domestic paradigm of reception and display. Quite possibly the prototype, Bliss was soon joined by a whole network of like-minded spaces, each with its own particular area of concentration or expertise, and just as eager to pick up the ball that had been dropped by the "official" gallery system.

One such space was The Guest Room. Established in January of 1991 by artist Russell Crotty with his wife and designer Laura Gruenther, this was basically a spare bedroom on the second floor of an old Victorian house in the Rampart area of Los Angeles that they were renting at the time. Although it was only in operation from January 1991 until April 1992, The Guest Room proved to be uniquely successful, as almost all of its exhibiting artists went on to make lasting careers in the field. Here again the most effective shows were those that responded directly to the specific nature of the space: to its original purpose, to its formal layout and to its given location, whether in socioeconomic or psychogeographic terms. For artists interested in such matters, the challenge would consist not simply in adapting one's output to the domestic context (i.e. making furniture or decoration) or adapting the context (and such things as furniture or decoration) to the condition of art. From the outset, that is, this new context would allow for the extension of a conceptual methodology past the institutional rut it had worked itself into. If conceptual art's "escape attempts," as Lucy Lippard famously put it, had been aborted at the symbolic stage, then here was a chance to follow them through to "The Real."[11]

Erik Otsea
Histoire Gogique, 1992
installation at
The Guest Room
mixed media,
dimensions vary
courtesy Laura
Gruenther and
Russell Crotty

left:
Frances Stark
Total Babe, 1991
installation at
The Guest Room
bed, linen, carpet,
dimensions vary
courtesy Laura
Gruenther and
Russell Crotty

right:
Frances Stark
Total Babe, 1991
detail
courtesy the artist
and greengrassi, London

Frances Stark's 1991 Guest Room installation *Total Babe* (her first in LA) stands out in this regard, precisely for seeming so absolutely banal at first glance. She had furnished the space with a bed, a smallish throw rug beneath it and some roll-up blinds on the windows—nothing out of the ordinary. It took a closer look to reveal the fine lines of text that had been inscribed into these items, painstakingly, with needle and thread. Instead of any sort of in depth reading, I will limit myself to noting the use of language in this case as a kind of virtual veneer, compelling the gentlest break with the determined utility of the object. While they might seem outwardly unrelated, Frances Stark and Jorge Pardo do share this strategy of enfolding the everyday object within a recursive sort of representational *mise-en-abyme* either by way of a literary or photographic paradigm, but in a manner so casual that it never gets completely swallowed or subsumed. It always retains a measure of autonomy as a non-art object, or an object one does not know exactly what to do with. Pardo describes this condition as "speculative," a philosophical opening up or unfolding of thing-ness that is not without practical consequence.[12]

This condition could not have originated anytime or anywhere else; it requires absolutely, in the words of the Art & Language group, "a background of normalcy," that is to say a setting which is itself private, utilitarian, and aesthetically as far removed as possible from the pristine void of the "white cube."[13] The conventional found object was essentially incapacitated by the process of recontextualization; as art, its function was strictly limited to a criticality aimed squarely at the structures that would contain it. Here, this logic is partly reversed: to begin with, the object is always partly re-made, but more importantly, its reconstitution as art involves a radical diffusion of purpose. The 1990s inaugurated the period of *détente* that continues to hold between the once-opposed aims of hyper-alienated 80s-era simulationism, with its hatred of the hand-made, and the much more easy-going and affirmative personal poetics of 60s assemblage. However, to characterize this turn as a re-turn, as critic Ma Lin Wilson, among many others, has done, from the logic of "reading" art that dominated the 70s and 80s and back to good old-fashioned "looking" is just magical thinking, since the gap between things and words is here effectively closed.[14]

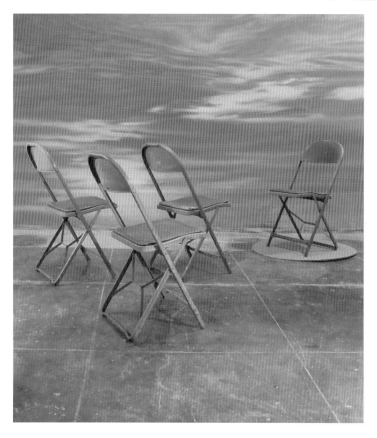

So many of the visitors to Bliss or The Guest Room—or, for that matter, Bill Radawek's Domestic Setting, or certain incarnations of Charles LaBelle's roving Nomadic Site project, or Stephen Berens' and Ellen Birrell's Project X, or the succession of storage and motel room shows that grew out of the 80s—reported experiencing the same sense of uncertainty as to what was art and what was not, what was to be scrutinized and what was to be passed by, what could be touched, moved, sat on, etc. and what was implicitly off-limits. This subtly skewed ambience made for a high degree of self-consciousness on the part of an audience who now had to consider the totality of a situation they once could take for granted. Accordingly, discussions touched on the shape of a fixture or outlet, the view out the window or the movement of shadows across the walls, just as often as the art *per se*. And the art, if and when it was discussed, generally found its way out of any pre-established frame of reference to become part of this moment, this place, and just as essentially arbitrary, differential, relational as anything else that was there.

As the century drew to a close, so many exhibitions mounted here and abroad by LA artists remained in dialogue with those originating conditions. Jorge Pardo unveiled *4166 Sea View Lane*, his sculpture-that-is-also-a-home, to the public on October 11, 1998, and he has gone on to design several more houses for his most adventurous patrons. T. Kelly Mason, whose last show at Marc Foxx in September 1999 included a direct reference to an installation he mounted at Bliss almost 10 years earlier continues to dwell productively on the politics of home-improvement. Architecture and the modernist "design for life" remain central concerns of Sam Durant as well, only now they are explored within the streamlined interiors of venues like Blum & Poe. Much the same can be said for Frances Stark whose 1999 show at Marc Foxx included *All My Chairs on Cartons,* a work that does just what its title suggests—to put her private space on public view. Also begun in 1999 is Pae White's ongoing series of "spider-web paintings," each of which is the outcome of a unique "collaboration" between the artist and her backyard menagerie of insects. Jacci den Hartog and Laura Cooper both teach classes on art and gardening, and apply their lessons to their own work—the result of two imaginations that had once been encouraged to wander out into the yard.

In effect, there are as many LA artists out there making work about the architectural interior as its exterior landscape. It is almost as if the object had to travel for a time outside the gallery to rediscover some modicum of social purpose; that is, how it might operate in an actual (as opposed to idealized) space, where some people live and others visit, where people meet, talk, drink and plan what to do next. Of course, this is just the sort of space where art has always wound up, the final leg of the journey that begins in the studio, yet for the Class of 90 it was this slight skewing of the itinerary that made all the difference.[15]

left:
T. Kelly Mason
***Theory of Sculpture
(after Mel Bochner),***
1994
image from slide
projection, no. 15 of 22

right:
Frances Stark
***All My Chairs on
Cartons,*** **1989**
assorted chairs, casein
on plaster of paris,
dimensions vary
courtesy the artist and
greengrassi, London

1 Myers, Terry R., "Art School Days," *Sunshine & Noir, Art in LA, 1960–1997*, Humlebaeck: Louisiana Museum of Modern Art, 1997, p. 202.

2 Klein, Norman, *The History of Forgetting: Los Angeles and The Erasure of Memory*, London: Verso, 1997.

3 Dear, Michael, "In the City, Time Becomes Visible: Intentionality and Urbanism in Los Angeles, 1781–1991," *The City, Los Angeles and Urban Theory at the End of the Twentieth Century*, eds. Allan J. Scott and Edward W. Soja, Berkeley, CA: University of California Press, 1996, p. 91.

4 This is merely a representative sample, spanning a range of positions, a range of art schools: Bunn teaches at USC, Prina at Art Center and Johnson at Otis.

5 Again, sampled by school: Stark studied at Art Center, Muller at CalArts and Thomson at UCLA.

6 See, in this regard, the writings of Daniel Buren and the Art & Language group.

7 Joyce, Julie, "Neutral Grounds/Fertile Territory: A History of Bliss," *True Bliss*, Los Angeles: LACE, 1997, p. 6.

8 Joyce, "Neutral Grounds," p. 9.

9 Joyce, "Neutral Grounds," p. 12.

10 See Jane McFadden's essay in this volume for a further discussion of this work.

11 Lippard, Lucy, "Escape Attempts," *Reconsidering the Object of Art, 1965–1975*, Los Angeles: The Museum of Contemporary Art, 1995.

12 Pardo is very emphatic in his attempts to adapt a language normally associated with business practices, such as "speculative," to poetic ends. Together with "virtual," however, the term also hints at the impact of the new information technologies. It would probably require a separate paper to outline the impact of the digital revolution on this generation; suffice it to say, for now, that by furnishing these artists with almost unlimited reserves of memory, it also served to exponentially augment the range of possible meanings that might be sustained by any one thing.

13 Baldwin, Michael, Charles Harrison, et al, "Memories of the Medicine Show," *Art & Language, New Series*, no. 2, June, 1997.

14 Wilson, Ma Lin, "Coming to Our Senses," *Art Issues*, no. 45, November/December, 1996, pp. 18–21.

15 As it happens, in 1999 as well, Jorge Pardo and Pae White would perform a "sensitive remodeling" of a bankrupt gift shop on Chung King Road in Chinatown for their Art Center colleagues Giovanni Intra and Steve Hanson, both of whom had decided to open a gallery there. Carrying over the name that graced the former storefront, this became the now notorious *China Art Objects*, at the very flashpoint of an emerging "Chinatown Scene." Drawing many of the central protagonists of the 90s back together, Chinatown, in a sense, closes the loop between DIY chutzpah and entrepreneurial spirit. At the same time, there is more to it than that—a whole other story, in fact, that deserves to be told in detail elsewhere.

Jorge Pardo
4166 Seaview Lane,
1998
mixed media,
dimensions vary
photo: Swan Moon
courtesy the artist
and Haunch of Venison,
London

Jane McFadden

Los Angeles: Then and Now, Here and There

Being in Los Angeles has had little or no affect on my work. I could have done it anywhere.
–Ed Ruscha, 1966[1]

I've wondered at times whether if I lived in another city, my art would be different, and I suppose it would be. The iconography of this place does mean something special to me. I love it and I have always loved it, because it feeds me and it feeds my work.
–Ed Ruscha, 1982[2]

The twenty-first century artworld is defined by terms that resist a sense of place: globalism, multiplicity, circulation.[3] What then might it mean to consider a specific locale such as Los Angeles within this context? Perhaps it is to recognize that even as the artworld circulates around the globe, an experience of art in the majority of instances involves an intersubjective communication between the material aspects of an artist's process and the physical, psychological and intellectual presence of the spectator. Or perhaps it is the opposite: to concede that an experience of art is in its discourse —in magazines, circulating exhibitions, art fairs, connections, conversations—exactly not in front of the work. A third possibility might be that "place" itself no longer has specificity. Critic and historian Lane Relyea concluded in 2001 that:

> the sense of the local implied by the… new interest in place names—London, Los Angeles, Berlin, etc.—has for its conditions the abolition of the local as such. 'LA' and 'London' and 'Berlin' and 'New York' only gain meaning now as functions within a larger comprehensive set, values emanating from a system.[4]

Los Angeles as location is then equally about dislocation, transformation, and circulation. The city has long been predicated on such notions—its population in cars on freeways, movie tickets to as many elsewheres as we can imagine, the earth quaking beneath our feet. This investigation in turn explores how place—both "here and now" and also as a node in a rapidly spiraling world—resonates in the history of practice for Los Angeles.

top left and right:
Mike Kelley
Three Valleys,
1980/1998
stills from a performance
sponsored by Foundation
for Art Resources, Los
Angeles, CA

bottom left:
Mike Kelley
Three Valleys (1: Golf
Course/Strip Mine/
Sun Valley), 1980/1998
Fuji crystal c-print,
20" × 24"

bottom right:
Mike Kelley
Three Valleys (2: The
Sun in Diminishing
Perspective),
1980/1998
Fuji crystal c-print,
20" × 24"

In 1981, Mike Kelley performed the work *Three Valleys* at Los Angeles Contemporary Exhibitions (LACE). The work, "an analysis based on poetic metaphors derived from geographical observation," considers Ojai and Sun Valley as two points for an exploration of greater Los Angeles.[5] These two places suggest distinct notions of the valleys of southern California—one a quaint enclave in the mountains north of the city ("where architectural sleekness dominates"), and the second, home to the industries of the working class and the resultant wasteland of low-slung buildings and littered stretches of concrete ("all work, all shut up").[6] This two-sided, even dialectical, nature of Los Angeles has been a part of its history throughout—heaven and hell, utopic and dystopic, sunshine and *noir*.[7] A sense of Eden emerging out of the desert, the fantastical spaces of Hollywood and boom are accompanied by bust, backbreaking racial struggle and the hard edge of capitalist expansion with all consuming consumption. One's perspective depends on where one is standing, but both will eventually come into sight.

Kelley arrived in Los Angeles from Detroit to attend the California Institute of the Arts (CalArts) in the late 1970s. At the time, the conceptual practices of John Baldessari, Douglas Huebler, Michael Asher and others were dominant at the institution, and the institution itself (which had been formed out of the Chouinard Art Institute and relocated to Valencia 1971) was becoming prominent within the Los Angeles artworld. Kelley absorbed the possibility of conceptual apparatuses presented by the faculty and also played off the influence of minimalism, resulting in an aesthetic that was neither. In his work Kelley inserts the body and increasingly complex texts into the systems of art, allowing the conscious and unconscious communications of our lives to come under scrutiny. In the sculptural forms from *Three Valleys*, for example, the abstraction of modernism becomes a symbolic prop.[8] Fellow graduates of CalArts from this period also offer multiplying perspectives on conceptual practices to generations of Los Angeles artists that follow: including Stephen Prina's interrogation of context and history, Chris Williams' investigation of photographic meaning, Jim Shaw's exploration of subjectivity, and Jim Isermann's play on the malleable status of abstraction in culture.[9]

In *Three Valleys,* Kelley performs Los Angeles through gesture, symbol, word, image, smell and action, without narrative—presenting a study of place and representation.[10] He shows a series of slides during the performance that form the foundation of the piece, a key image of which depicts a lush green golf course backed up against the desolation of a strip mine. The comparison does not form a polemic—indeed, Kelley notes of the mine: "they work here but it's still out in the country."[11] Similarly Kelley concentrates on other juxtapositions that complicate these sites. For example, he repeatedly references the presence of stinking sulfur pits positioned on the outskirts of refined Ojai. Things are never one-dimensional for Kelley and perspectives multiply. Perspective itself becomes a trope in the work in photographs, texts, and sculptures—drawing attention to the almost irreconcilable, but also symbiotic, cultural viewpoints of the two valleys. This trope is appropriate to a general sense of Los Angeles, which exists as an accumulation of instances, often difficult to reconcile, that we know through signs, shapes, glimpses and scattered experiences.

A similar sort of view—glimpses and shifting angles—emerges in historical investigation. The writing of this particular history will thus follow suit—offering not one linear narrative of Los Angeles but a series of sights. One particular glimpse of Los Angeles is of an earlier city that has not yet hit the global treadmill. In the immediate postwar decades, it existed as an artistic outpost of sorts to New York, under-recognized and unfettered by the East Coast dynamic, while also charged by the blinding light of the visual culture of Hollywood. Here artists staked out some geography—along La Cienega Boulevard, at the beach in Venice, or out in Pasadena—set up shop, and went to work in a variety of ways.

In 1965 a young Los Angeles artist, Ed Ruscha, began work on a painting, *Los Angeles County Museum on Fire,* 1965–1968. The painting paid both tribute and critique to the new building for the museum that opened in 1965, what art critic Peter Plagens described as its "sumptuous Babylon quarters."[12] Ruscha's representation is cool and graphic. It evokes a sense of an architectural model, with the museum sitting within a nondescript undefined environment. No signs of life surround it and grand Wilshire Boulevard, to which the museum had anchored its bold cultural proclamation, becomes a small shadow in the lower left corner of the canvas. Ruscha's painting grants an aerial view of the complex, as the artist explained in a 1972 interview:

Jim Isermann
Untitled No. 0105,
2005
oil-based paint on wood,
hardware
9' 2" × 7' 6" × 6"
courtesy the artist and
Corvi Mora, London

Ed Ruscha
*Los Angeles County
Museum on Fire,*
1965–1968
oil on canvas,
54" × 134"
courtesy the artist
and Gagosian Gallery,
Beverly Hills

*I had gone over the art museum in a helicopter, kind of by mistake, and took a lot
of pictures of it. Also there was an aerial photograph of the museum on the cover of
the telephone book; it was a really nice picture, with a beautiful background to it,
so that kind of moved me in that direction too.*[13]

Ruscha's comments, which deny any interest in the museum *per se*, echo his deadpan photographic
publications of the period. Photographs of every building on the Sunset Strip, nine swimming pools or a
few palm trees promise objective distance, but instead deliver a complex examination of Los Angeles.[14]

Ruscha's work in the 1960s provided one manifestation of what might be called West Coast
pop (along with Baldessari, Billy Al Bengston, Wallace Berman, Vija Celmins, Robert Dowd, Llyn
Foulkes and Joe Goode). His work also resonates with developing conceptual practices in Los
Angeles that became influential at CalArts. These overlapping configurations challenge the efficacy
of historical categories that might suggest that pop and conceptual tendencies are not reconcilable.
In fact, in the practices of many Los Angeles artists, they are often intertwined, reminding that
this region of multiplying perspectives and cultural ambiguities resists such simplified terms.
Both Baldessari and Ruscha, as well as their contemporaries Allen Ruppersberg and Eugenia Butler,
demonstrate the fallibility of the generalizing structures of conceptual and pop. This trend continues
with Kelley and others of his generation (including his colleagues from CalArts as well as other
important Los Angeles figures like Charles Ray) who test these boundaries, as well as younger
generations who have merged notions of the conceptual with a sense of the everyday, aspects of
popular culture, and a play with form. A fruitful sampling of practices might include David Bunn's
work with text and chance, Sam Durant's explorations of 1960s culture, Martin Kersels's investigations
of sound and environment, Jennifer Pastor's sculptural investigations, Frances Stark's materialized
texts and Mungo Thompson's roving conceptual enterprises. Their work mines these historical
categories and moves beyond them, offering idiosyncratic analyses of their environments and experience.

Ruscha's deadpan representation of place in *Los Angeles County Museum on Fire,* is
however, complicated by the drama of it being "on fire." Flames and smoke leap out of the left hand
side of the building moving into the depths of the canvas. To represent fire in 1965 was to evoke
the social tensions that raged across the United States at the time—emerging from the precarious
balance between utopian visions of a new society and the violence that accompanies a sense of
revolution. LA, itself, was burning at the time. In the summer of 1965 riots broke out in Watts in
response to the racism and brutality of the police, as Joan Didion describes: "For days one could drive
on the harbor freeway and see the city of fire."[15] Raised above Los Angeles on the freeway, looking
out from a distance at the city on fire, Didion, like Ruscha, presents an aerial view of sorts. Ruscha's
painting draws prescient attention to the distance between the high status of the cultural institution,
signifying social development within the city, and the social reality of the larger urban space.

Ruscha did not finish the painting until 1968, and by the time he had, the Los Angeles County Museum of Art (LACMA) had created its own social conflict. In 1966, LACMA organized a retrospective for Edward Kienholz, a pivotal figure of the Los Angeles art scene both as an artist whose assemblages addressed a wide array of social possibility, and also as one of the founders, with the young curator Walter Hopps, of the Ferus Gallery in 1957. The Ferus Gallery had in many ways marked the beginning of an art scene in Los Angeles and it showed important emerging artists of the period including John Altoon, Bengston, Craig Kauffman, Edward Moses, Ruscha, Robert Irwin and Larry Bell, as well as important artists from beyond LA. Hopps, who guided the gallery in its early years, would go on to become curator of the Pasadena Museum of Art in 1962 and nourish almost a decade of innovative exhibitions there (including the first retrospective for Marcel Duchamp in 1963, where a famous chess match between Duchamp and a nude Eve Babitz took place).[16] As Peter Plagens noted: "You can't underestimate the effect of the museum, not only on artists who worked in the city during the period… but also on the Southern Californian artworld as a whole."[17] The Kienholz retrospective at LACMA opened to much fanfare, as his work was well known. However, his tableaux depicting dark and often sexual elements of human interaction caused the Board of Supervisors of Los Angeles County to call for the closing of the show. After heated discussions, the exhibition remained intact and drew record crowds, but not before revealing tensions between the developing artworld and the social conditions beyond. Indeed, one of the earliest exhibitions at Ferus Gallery had resulted in the arrest of Wallace Berman due to "indecent material."[18] Ruscha's painting "on fire" then bridges the distance between the elite cultural institution and a sense of social unrest—making them visibly intertwined. The graphic seamless exchange between architecture and flames in the work is not violent but matter of fact, showing both sides of the city, its Babylonian splendor and violence, in clear view.

Ruscha's investigation of a specific place, Los Angeles, within the context of the late twentieth century, relates to the emerging importance of an analysis of place in general in art. These are the decades in which artists choreographed "destruction," art objects "dematerialized," and "you had to be there."[19] Any sense of place then might engender an emerging sense of distance: no longer here, or here not there. In turn, any distance engenders a different sense of place: not just anywhere. Place is emphasized in its dislocation. In turn, artists explore place in a variety of forms in these decades from the more literal notions of the site-related and the geographic, to the more theoretical sense of place found in concepts of institutional critique and identity, as well as through interdisciplinary and multimedia challenges to the boundaries of the visual arts.

Edward Keinholz
The Back Seat Dodge 38, **1964**
paint, fiberglass and flock, 1938 Dodge, chicken wire, beer bottles, artificial grass, and cast plaster figure, 66" × 240" × 144"
Collection the Los Angeles County Museum of Art, Art Museum Council Fund
courtesy LA Louver Gallery, Los Angeles, © Nancy Reddin Keinholz 2005

In 1993, Diana Thater produced an installation at Bliss, a student run exhibition space in a house in South Pasadena. *Up to the Lintel*, 1992, included five projections onto the interior windows and surrounding walls of the space. For the projections, Thater filmed the inside of the rooms from the outside through the liminal space of the window, and then projected the inside toward the outside via the same conduit, turning the site literally inside out. The seeming one-to-one correlation was complicated, as the projected view was obscured by colored bars. Referencing the color bars of video, Thater had built wooden "bars" on the windows for filming which were painted red, yellow, green and blue. The internal mechanisms of the machine were externally constructed and then returned to the confines of the medium—once again inside out.

Thater's layering of reversals is a sophisticated take on the possibilities of site-related practice. In the site and of the site, the work still resists one-to-one correlation in space or in time. As critic Tim Martin writes of an experience of the piece (to which we do not have access):

> *Indeed, the whole scheme has an architect's temporal sense to it. Walking up from the street, through the room of the whirring projectors and activity, and down the darkened hall into the rear room where an illuminated model of the house sits on the floor, one gets a sense of moving backwards in time, through the 'before/during/after' stages of architectural genesis.*[20]

Diana Thater
Up to the Lintel, **1992**
installation at Bliss
video tape, projectors,
mylar and existing
architecture,
dimensions vary
photo: Fredrik Nilsen
courtesy the artist and
David Zwirner, New York

Thater's work, embedded in the specificity of the site sends this specificity circulating itself. She is kind enough to give us an index for the work in the invitation, modeled after a standard book index, suggesting references we might want to explore. With page numbers that do not exist—a map without referent—the index sends us off again circling. Even as we are there we are not there, or as Martin riffs off Gertrude Stein: "There is no there there."[21]

"There" was Bliss—an alternative space that emerged in the late 1980s under the casual direction of Kenneth Riddle, Jorge Pardo, and Gayle Barklie in a house at 825 North Michigan Avenue in Pasadena. The space was both Riddle's home and his studio, which he had originally used as an exhibition space for a class project for Art Center College of Design, where he, as well as Pardo and Barklie, were students. Many emerging artists (from Art Center and elsewhere), including Pae White, Andrea Bowers, Laura Cooper, T. Kelly Mason, Adam Ross, Sam Durant, Jennifer Steinkamp and others, exhibited at Bliss, where they were able to experiment with the possibilities of the site.[22] The relation between the student run house and the diverse manifestations of art found there raised once again the long-standing modernist anxieties about the boundaries of art. These were particularly prescient at a time when installation was emerging as a dominant form of practice.

Installation exists as a broad category defining work that moves beyond the limits of the canvas, object and screen, and that interacts with the conditions of exhibition. In the 1990s, installation received crucial support from exhibiting institutions that were becoming receptive of art that did not take the form of singular objects, granting this interdisciplinary and multimedia work a space. In addition to Thater, many Los Angeles artists of this period—Pardo, Jason Rhoades, and Toba Khedoori among others—formed their careers within and in reference to this medium.[23] Its rise in importance accompanies the growing circulation of the global artworld—even as the work of art is not permanently "in place," it is in place wherever it is. One might think of installation as the medium through which the diverse sites for practice that artists had begun to explore in the 1960s return to the gallery—the outside coming back inside. This "return" included as well a rethinking of the challenges to the institution posed during the previous decades—namely the questioning of the validity of what takes place "inside" the institution, and the need to address the possibility that institutional bounds are not only supportive but also determinant. Bliss then provided an early crucible in which young artists could explore installation as a form of practice outside the mainstream institutions of exhibition.

The questions that accompany the rise of installation as medium reflect earlier explorations of the sites of exhibition in the history of Los Angeles. The tenuous connection between site, institution and critique had emerged in Los Angeles prominently in the work of Michael Asher, who turned his conceptual explorations to the site of exhibition in the 1960s, laying bare the inextricable exchange between work and its physical, social and economic contexts. For example, for his project at Pomona's Gladys K. Montgomery Art Center in 1970, Asher constructed three walls that transformed the gallery space into interlocking shapes. Two points of entry revealed the different concerns of the space. The front entrance had been transformed to provide a seamless and undeterred transition from inside to outside leaving the space open 24 hours a day, and the rear entrance provided access to the offices of the gallery and to views of the structural supports of the constructed walls. Each suggests a sense of the inside-out, and exposes the basic institutional structures of access and artifice.

Simultaneous to Asher's practice was the growth of the feminist movement and its questioning of social and institutional assumptions about the place of women and women's practice in art. In particular, *Womanhouse*, 1971–1972, the project of the Feminist Art Program at CalArts run by Judy Chicago and Miriam Schapiro, provided a pivotal experiment in considering institutional boundaries, social context and critique. The project included the reconfiguration of a house in Los Angeles by Chicago, Schapiro and 22 students.[24] Various rooms of the house became projects for different women, for example, Camille Grey's *Lipstick Bathroom*, Robin Weltsch and Vicki Hodgetts' *Nurturant Kitchen,* or Kathy Huberland's *Bridal Staircase*. The house was also the site of collaboration, consciousness-raising and performance, including the Feminist Art Program Performance Group's *Scrubbing*, 1972, and Faith Wilding's *Waiting,* 1971. The result was a large scale interdisciplinary critique of the cultural place of domestic concerns. These activities coincided with the strong conceptual presence at CalArts at this time that included Asher, and speak to the pivotal role of the institution in nurturing the artistic legacy of Los Angeles.

Thater's work reflects the legacy of these practices, and indeed Bliss was representative of the Los Angeles scene of the 1990s, not only for its art school connections, its fly-by-night style, and its edgy rethinking of the gallery and installation, but also for its very domesticity—the house as site, and also the very house-ness of the site. The domestic on display, and the display of the domestic, reflects the culture of Los Angeles where the private parades in public constantly. It is a city of cars on streets, miles upon miles of storefront displays beckoning and refracting, celebrity exposé and porn. Boundaries blur and artists will play upon this blurring in a variety of ways—not only through the physical possibilities of the place of art but also in more indirect forms. For example, in the work of both Laura Owens and Liz Craft, the gravitas of large scale painting or bronze sculpture becomes intertwined with the adolescent spaces of the psyche—the humorous, both lighthearted and dark, the fantastical, and the awkward.

At the turn of the millennium, one can be at home anywhere and installation as a genre reflects this possibility within the artworld at large. Thater in particular reminds us that the result of such mobility is a precarious balance between public and private, presence and mediation, inside and out. This balance seems key as well to any notion of an LA Artland. To my mind, "artland" as a concept seems to suggest some fantastical nether regions, or weathered treasure maps, a neverland of sorts, and appropriately so as one of the inspirations for the term is Hollywood with its own treasures and cryptic maps to the stars. Yet however constructed the idea may seem, the name suggests a place one can find. It is an art land, acting as one site for the artworld. It has coordinates.

In 1980, Robert Irwin installed a site-related work at 78 Market Street in Venice Beach. The piece consisted of the removal of the front wall of the building, and the implementation of a scrim that formed a filter for light between the space and the street, the public and private. Unmarked, the large scale reconfiguration allowed for a shifting sense of light, space, and architecture for the interested viewer. The idea for the piece had occurred to Irwin as early as 1968 when he was beginning to explore issues of presence and perception in diverse forms.[25] It was around this time he moved beyond the medium of painting and made a series of white aluminum discs. These works were minimal, even "pure" in form, producing a disorienting sense of light that tested the limits of vision. With their sprayed automobile lacquer, they subtlety suggested influences of Venice and Southern California beach culture—sunlight and cars.

Irwin's practice was part of what would become known as the Light and Space movement that included other Californians Craig Kauffman, Bell, James Turrell, Maria Nordman and Eric Orr. Irwin in particular emphasized an exploration of Light and Space in terms of optics and phenomenology *in situ*, as an issue of presence.[26] An experience of the work was to be about the specific physical conditions of it, not a generalized and circulating idea; at the same time, Irwin was also testing the limits of physical experience. In 1969, Irwin and many of his colleagues on the West Coast participated in the Art and Technology program at LACMA, which matched artists with scientists, engineers, and others from Southern Californian industry. (Irwin had also been a part of the West Coast arm of Experiments in Art and Technology, EAT). During his involvement with Art and Technology, Irwin, along with Turrell, worked with Dr. Edward Wortz, a perceptual psychologist, experimenting with perceptual possibility in anechoic chambers (a space designed to block out external sensory stimuli).[27] These projects explored the extreme focus of sensory awareness, and, as the artists described, were "dealing with the limits of experience."[28] Simultaneously, Irwin explored the limits of experience elsewhere, working with NASA on various projects. These investigations into perception and presence were for Irwin an important challenge to the established boundaries of art.[29]

Laura Owens
Untitled, 2004
oil on linen, 18" × 21"
Courtesy Gavin Brown
Enterprise, New York

48

At the time that Irwin made his Market Street piece in Venice, he was involved in the initiation of the fledgling Museum of Contemporary Art, and Irwin saw the work as a demonstration of the issues at stake between the expectations of art institutions and emerging possibilities for art:

> *I was advocating a kind of learning in the field, a process of sorting out the various meanings implied in the current range of activity. My gut questions were: given how much of that activity is simply uncollectible, doesn't it make you uneasy to simply perpetuate a system which cannot even deal with—i.e. collect, hold, or record— anything which does not exhibit the properties of object (thing), permanence, or image/form? What do you make of a 'history'—i.e. a structured system—with such a built in bias that it has essentially excluded anything non-object, impermanent, or ephemeral?... Finally I decided the best way to make my point was to give the board members a working example.[30]*

For Irwin, the questions of modern art: "direct experience... vs. prestructured expectation, phenomena vs. permanence, presence vs. abstraction," had consequences to which the museum was not attuned. His work and the explosion of non-object, site-related practices of the period that includes that of Asher, Bruce Nauman and many others, demanded viewing situations beyond the object, as well as institutions that would support them.

The Museum of Contemporary Art (MOCA) found its first manifestation in an old industrial garage that was known as the Temporary Contemporary. The large warehouse space has since been home to a wide range of installation possibilities that have attested to Irwin's concerns. Perhaps the most aggressive of these was Chris Burden's 1988 piece *Exposing the Foundation of the Museum.* Burden, who began his practice with excruciatingly physical and violent performances in the 1970s (the most infamous of which was *Shoot,* 1971, in which the artist was shot in the arm by a colleague), had, by the 1980s, turned his attention to more abstract forms of power. For the MOCA piece, Burden literally exposed the foundation of the museum and challenged its boundaries— making nine foot excavations in the floor, and providing stairs for the viewers that wanted a closer view.[31] Further, Burden's use of the metaphor of exposure, like Irwin's concerns, reflects the tension between the challenging possibilities of art and the institutional foundations on which it depends.

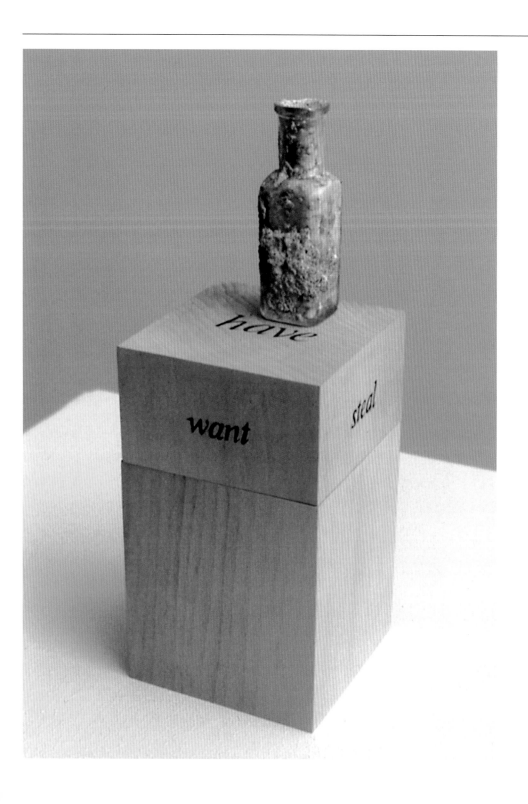

In 1989, the young sculptor Liz Larner responded to Burden and the institution, by exhibiting a small dirt-encrusted glass bottle on top of two unassuming wooden cubes. The title of the work, *Something I Got Out of the Museum Here in LA,* provides a key to its origins: Larner had supposedly found the bottle while looking at the "exposed" foundations of Burden's MOCA piece. Larner's layering of her own institutional consideration onto Burden's offers a subtle critique of his work. She counters his aggressive machinations that depend upon the presence of the viewer *in situ* with the small delicate artifact of an excavation—encouraging a re-valuing of the sculptural object. The work also suggests some sense of novelty of "getting something" out of the museum at all; and at the same time, the wooden base, inscribed with the words "want," "take," "steal," "buy," and directly under the bottle, "have," suggests that Larner will get something out of the museum one way or another—perhaps as an artist who will need the institutional foundation, and also as a viewer who desires something of the art within.

Liz Larner
Something I Got Out of the Museum Here in LA, **1989**
glass vial on wood stand filled with materials found in the third pit during Chris Burden's *Exposing the Foundations of the Museum* at MOCA Los Angeles, 9" × 3" × 3"
Courtesy the artist and Regen Projects, Los Angeles

Questions of what one may expect to get out of a museum proliferate in the late twentieth century. In the contemporary artworld, as works seem less and less bound to site, questions of the place of art not only include a sense of a spiraling global market onto which it is difficult to grasp, but also a constant barrage about the role of art in the world at large. Issues of class, market and function that have been historically bound to artistic practice continue and further challenge artists. As the speed of late capitalist culture accelerates, where does art belong? How does art relate to the rest of a massive global visual culture? Should art partake in particular social and cultural statements, or is "uselessness" its politic?

In 1977, Suzanne Lacy and Leslie Labowitz staged *In Mourning and in Rage* on the steps of City Hall in Los Angeles, featuring a group of women draped in black (and one in red).[32] The performative action was meant to draw attention to the media treatment of the Hillside Strangler serial killings, through which these deeply unsettling murders that surrounded the city in violence became sensationalized. The performers presented themselves in a press conference, including a motorcade to the site, and addressed the real and pervasive effects of violence against women at large in the face of this one spectacularized event. Lacy stated: "We wanted to use media conventions to subvert media messages, and to introduce a more complicated feminist analysis into the coverage of the case."[33] In order to do so, they placed their bodies in the interstice between the horrific reality of women's bodies dumped by the side of the road and the media that fluidly transforms events into circulating signs. At the same time, they employed the media to their own purposes. Offering an antidote to the titillating coverage of real horror, they enacted rage and mourning within this particular social space.

Lacy and Labowitz's protest in *In Mourning and in Rage* posits performative action in a social realm beyond that of the artworld. It enters the realm of local politics and its architectures—both that of city hall and that of the media. For it is not only the violence they wish to protest but the ways in which that violence is re-presented, and subsumed by spectacle. This work in turn draws attention to the relation between art and the powerful force of mediated visual culture. During this decade, many artists were confronting the media of film and video in their own practice as tool, form, document and content. Eleanor Antin, Baldessari, Burden, Paul McCarthy, Susan Mogul, Nauman, William Wegman and others used video to expand the possibilities for and expose the limitations of visual art in the face of the growing presence of the media.[34]

Suzanne Lacy and Leslie Labowitz
***In Mourning and in Rage,* 1977**
performance at the Los Angeles City Hall
photo: Maria Karras

In *Mourning and in Rage* led to a larger project, *Ariadne: A Social Network*, founded in 1976 by Lacy and Labowitz to address violence against women. Alternative organizations of this sort were part of the larger feminist movement in the 1970s where networking, community and context were crucial. In Southern California in the 1970s, educational institutions were particularly important in developing these dialogues. Judy Chicago had founded a feminist art program at Fresno State in 1970 and in 1971 followed with the program at CalArts. This program was allowed by the administration to determine its own structure, which resulted in non-traditional modes of learning and making including consciousness-raising, reading, research, and role-playing. *Womanhouse* was the most famous result of these processes and in turn encouraged the opening of a more permanent Womanspace in 1973. Shortly thereafter, the Women's Building was founded as alternative space that also included the Feminist Studio Workshop (for alternative arts education), a bookstore, a press, a literary salon, and a theater. These projects reflected the proliferation of alternative spaces during this time that provided venues for innovative exhibitions and programming. Important among these were Beyond Baroque, founded in 1968, Los Angeles Institute of Contemporary Art (LAICA), founded in 1973, and Los Angeles Contemporary Exhibitions (LACE), founded in 1978.

The model of social protest used in *In Mourning and in Rage* was prominent in performance practices at the time, emerging from the forms of protest that had defined the previous decade in the civil rights and anti-war movements, and would be crucial to feminist movements as well. These protests both addressed society at large and the social conditions of the artworld—namely the under-representation of women and minorities within the history of art and its institutions. Many of these protests were centered in New York, although the Art and Technology program at LACMA, which had included only white male artists and scientists, was the focus of a key protest on the West Coast. Despite this questioning of art institutions, and even as Los Angeles developed into one of the most ethnically diverse cities in the world in the late twentieth century, the artworld and its complex systems has not generated equal representation by gender, and certainly not by race. This social formation is reflected in a book of this nature where a sense of an LA Artland is of a fairly narrowly defined artworld—one that is less likely to include the Watts Towers or the work of Chicano muralists. The legacy of the questions of the 1970s then is to give the cultural and social stakes of identity a place within this realm.

Andy Ledesma, John Zender Estrada, Rafael Corona, Jaime Ochoa, Dominic Ochoa, Isable Martinez, Oscar de leon, Mario Mancia, Jesse Silva, Anthony Ortega, and Jerry Ortega
Mexico-Tenochitlan-The Wall That Talks, 2005
mural in Highland Park, Los Angeles
photo: M. Paige Taylor

Identity provides another sense of "inside" and "outside," questioning what constitutes a sense of the self and other and their construction in the world. Several generations of artists have participated in these developments, providing representations that move beyond standardized forms of identity, including Catherine Opie's documentation of underground cultures, Larry Johnson's sense of subjectivity and celebrity, and Andrea Bowers's questioning of art historical assumptions. Their work raises questions about who belongs where, and where is for whom, in terms of race, gender, sexuality, celebrity, and community within the artworld and beyond. They and many others have built their practice on the unresolved questions of what, in fact, a politic may look like, and where it may be found.

In 1971, a young Paul McCarthy, sat in his studio on the top floor of a run-down building in downtown Los Angeles, turned on his video camera and began to pour motor oil over a Los Angeles phone book. He added flour and cotton to the mix, until the book itself was transformed, with its rational listings broken down into an incomprehensible material mass. Through the process, the entire population of the city was symbolically drowned, overwhelmed by the chemical substance (used motor oil) that is also necessary to its survival as an automobile town. McCarthy states of the performance, entitled *Ma Bell*:

> It all sort of clicked into this thing, pouring oil onto these pages of the telephone book in this crazy lab, you know, this insane lab. And being at the top of this building, kind of on top of LA, almost like putting a curse on LA.... The book itself had everybody's name; everybody was in the book. I was pouring oil over them with this sort of primal goo.[35]

The building in which McCarthy produced *Ma Bell,* had a history of transformation itself—as an induction center for World War Two and Vietnam. McCarthy notes: "It still had lines on the floor—follow this line to the psychiatric testing area, you know...." And in turn, McCarthy "imagined himself as a kind of hysterical person" in his performance.[36] Facing Los Angeles, McCarthy opted for the unstable and frenetic—testing the limits of the psyche and body far removed from the images and identities of popular culture emanating from the city. Rather than produce a manicured image of the self as found in mediated culture, or gesture within a seemingly contained canvas as his painting predecessors had done, McCarthy creates a mess. This work is one of the earliest pieces in which McCarthy conceived of his own transformation into character in his work, and he continues to take on roles—investigating the actual and symbolic violence of human interaction and social mores, particularly as forced upon society through the lens of Hollywood and its empires of entertainment.

Paul McCarthy
Ma Bell, 1971
performance/video

THE PAPER CUT, IT BECAME INFECTED.
I LOST THE FINGER.

LIFE ITSELF AN
ADVENTURE.

In this land full of stories, home to the engine of our narratives that is Hollywood, artists may offer an antidote to a suffocating generalization and spectacle of culture. The visceral, difficult, performative nature of McCarthy's work grounds an experience for the spectator—working against dominant images of the self in society. His work references the neurotic, the scatological, the Freudian, and at times is shocking in its willingness to make these human conditions visible, to enact them, to make material our psychological mess. Similar effects are found in the work of some of McCarthy's contemporaries, who challenge mainstream representations through the proliferation of material and mediation, although in quite different forms. For example, Raymond Pettibon confronts cultural myths and violence through a wide variety of imagery in his drawings. The repetitive nature of his project, where we are exposed to images over and over in a distinct storied form, what one critic has described as "drawing outside of time," does not allow us to digest or dismiss his violence, our violence.[37] The painter Lari Pittman uses a complicated layering of color, symbolic forms, and cultural references that produce a complexity of representation in the face of simplified social images. The result is a multi-faceted and distinct vision that resists assimilation into the categories of the artworld as well as into the categories of the self. These artists, through their subject matter of the self in society, and through the use of rigorous material exploration—in the fluids of McCarthy, the dexterity of Pittman's layers of paint, or the voluminous supply of drawings from Pettibon—offer some sort of late twentieth century existential response to the loss of self in the face of mediated culture.

These concerns will echo in the explorations of later generations of artists who pile mediation upon mediation in an attempt to arrive elsewhere. From Jeff Burton, who produces photographs that mediate the already highly mediated industry of porn in carefully captured compositions, to Monique Prieto who subverts the formal conditions of painting through digitally composed structures, to Amy Adler who photographs and then destroys meticulously rendered drawings, these artists demonstrate an ability to think in layers of representation and experience. McCarthy seemed to understand this well in 1971, working in his "insane lab," taking on a persona, in front of the camera, layer upon layer: "like baking a cake or something."[38]

left:
Raymond Pettibon
Untitled
(the paper cut), 2004
gouache and ink on
paper, 30" × 22"

right:
Lari Pittman
Untitled No. 2, 2004
alkyd, acrylic, enamel
on gessoed canvas,
52" × 40"

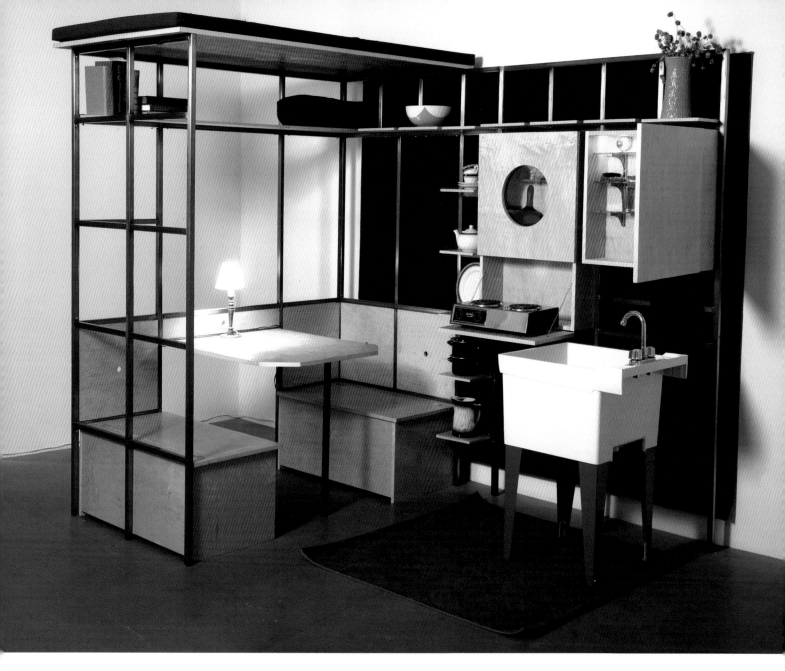

Performance has been crucial to the development of many Los Angeles artists, and to postwar practice in general, although it is still underestimated by scholarship. Its temporal nature poses certain difficulties for historical consideration (you had to be there), and at the same time, creates a necessary integration with mediation in practice (for example, the use of video). These conditions produce a sense of dislocation that is similar to that found in concerns of site in this period as well. Performance is one response to the growing dislocation of experience in general—creating a visceral sense of embodiment in time and space even as the experience is fleeting. In this context it also serves as a peculiar kind of mirror to the social conditions of this place, Los Angeles, where self and site circulate endlessly.

Andrea Zittel
A–Z Management and Maintenance Unit No. 3, **1992**
steel, wood, carpet, plastic sink, glass, mirror, 86" × 94" × 68"

In 2000, Andrea Zittel founded *A–Z West*—the West Coast hub of her decade-old *A–Z Management* that she had begun as a young artist in New York. Zittel's move might point to the growing global sense of the artworld in this new millennium—the artist herself as circulating. However in 2002, she made the decision to cut the east off from the west and settle in Southern California, at least to the extent that an internationally renowned artist may settle at all. Her base is a homesteaders cabin in the high desert plateaus of Twenty-Nine Palms, where Zittel applies the ideas of her management and maintenance—including questions of food, clothing, shelter and activity—to herself. In her investigations and their resultant objects and procedures, she has continually functioned as a test case—performing her management in a complex mixing of public and private. Indeed, Zittel's move to Southern California coincided with the publication of a journal of her experience—in which she shares emotional and psychological tribulations of her move, the logistics of her continuing practices, and the variety of events that are forming her life in this new place.[39]

Even as Zittel's work grants a certain sense of place, her work has almost always incorporated a sense of mobility; from her earliest *Living Units*, 1992, to her *Escape Vehicles*, 1995, and beyond, she has provided a chance to hit the road. This notion of portable place becomes most extreme in works such as the *A–Z Pocket Property*, 2000, that combines "your plot of land, your home, and your vehicle—into a hybrid."[40] Speaking to the issues of globalization and mobility that define our culture at large, Zittel in these works provides a locale that moves with us—what she has described as a "small intimate universe."[41] This sense of place does not suggest a permanent site, but instead a place embodied or contained by a subject. In the case of the *A–Z 2001 Homestead Unit*, 2001, she suggests: "today's independence seekers prefer small portable structures that evade regulatory control."[42] The possible contradictions between independence and a certain "hemming in" of oneself reflect the embedded contradictions of high modernist design which her work is informed by, that has the potential to both liberate and oppress. Zittel's work plays between the two, with an understanding that they are inextricably intertwined. She explores, in turn, an interest in the freedom to choose one's own limitations.[43]

In Los Angeles—the most expansive metropolitan area in the world, home of the Hollywood dream and the NASA space probes—limits are not easy to find. The artworld that has found its home here has also remained expansive. In the 1950s followers of art might move between Ferus Gallery in midtown and the Pasadena Museum. In 2005, they must travel from Santa Monica to Eagle Rock with multiple stops in between and beyond. Practices found in these sites range across media and subject, high and low, serious and playful. Similarly, the historical coordinates of this artworld are fluid, encouraging synchronic as well as diachronic dialogues. Indeed there is no one place in Los Angeles to find the artworld, and the writing of a history of this place immediately produces difficulties as well. Many of the stories have been told and retold, lists have been made and remade, yet comprehensive coverage remains appropriately elusive.[44]

The growth of this allusive Los Angeles artworld coincided with an increasing interest in place in the practices of the late twentieth century. Los Angeles in particular encouraged a theory of place as circulating and dislocated just as these conditions drove the development of its artworld. As it emerged in the postwar decades as an elsewhere to New York, Los Angeles' dislocation from the center of the artworld allowed innovative practices that were out of place in the critical categories stemming from the east (often in the pages of *Artforum*, which itself had dislocated from the city in the 1960s). In turn, educational institutions emerged as important sites of discourse and practice that encouraged generations of students to question the boundaries of those very institutions—in particular, where art belongs and to whom.[45] These shifting senses of place were reflected in the city itself with its circulating freeways, confusion of public and private, and the nowhere and everywhere that is Hollywood. Of course, one could draw another map of these decades altogether—as any definition of an LA Artland must start with the choosing of limitations.

To write a history is to create as well as to discover. Here our image of Los Angeles emerges from performance, installation, video, sculpture, site-related practice, photography, painting and drawing. In this process, Los Angeles seems less a place that resists history and more of a broad challenge to the forms that historians have often chosen.[46] Indeed, like the practices within it, Los Angeles can teach us a lot about history—its ambiguities, its layering, its complexities, its mess. Similarly, if we choose to see Los Angeles through the aerial views, shifting perspectives and mediations of its work, we see that its coordinates are both then and now, here and there.

1 Hopkins, Henry, "West Coast Style: Something About Los Angeles," *Art Voices,* vol. 5, no. 4, Fall 1966, pp. 61, 68. Reprinted in *Leave Any Information at the Signal,* ed. Alexandra Schwartz, Cambridge: The MIT Press, 2002, p. 3.

2 Failing, Patricia, "Ruscha, Young Artist," *Art News,* vol. 8, no. 4, April 1982, pp. 74–81. Reprinted in *Leave Any Information at the Signal,* p. 237.

3 See for example, the recent roundtable discussion on globalism "Global Tendencies: Globalism and the Large Scale Exhibition," *Artforum,* vol. 42, no. 3, November, 2003, pp. 152–167.

4 Relyea, Lane, "LA Based and Superstructure," *Public Offerings,* Los Angeles: Museum of Contemporary Art, 2001, p. 250.

5 Los Angeles Contemporary Exhibitions, press release, March 1980.

6 Citations are from Kelley's unpublished script of the performance, *Three Valleys,* 1981.

7 The phrase sunshine and noir stems from Mike Davies's influential book on Los Angeles, *City of Quartz: Excavating the Future of Los Angeles,* London: Verso, 1990. It was also the title of an important 1997 exhibition of Los Angeles art curated by Lars Nittve and Hellen Crenzuien for the Louisiana Museum of Modern Art, Denmark. See *Sunshine and Noir: Art in LA 1960–1997,* Humlebaeck: Louisiana Museum of Modern Art, 1997.

8 One of Kelley's abstract sculptural renditions of "sun valley" closely mirrors Robert Smithson's own complex considerations of perspective in sculpture in the 1960s. See Ann Reynolds, *Learning from New Jersey and Elsewhere,* Cambridge, MA: The MIT Press, 2003.

9 CalArts boasts many prominent graduates from this period who became important in the booming New York art scene of the 1980s, including Barbara Bloom, Troy Brauntuch, Eric Fischl, Jack Goldstein, and David Salle. These practices, in particular what has been loosely (and problematically) named the "Pictures" generation by critics and scholars, often overshadowed work on the West Coast by Kelley and others.

10 Kelley's influences for *Three Valleys* stem from avant-garde theater including Antonin Artaud, Samuel Beckett, Richard Foreman and Japanese Noh Theater, rather than merely the performative practices of the artworld.

11 Kelley, *Three Valleys,* 1981.

12 Plagens, Peter, *Sunshine Muse,* New York and Washington: Praeger Publishers, 1974, p. 155.

13 Bourdon, David, "Ruscha as Publisher (Or All Booked Up)," *Art News,* vol. 71, April, 1972, pp. 32–36, 68–69. Reprinted in *Leave Any Information at the Signal,* p. 45.

14 These concepts become titles of some of the many books Ruscha published during this period: *Every Building on the Sunset Strip,* Hollywood: Heavy Industry Publications, 1966; *Nine Swimming Pools and a Broken Glass,* Hollywood: Heavy Industry Publications, 1968; and *Few Palm Trees,* Hollywood: Heavy Industry Publications, 1971.

15 Didion, Joan, *Slouching Towards Bethlehem,* New York: Dell Publishing, 1968, p. 65, cited in Norman Klein, "Inside the Consumer Built City: Sixty Years of Apocalyptic Imagery," *Helter Skelter,* Los Angeles: MOCA, 1992, p. 27.

16 See Eve Babitz, "Marcel Prefers Nudes: Eve Babitz's Account of Her Chess Match with Marcel Duchamp," in Craig Krull, *Photographing the LA Art Scene,* Santa Monica: Smart Art Press, 1996, p. 41.

17 Plagens, Peter, "Crown City Chronicle," *Radical Past: Contemporary Art and Music in Pasadena 1960–1974,* Pasadena: Armory Center for the Arts and Art Center College of Design, 1999, p. 19.

18 See "The Arrest of Wallace Berman," in Craig Krull, *Photographing the LA Art Scene,* p. 25.

19 Canonical examples include: The Destruction in Art Symposium, September 1966, and Lucy Lippard and John Chandler, "The Dematerialization of Art," *Art International,* vol. 12, no. 2, February, 1968, pp. 31–36.

20 Martin, Timothy, "What Cyan said to Magenta about Yellow (Notes from the Apparatus on the Work of Diana Thater)," *Witte de With, Cahier,* no. 3, Rotterdam: Witte de With Center for Contemporary Art, and Dusseldorf: Richter Verlag, February 1995, p. 127.

21 Martin, *Witte de With, Cahier,* no. 3, p. 127.

22 This is only a cursory sampling of these trends in the 1990s, for a more extensive discussion see Jan Tumlir's essay in this volume.

23 Pardo's interest in the intersections of art, design and domesticity resulted in the construction and exhibition of his home in 1998 at 4166 Sea View Lane under the auspices of the Museum of Contemporary Art. This sense of the private space of home in Pardo's work is echoed in a later 2003 *Artforum* advertisement that shows the artist in his pajamas outside of what we assume to be his home.

24 Raven, Arlene, "Womanhouse," *The Power of Feminist Art,* New York: Harry N. Abrams, Inc., 1994, pp. 48–65.

25 Irwin stated: "I had known this space and wanted this opportunity since 1968. At that time, the space next door, 72 Market, was my last studio (virtually a carbon copy of 78 Market). I had originally intended to do something similar at that time." Robert Irwin, *Being and Circumstance: Notes Towards a Conditional Art,* New York: Pace Wildenstein Gallery, in association with The San Francisco Museum of Modern Art, 1985, p. 87.

26 Irwin resisted and often refused photographs of his work during this time, stating: "I am concerned with *specifics* and reject the generalities of photographs." Robert Irwin, "Statement," *Artforum,* vol. 3, no. 9, June, 1965, p. 23.

27 See Jan Butterfield, *The Art of Light and Space,* New York: Abbeville Press, 1993, pp. 25–28.

28 Butterfield, *The Art of Light and Space,* p. 27.

29 Irwin was working on the International Habitability Symposium for NASA. He stated of his Market Street studio: "I... was forced to give up the place by the Building Department who were miffed at changes I had made in preparation for 'housing' NASA's First International Symposium on Long Term Space Travel." Irwin, *Being and Circumstance: Notes Towards a Conditional Art,* p. 87.

30 Irwin, *Being and Circumstance: Notes Towards a Conditional Art,* p. 89.

31 Burden, Chris, "Excavation," *Chris Burden: A Twenty-Year Survey,* Newport Beach: Newport Harbor Museum, 1988, p. 148.

32 Lopez, Yolanda M. and Moira Roth, "Social Protest: Racism and Sexism," in *The Power of Feminist Art,* p. 149. See also Laura Cottingham, "LA Womyn: The Feminist Art Movement in Southern California, 1970–1979," in *Seeing Through the Seventies: Essays on Feminism and Art,* ed. Laura Cottingham, Amsterdam: G+B Arts international, 2000, pp. 161–174.

33 Lacy in conversation with Moira Roth, 1993. Cited in "Social Protest: Racism and Sexism," p. 149.

34 In this decade Burden turns his attention not only to video, but also to the television broadcast itself—producing several works that aired within the venue of television. See *Chris Burden: A Twenty-Year Survey.* Such work had precedents in Gerry Schum's television gallery of the 1960s and in the television programs run by the Dilexi Foundation in San Francisco in the 1970s.

35 Stiles, Kristine, "Kristine Stiles in conversation with Paul McCarthy," *Paul McCarthy,* London: Phaidon Press, 1996, p. 26.

36 Stiles, "Kristine Stiles in conversation with Paul McCarthy," p. 28.

37 Ohrt, Roberto, "The Abandoned Decades," in *Raymond Pettibon: The Books 1978–1998,* ed. Robert Ohrt, New York: Distributed Art Publishers, 2000, p. 51.

38 McCarthy stated of the piece: "It was almost as if I was mixing a recipe: flour, or food, oil...." See Stiles, "Kristine Stiles in conversation with Paul McCarthy," p. 27.

39 Zittel, Andrea, *Diary No. 01: Andrea Zittel,* ed. Simone Vendrame, Milan: Tema Celeste Editions, 2002.

40 Zittel, *Diary No. 01: Andrea Zittel,* p. 20.

41 Zittel, *Diary No. 01: Andrea Zittel,* p. 20.

42 Zittel, *Diary No. 01: Andrea Zittel,* p. 60.

43 Zittel has expressed this interest in a variety of ways over the course of her career. Most recently in her work for *Tema Celeste,* Zittel writes of "things I know for sure": "What makes us feel liberated isn't a total sense of freedom, but rather living in a set of limitations that we have created and prescribed for ourselves." See Zittel, *Diary No. 01: Andrea Zittel,* p 114.

44 See for example, *Sunshine and Noir: Art in LA 1960–1997*; Peter Plagens, *Sunshine Muse: Contemporary Art on the West Coast,* New York and Washington: Praeger Publishers, 1974; Mark Johnstone, *Contemporary Art in Southern California,* Sydney: G+B Arts International, 1999.

45 If there is one dominant location of the artworld in Los Angeles, it might be in its pedagogical institutions. The role of various art programs in Los Angeles has been pivotal in the development of practice here. CalArts, UCLA and Art Center have formed long standing foundation for practice, along with Otis Institute of the Arts, University of Southern California, and schools in outlying regions of Los Angeles, including the University of California, Irvine, and the University of California, San Diego. Important personalities in these institutions—Eleanor and David Antin, Alan Kaprow, Tom Lawson, Mary Kelly, Charles Ray, James Welling, Jeremy Gilbert-Rolfe, as well as Baldessari, Burden, Kelley, Prina, Pittman, and too many others to count, have had an enormous impact on the development of art in this region, as have the friendships made while studying in these institutions.

46 See Tumlir's reference to Los Angeles as the "capital of forgetting" or the "post-historical city" in his essay in this volume.

Desig
Envi-
ronm

Jorge **PARDO**
Jennifer **STEINKAMP**
Diana **THATER**
Pae **WHITE**
Andrea **ZITTEL**

Jorge PARDO

Jorge Pardo's creations defy categorization. They spring from the polemical and confusing space where the utilitarian meets art. He creates a fusion of the functional and the aesthetic, a place where design, architecture, drawing and painting exist symbiotically. While seeking to blur the linear distinctions between art forms, categories, and practices, Pardo aims at dissolving the viewer's understanding of the function and place of both art and design, challenging the belief that art is always symbolic or metaphorical. His work often mixes organic forms with the 60s and 70s kitschy appropriation of modernism making use of everything from digital printing techniques and lighting design to paper, cloth, and card. This creates contrast within his work: while some pieces, such as his redwood pier for Skulptur Projekte in Munster, 1997, exhale seriousness and luxury in their material, form, and location, others such as his paper, ink and wood sculptures transmit the humble spontaneity of a creative artist.

 Blending the Russian Constructivist vision of art as integrated to life by utilitarian objects and architecture with the Minimalist concept of presence, Pardo aims to affect the social relations that occur in the environments he creates. Working on large scale architectural projects like the bookshop, lobby and exhibition space at the Dia Center for the Arts in New York or a sculpture that he lives in and calls home called *4166 Sea View Lane* and a bar in Los Angeles's art zone, Chinatown, Pardo takes into consideration the environment and context of buildings as part

Penelope, 2004
public light sculpture
installed for the
Liverpool Biennial, UK
mixed media,
dimensions vary

opposite top:
Delegates dining room,
2003
German Parliament,
Paul-Lobe-Haus, Berlin
mixed media,
dimensions vary

opposite bottom:
Oliver, Oliver, Oliver,
2004
installation for
Braunschweigl Parcours
translucent waterproof
material, lightweight

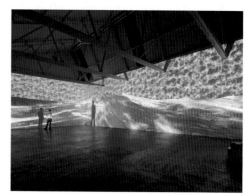

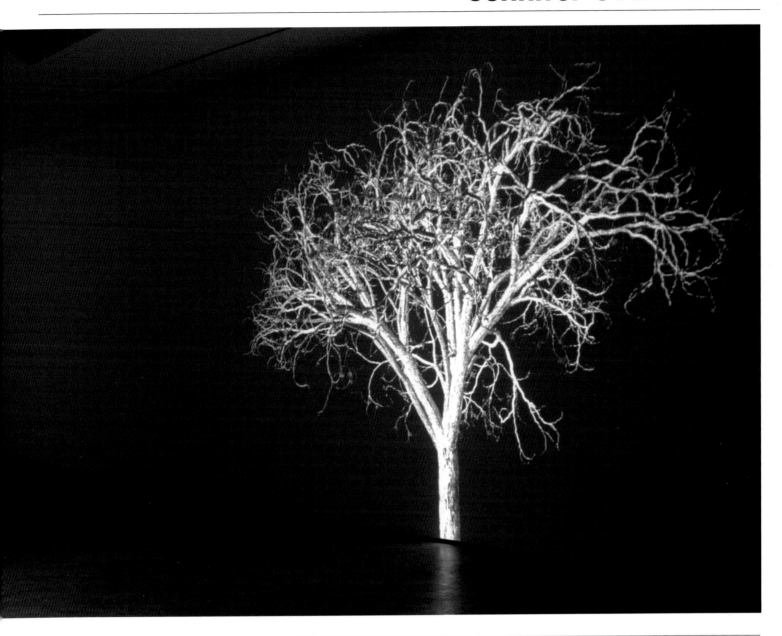

Dervish, 2004
installation at Lehmann
Maupin, New York
four Epson 7800, 3500
lumen projectors,
each tree: 12' × 16'
Collection: Albright
Knox Art Gallery,
Buffalo, New York

opposite left:
Jimmy Carter, 2002
installation at ACME,
Los Angeles
Epson 7800, 3500 lumen
projector, 35' × 18' × 14'
photo: Robert Wedemeyer

opposite right:
**The Wreck of the
Dumaru, 2004**
installation at
greengrassi, London
four Epson 7800, 3500
lumen projectors, five PC
computers, projection:
48' × 15' and 22' × 15'
photo: Marcus Leith

Jennifer Steinkamp works primarily with video projections in her installations, focusing on the phenomenology inherent in light, space, and motion. Although her projections are often derived from simple images, they draw attention to the perception and experience of motion, emotion, and imagination on the part of the viewer and the artist. Her projections may appear to be hallucinogenic products, almost dream-inducing, but Steinkamp's project is not merely to create high-tech psychedelia. Each of her environments is backed with a story—one invested with personal history, storytelling and mysticism.

Her 2004 installation at greengrassi gallery in London, entitled *Dumaru*, found its inspiration in Steinkamp's great uncle, whose ship (after which the installation was titled) was wrecked in World War One after a lightning strike. Suffering in a poorly-provisioned lifeboat for nearly two weeks, his own seawater-induced hallucinations brought him to insanity and eventually to death. In this piece, Steinkamp combined two ocean animations—one from above the water and one from below—manifesting walls with fluidity and an ocean without depth.

Similarly, her *Dervish* installation at Lehmann Maupin in New York, also in 2004, was inspired by the shamanistic rituals of the Mevlavi sect of Islam. The fantastic whirling movement of the tree branches mimes the mid trance motion of the priests, or dervishes, and symbolizes the soul's deliverance from the earthly to the divine. Steinkamp's expression of transcendence offers insight into her own consciousness as much as it challenges the viewer (whose shadow pronounces their presence) to examine her role in the perception of the work. Although Steinkamp's works are neither material nor explicitly interactive, they embody space, light, and motion in such a way that invites the viewer's sense of perception to a kind of passage—as both rite and voyage—and reveal a refined sensitivity to consciousness itself. **N.B.**

Diana THATER

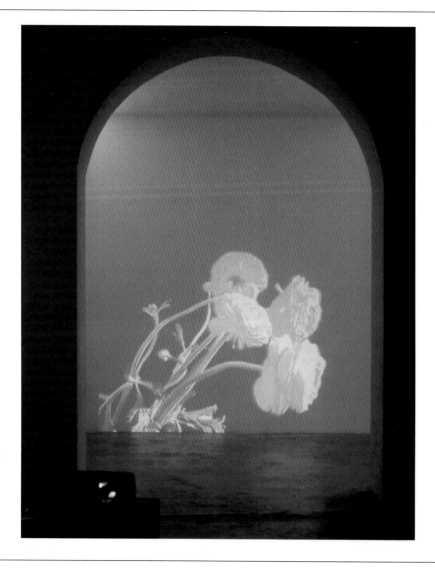

Diana Thater constructs large scale installations using the mechanics of her media to accentuate and investigate notions of space. Thater emphasizes environment, but extends this notion beyond the physical context of her installations to form meditations on the nature of temporality and space, using video footage as projections and interventions into the surrounding architecture. She explores the relationships between humans and animals, culture and nature, and—both literally and metaphorically—the ways in which technology necessarily mediates their interaction. Since the early 1990s, Thater's installations have formed an analysis of the sites they are placed in, as well as complex narratives around subjectivity in general. Works such as *The best animals are the flat animals—The best space is the deep space*, 1998, consists of a number of pieces which were exhibited in different venues simultaneously, including one which combined projected footage of a zebra performing tricks within a room that has had the windows covered with colored film. In this segment, the videos become sculpture, shown on monitors or projected onto fake walls, while the room becomes a projector (the windows are covered with films in the three colors of video: red, green and blue).

Thater's installation *Knots and Surfaces*, 2001, continues her mapping of space and time, the piece consisting of layered projections inspired by a mathematical mapping of a six-dimensional space that was discovered to be the same as the dance of the honeybee—a movement believed to relate the four-dimensional (latitude, longitude, altitude and time/distance) location of pollen to other bees. Yet Thater's installation is not simply "about honeybees or math but about meaning-making and image-making and ultimately about abstract space."[1] The video projections call upon the viewer to re-think the capacity of humans for understanding space, even with scientific and technological mediation. By focusing on this coincidence between the exploration of quantum fields and the dance of the honeybee, Thater again explores the relationship between the abstract and the natural—and the complicated space beneath everyday assumptions. **N.B.**

1 Thater, Diana, in an interview with Melinda Barlow for *Sculpture Magazine*, vol. 20, no. 8, October, 2001, p. 35.

Bastard Pink, 2002
video projector, DVD player, DVD, green gels, dimensions vary

opposite top:
Untitled Commissioned Work for a Private Residence, 2003
installation view, Brentwood, CA
video projector, DVD player, DVD, custom-designed outdoor projector housing, dimensions vary
photo: Fredrik Nilsen

opposite bottom:
White is the Color, 2002
installation view at 1301PE, Los Angeles
LCD video projector, DVD Player, DVD, two-tube fluorescent light fixture, dimensions vary
photo: Fredrik Nilsen

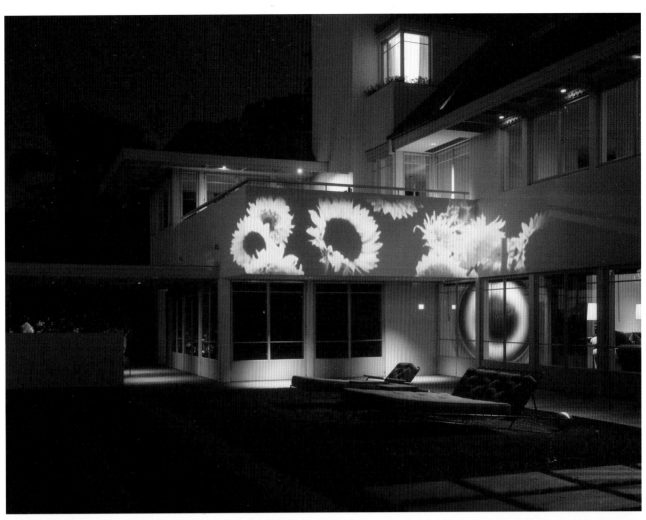

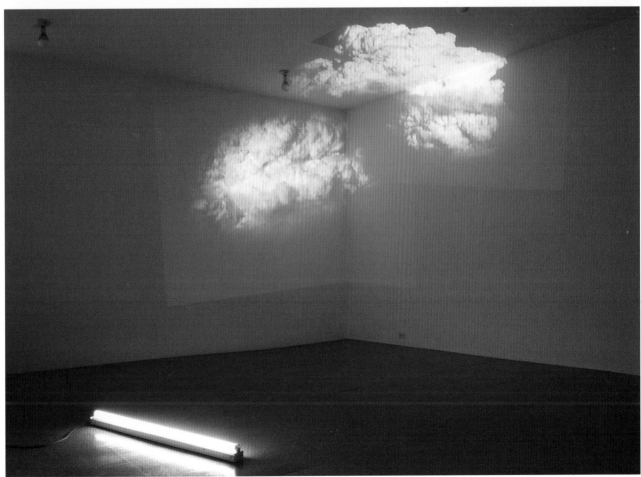

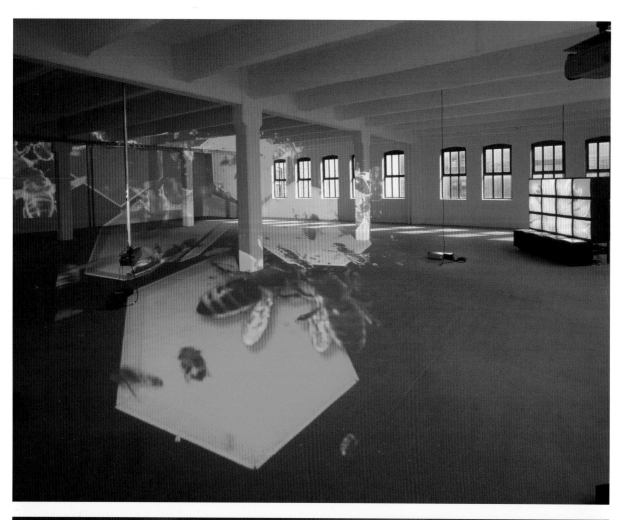

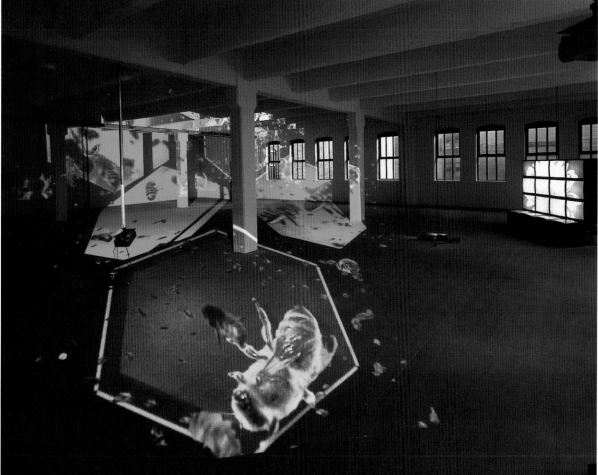

***Knots and Surfaces,
2001***
installation views at the
Dia Center for the Arts,
New York
five LCD video projectors,
16 video monitors, six
DVD players, VVR-1000
synchronizer, six DVDs,
film gels, dimensions vary
photo: Fredrik Nilsen

opposite:
***Untitled
Commissioned
Work for a Private
Residence, 2003***
installation view,
Brentwood, CA
video projector, video
monitor, two DVD
players, two DVDs,
dimensions vary
photo: Fredrik Nilsen

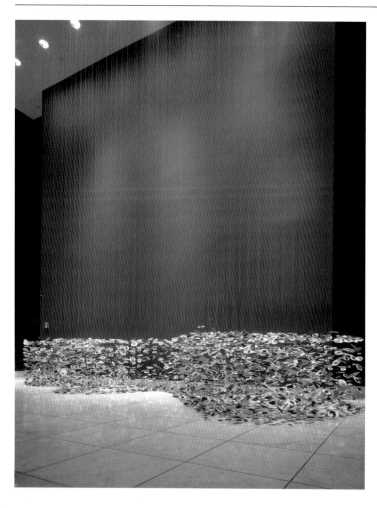

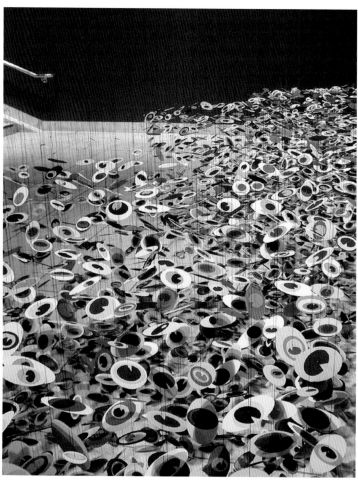

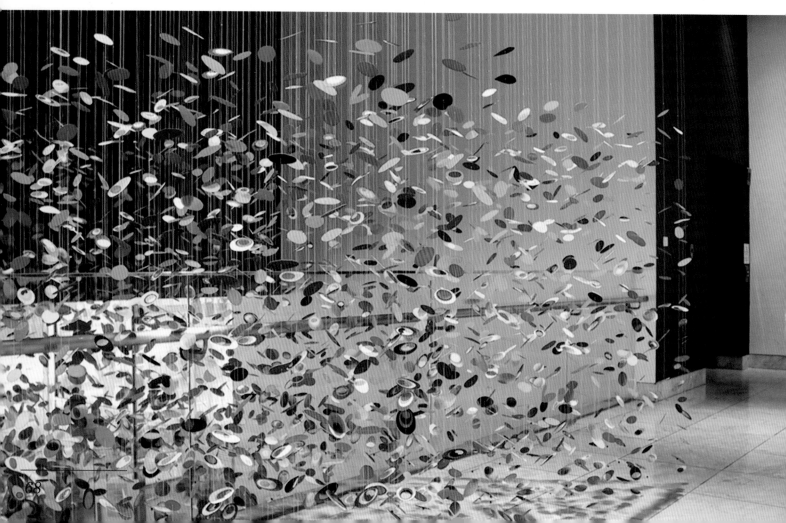

left:
***Untitled*, 2003**
installation view at Des
Plaines Library, Des
Plaines, Illinois
digital output on vinyl
45' × 17'

right:
***Untitled*, 2001**
neugeriemschnieder
advertisement No. 8
This was part of a
two year ad campaign
on page 4 of *Frieze*
magazine, from 2000
to 2001

opposite top left:
***O R O S C O P O*, 2004**
installation at UCLA
Hammer Museum
paper and thread,
dimensions vary
Private Collection
photo: Fredrik Nilson

opposite top right:
***O R O S C O P O*, 2004**
detail

opposite bottom:
***Aviary*, 2004**
installation at UCLA
Hammer Museum
paper and thread
4' × 16' × 8'
Collection: Angelika
Taschen

Pae White is an artist who takes advantage of just about every medium and form. Whether suspended in mid-air, expanded around a room, printed in a magazine or on a shopping bag, her work combines highly skilled graphic design and an engagement with architectural space that challenges definitions of fine art, design and public sculpture.

Her murals, such as the one in the Des Plaines Library, Illinois, completed in 2003, are playful and energetic, created from computer graphics. Formally and stylistically, White's Japanese-pop-dreamscape mural is a hallucinatory and prismatic peppering of scattered shapes and characters, creating a space for the viewer to project his or her own fantastical narratives. White improvises around shapes and forms, drawing on a huge range of influences—from art history to pop culture. This method reflects her changing status as a maker: she has designed catalogs, magazine covers, advertisements, as well as installing in spaces that are tangential to the gallery, including education areas and bookshops. Alongside a number of other artists who came to prominence in the 1990s, such as Takashi Murakami and Jorge Pardo, White explores the potential of design and applied art, in a trend that writer Alex Coles has labelled "Design Art."

White's mobiles have become a signature strand in her diverse practice, with their delicate cut out paper shapes suspended in public spaces such as the foyer of UCLA Hammer Museum. As distinct as they are intricate, each portion of White's mobiles enunciates the time and care involved in its creation. They are frequently compared to flocks of birds or schools of fish, but equally resemble suspended frames of falling snowflakes or tossed confetti. And, as tiny pieces suspended in a mass, her mobiles also demonstrate a unique fluidity—what she calls "an exploration of movement contained... a flurry of color and gentle movement, suspended for contemplation."[1] **N.B.**

1 White, Pae, quoted by Alex Farquharson in the introduction to her Hammer
 Projects exhibition at UCLA Hammer Museum, Los Angeles, www.hammer.ucla.
 edu/exhibitions/50/.

Andrea ZITTEL

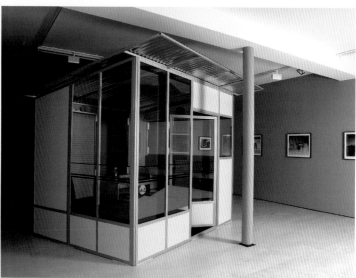

While struggling as a young artist in a cramped New York apartment, desperation drove Andrea Zittel to design an enclosed space that would provide her with a refuge. This early work became the inspiration for her *A–Z Escape Vehicles*, a series of sculptures that put her on the map in the early 1990s. These 60 × 40 × 84 foot steel shells are the same on the outside, but their interiors are designed to the specifications of their owners. Clients, from Andrea Rosen to Muccia Prada, have chosen personal idealized environments including a sensory deprivation flotation tank, or nothing but blue velvet upholstery. This conceptual strategy blurs the line between product design, artmaking, and architecture.

By designing uniforms and creating ads for her products Zittel has adopted the language of commerce. *A–Z West*, located in Joshua Tree, California, is Zittel's primary workspace and home. In the artist's own words "The A–Z enterprise encompasses all aspects of day to day living. Home furniture, clothing, food all become the sites of investigation in an ongoing endeavor to better understand human nature and the social construction of needs." A–Z's output has included *Homestead Units*, *Cellular Compartments*, and *Deserted Islands*. These sculptures investigate the often uncomfortable relationship between individuals and society at large.

The *Homestead Units* highlight the multi-layering of meaning in Zittel's work. While they purport to embody the pioneering spirit of the West, they make sly reference to a US policy of the 1940s and 50s which granted land to settlers if they could develop it. The only structure required was a small homestead. By fusing this humble domicile with commodity culture and a luxurious aesthetic, she has turned the idea on its head. But her pursuit is not strictly ironic. Each *Homestead Unit* is small enough to be zoned as a "temporary structure," requiring no building permit. Since the units can be easily assembled and disassembled, anyone could in effect become a pioneer. **M.M.**

top left:
A–Z Escape Vehicles,
1996
installation view at
Andrea Rosen, New York
mixed media,
each unit: 5' × 3' 4" × 7'

top right:
A–Z Homestead Unit
from A–Z West with
Raugh Furniture, **2004**
steel, birch paneling with
paint and polyurethane,
corrugated metal roof,
sculpted foam furniture,
25' 6" × 15' 3" × 25' 6"

bottom left:
A–Z Fiber Form
Garment, **2004**
felted wool

bottom right:
A–Z Homestead Unit,
2001
steel, wood, glass,
10' × 13' × 10'

opposite:
A–Z Escape Vehicle
Customized by Dean
Valentine, **1996**
steel, insulation, wood,
glass, 5' × 3' 4" × 7'

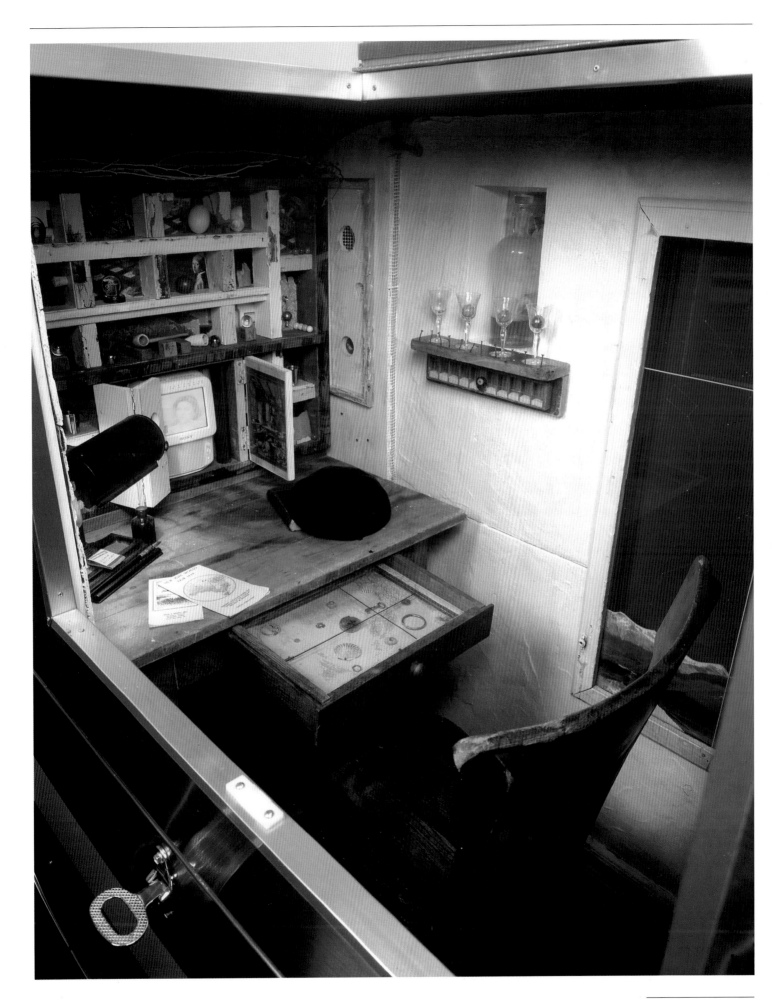

Elabo
Fictio

Anthony AUSGANG
Brian CALVIN
Carole CAROOMPAS
Carolyn CASTAÑO
Russell CROTTY
Nick LOWE
Ivan MORLEY
JP MUNRO
Laura OWENS
Lari PITTMAN
Mark RYDEN
Jim SHAW

Anthony AUSGANG

Anthony Ausgang's artistic production consists of customized cars, original acrylic paintings, and commercial merchandise. The influences behind Ausgang's decidedly low brow aesthetic are manifold, and include, world-renowned artists such as Andy Warhol and Jean-Michel Basquiat; *New Yorker* magazine cartoonist, Charles Addams; underground illustrators Robert Crumb and Robert Williams; as well as Tom and Jerry animators Hanna and Barbera. His imagery ranges from the twisted neon-colored descendants of Wile E. Coyote and Felix the Cat to garish automobiles cruising through LSD-induced desertscapes. In his smoothly painted canvases felines strut like Vargas pin-ups through darkened cityscapes, while stained glass windows depict Jesus about to run over a cat with his hotrod. It is the iconography of an American childhood, infused with the aesthetic of adolescent drug culture carried out with prolific fervor.

According to Ausgang he attempts to explain the "human condition" by depicting anthropomorphized cats, malleable curvilinear forms of cartoon animals more readily manipulated to his psychedelic narrative ends. Developing individual paintings, he forsakes the effort of creating an entire cartoon in favor of depicting "the most critical moment of a scenario."[1] Ausgang states: "My characters are metaphors for the nonplused people we meet everyday, and parables for the kinds of situations in which these people find themselves mired."[2] The painter's scenarios include a cat just realizing he has stepped in chewing gum; a decapitated alley cat praying as his body casts a shadow of a cross beneath him; and a cat with two bodies leading himself over a cliff's edge in pursuit of a carrot that he himself holds. Sharing a fascination for thrift store art with his LA contemporaries Jim Shaw and Wayne White, Ausgang has also created numerous modified thrift store paintings. Exemplary of this series is *The Car-Go Cult*, 1996, in which the artist has transformed an intricate painting of a Buddhist ritual into a hotrod swap meet. In numerous other works oversized American cars invade the quaint and idyllic European streets of pre-fabricated kitsch canvases. **O.F.**

1 Ausgang, Anthony, "Manifesto", www.ausgangart.com/propmin.html.
2 Delio, Michael, "Loony Tunes," (interview with Ausgang), *Art Alternatives?*, vol. 2, issue 4, February, 1994, p. 41.

top left:
Valdez 2, **1996**
acrylic on found canvas,
12" × 20"

bottom left:
Car Phone Sex, **1997**
car paint on 1970
Mercury Cougar,
dimensions vary

bottom right:
Car-Go-Cult, **1996**
acrylic on found canvas,
24" × 36"

opposite:
The Urban Annoyance,
2005
acrylic on canvas,
30" × 40"

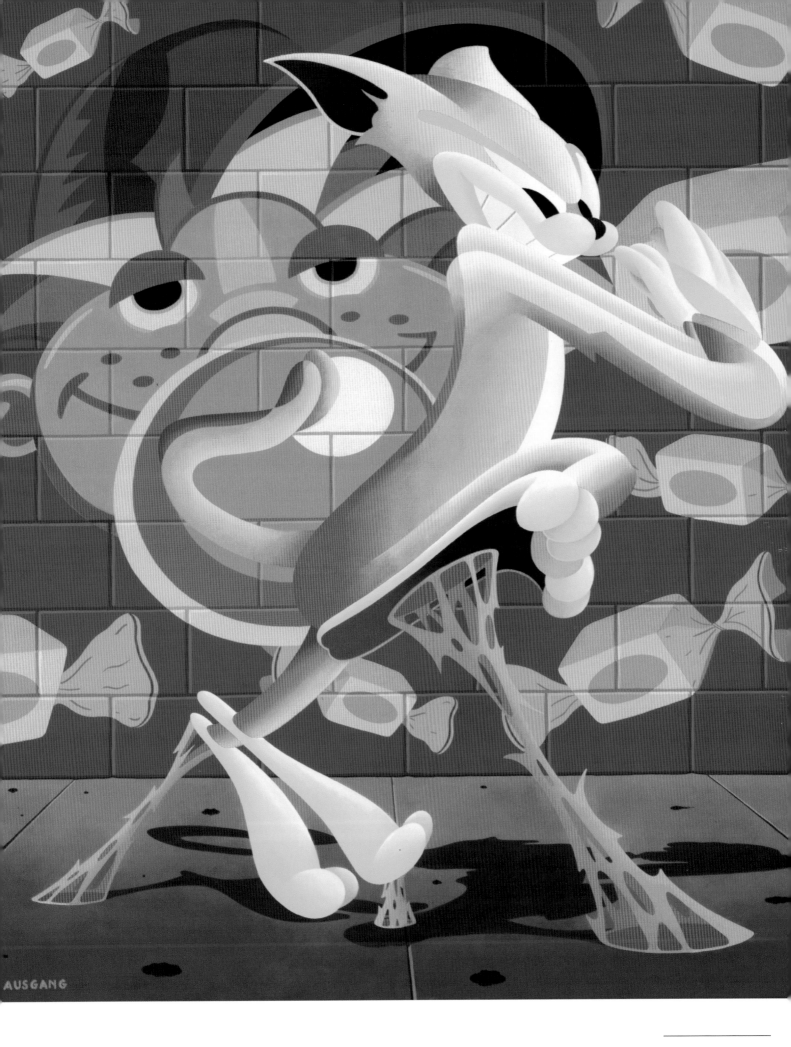

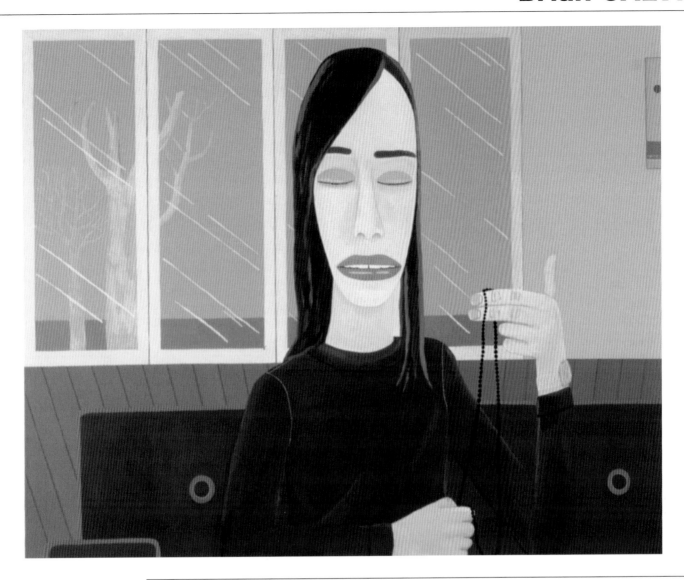

Brian Calvin's paintings are a melancholic, disconcerting and contemporary continuation of the rich history of figure painting. The blank faced protagonists, a celebration of the morose bewilderment of slacker kids with their inexpressive mouths and glassy eyed androgyny, find themselves frozen in moments of a suspended narrative. Calvin never anchors his stories to a beginning or an end but instead concentrates on an endlessly protracted middle. Small actions accumulate at the edge of the canvas, offering little more than hints and suggestions of time and place; references to reality magnify the ambiguity of the mood, and add a sense of unease to their otherwise withdrawn calm.

Like the residue of a dream, *In a Place*, 2004, has one of Calvin's protagonists feeding a string of beads from hand to hand in an interior with glimpses of a landscape, each refusing to offer any clues towards specificity. Even the watch worn by the figure refuses to tell the time. As the paintings veer into an emotional and compositional abstraction, achieved by shrewd cropping, awkward perspective and a flattened palette, they hold the memory of a painfully longed for moment, embuing the ordinary with a sense of the spiritual.

Calvin shares something of Alex Katz's deadpan graphic chic in the arrangement of his figures in space. But it is an influence more of attitude than imagery. The ennui of Calvin's red-eyed and misunderstood youth resembles Katz's Tri-State, Upper East Side society vagueness. Both pay enormous attention to the details of the sympathetic emptiness they portray, acutely observing the finer points and styling of the figure's attire. In *Nowhere Boogie*, 2001, the guitar playing figure with a bright satanic motif across his black T-shirt "may groove and toke in order to 'escape' but the flat, no nonsense, non-illusionistic way he's painted signifies he is stuck struggling with the real."[1] Unlike Katz, Calvin is searching for a sympathy through and with his characters, and rather than being iconic they seek to relate a common fear and anxiety of the modern world. **P.F.**

In A Place, 2004
acrylic on canvas,
50" × 60"

opposite top:
Nowhere Boogie, 2001
acrylic on canvas,
50" × 60"

opposite bottom:
Passing Through, 2001
acrylic on canvas,
54" × 40"

1 Hainley, Bruce, "Openings: Brian Calvin," *Artforum*, vol. 39, no. 6, February, 2001, p. 140.

Carole CAROOMPAS

Carole Caroompas has been investigating gender roles in literature, art history, folklore and contemporary culture through her painting practice for over 20 years. Her aesthetic combines the graphic art historical references of Nancy Spero with the frenetic energy of Sigmar Polke. The collage feel of her work developed out of the style of painting made popular by Polke, David Salle and their contemporaries in the 80s, only in Caroompas's case, the layering of images serves to produce meaning and narrative rather than a nihilistic denial of both.

Caroompas works in series, titling each painting in a group before setting to work on each one individually. In this way language drives the work, with the flow of images generated from the words and references within the title. The texts she develops her works from are always well known and often referenced in film, for example Mary Shelley's *Frankenstein*, Hawthorne's *Scarlet Letter*, or the fairy tale *Little Red Riding Hood*. In this way, the subject matter is always something the viewer comes to with preconceptions that Caroompas can toy with and subvert in her high contrast montages. The vibrant palette and lyrical grace with which she paints counterbalances the explicitness of the material, and it is in the fissure between form and content as well as clashing imagery that meaning emerges. In her work named with a quote from *Wuthering Heights* by Emily Bronte, *Blue Impressions Are Left On Her Colorless Skin*, 2001, she juxtaposes images of women as well as text from sex ads in the back section of *LA Weekly* with Latin embroidery patterns of flowers and saccharine Spanish love poetry to provoke questions about conflicting contemporary expressions of desire, lust and devotion.

Her recent series *Psychedelic Jungle*, 2004, moves away from the themes of gender and romance that dominated her earlier work and instead takes up contemporary conceptions of freedom and the search for home as the focus. Imagery from Tennessee Williams's *Night of the Blue Iguana* and portraits of punk icons Exene Cervenka, John Doe and Henry Rollins vie for space amongst 60s psychedelic flora and fauna in these overloaded riffs on liberty, outsiders and the creative process. **O.F.**

left:
Psychedelic Jungle:
A Saint Dancing on
Broken Glass, 2003
acrylic on found
embroidery over panel,
34" × 28"

right:
Psychedelic Jungle:
Teenage Medea and
the Cha Cha Boys,
2002
acrylic on found
embroidery over panel,
33" × 26"

opposite:
Psychedelic Jungle:
Floating Poppy Seed
Tea Party, 2002
acrylic on found
embroidery over panel,
34" × 28"

Carolyn CASTAÑO

Carolyn Castaño uses what she calls a "Latin pop" aesthetic of flamboyant, calligraphic gestures to combine whimsy, excess and glamour. The decoration and artifice she uses in her drawings serve as an investigation of gender, with depictions of birds, flowers and nature emerging from a world that luxuriates in an opulent femininity. She creates an elaborate fiction that examines notions of the gaze, the beauty ritual and feminine aggression. Castaño's drawings are constructed from gems cut from fashion magazines, as well as feathers and glitter which will often, by happy accident, fall from the surface of the image and settle on the frame, serving to highlight the fragility and facade of the luxury myth.

Castaño utilizes the notion of facade by often featuring her alter ego "Betty Ramirez" in her work. Modelled after stars of Mexican and Italian cinema, the character of "Ramirez" has been developed as a tool to explore the realm of the feminine in its various manifestations. Castaño's notions of femininity, however, are not limited to her depictions of women. In her recent series *Hair Boys*, 2004, photographs of male friends are prettified with 60s and 70s style haircuts or with the curls of an eighteenth century aristocrat. The hair is made of repetitive strokes with a brush no thicker than lip liner. The male subjects stare out fetishized and beautified, challenging notions of fixed gender identity and exposing the excess of artifice. In doing this, Castaño's intention is one of subversion, forcing the viewer to re-evaluate and accept the "sexy, [the] pretty, [and the] feminine" as serious and valid subjects for art.[1] **P.F.**

1 Castaño, Carolyn, quoted in the press release for her 2005 solo show at Kontainer Gallery, Los Angeles.

Monaco Tonight, **2005**
watercolor, sumi ink, rhinestones, feathers, and glitter on paper, 33" × 25"

Looking for Baade's Window, **2005**
watercolor and India ink on paper on fiberglass, plywood rings, steel plates, 6' in diameter

From his self-built observatory at his Malibu home, Russell Crotty records the movements and activities of the night sky, detailing the star clusters, constellations and planets above. A member of the Association of Lunar and Planetary Observers, he chronicles the cosmos with the scientific rigor demanded by such an establishment. Back in his studio, from memory, the daytime nine to five activity is taken up by transferring the night time studies into immense ballpoint pen drawings in books, on large sheets of paper, and on paper-covered Lucite spheres. Often taking weeks of eight-hour days to complete, the drawings are covered with thousands of tiny pen strokes, the humbleness of the pen and the labor magnified by the stellar scale of the pieces (literally and metaphorically). His fascination with astronomy is a continuation of a childhood obsession and his drawings maintain the wonder felt by a child when first contemplating the size of the universe.

Like the great Ruskin-esque chroniclers of nature and the landscape, Crotty does not use photographic or computer enhancement; he makes studies and notations in sketchbooks at the eyepiece of his telescope. Where he differs from this tradition however is that by translating and recalling his studies from memory he flips the notion of observation from nature or surveillance through his ten inch f/8 Newtonian Reflector telescope into one representative of what he "knows, thinks and feels" about them.[1] There is a collision between memory and object similar to the experience of seeing a star that may have burned out thousands of years before he sees it.

Crotty's books, or atlases, contain series after series of drawings, diagrams and notations. When folded out, they sometimes measure up to seven by 13 feet, reflecting the scale of his subject. In the foregrounds of his book pages and on the poles of some of his globes, Crotty often inserts passages of text that serve as a reminder of the experiential nature of his observations. Included amongst astronomical reports are snippets of radio talk shows, diatribes against real estate scams and excerpts of poetry. The imposed reality of material culture in a celestial space enables critique and reassessment of our own dreams. On the lower half of *Extinction 1*, 2005, for example, are phrases like "beachfront opportunity" or "tremendous upside potential." Crotty though, while acknowledging the quest for consumption of the finite, seeks rather to chronicle the infinite. **P.F.**

1 Crotty, Russell, quoted in *WDAYANO?*, Tuscon: University of Arizona, 1999.

Nick LOWE

Nick Lowe's obsessively detailed drawings and collages hum with enthusiasm, imagination and their own sense of the bizarre. Taking months to complete, Lowe's dense drawings push artifice and display almost to the point of overload. Lowe speaks of the "visual hustle and bustle" and the excitement of always being able to look for new things in his work, recalling the labyrinthian paintings of Hieronymus Bosch or the children's book *Where's Waldo*. His aesthetic approach reflects an attempt to get down to the details in order to understand the world. Lowe describes the influence of *Where's Waldo* on his work: "The goal was to find Waldo in various places in space and time, but finding Waldo wasn't what I was interested in—it was the tomfoolery and shenanigans around Waldo that captured my imagination."

In *The Fresh Eleven*, 2002—a colored pencil and graphite drawing of rock and roll excess that is straight out of *Spinal Tap*, with its four-storey Stonehenge stage and dials that go up to eleven—ornamental marks bounce off at different trajectories creating cacophonous visual rhythms of infinite noise. There is something almost pagan in its celebration of the cosmic forces it depicts and the minutiae used to do so. Similarly, *The Business of Fancydancing*, 2002, an eight foot tall collage made entirely from construction paper, pulses in its complexity, fusing the visual tropes of the Mandala and Rorschach ink blots.

With fellow artist Ry Rocklen, Lowe developed what they call a "boy-oh-boy" aesthetic. One that uses "art to flesh out adolescent boys' fantasies... infused with a youthful luster to make something perfectly imperfect, take something ugly and make it look good." In the artists' words: "We take something dumb and make it look smart. Stupid things are important. Stupidity is probably more important than intelligence; there's more of it."[1] For all the faux naivety Lowe attests to in his manifesto, his works are richly complex. Attempting to find a balance between both, Lowe's pictorial complexity and narrative absurdity become the fabric of his affected universe. **P.F.**

1 Lowe, Nick, quoted in Nathan Ihara "Boy-Oh-Boy," *LA Weekly*, November 2–8, 2001.

The Fresh Eleven, **2002**
colored pencil and graphite on paper,
4' 6" × 8' 6"

opposite top:
Untitled, **2005**
graphite on paper,
31" × 42"

opposite bottom left:
Rugmuncher, **2004**
oil on canvas, 60" × 60"

opposite bottom right:
Baghdaddy Kane, **2004**
acrylic on linen, 76" × 76"

From Don, George, Diane, 2004
oil, wax, KY jelly on canvas over panel, 60" × 80"
photo: Josh White

opposite:
Logo, 2004
oil, wax, KY jelly on panel, 24" × 25"
photo: Josh White

Ivan Morley's multi media paintings record the idiosyncratic histories of anonymous small-town California, places which seem to have had less than noteworthy pasts. His works also mark the passing of time by documenting the artist's creative output in the process of making each work, mark by mark, or in some cases, stitch by stitch. In this way, Morley's work comments on the way in which history is constructed by the present moment, always a retelling that transforms the story, distancing it from the original event. However, the histories Morley presents, inspired as they are by the activities of local squirrels, memorable cockfights, or the explosion in "Bill's Asphaltum-Camphene Lab" of 1850, are more evidently products of the artist's roving imagination than the reality of Los Angeles's mid nineteenth century past. Taking on the traditions of visual narrative and oral storytelling in terms of content, materials and technique, Morley has created a body of work that is both complex and visually intriguing.

Morley's painting, or "poetic myth objects," as he calls them, are constructed from a concoction of oil paint and a variety of visceral materials that wouldn't seem out of place in a work by Paul McCarthy. KY jelly, soap, wax and varnish are skillfully manipulated with paint to form brightly colored images on top of a myriad of surfaces, from canvas and glass to wood panels and batik. The work's material diversity is echoed by a variety of content and style, with some paintings bearing text and figurative elements while others remain abstract or pattern based. Morley often displays a series of paintings alongside a few lines of anecdotal information written by hand and pinned to the wall; these texts relate to the works, but do not provide a strict guide or formula. For example, *Logo*, 2004, depicts three masked squirrels and the words "Clifford Still Real Estate" written backwards as if painted on a storefront window viewed from inside. The work is in fact a solid piece of paint that was done in reverse on glass and then removed and placed on a panel. The imagery of the painting loosely relates to some gossip that Morley heard as a child regarding the death of a family friend who had studied under the painter Clifford Still. When the widow called Clifford Still to report the death of his student, the painter had supposedly remarked that he was now more interested in real estate than art. **O.F.**

JP MUNRO

JP Munro's paintings are rich vistas of pictorial possibility resulting from the artist's forays in and out of various genres of history painting. Far from appropriation and pastiche, Munro dissolves and reconstitutes the sum of his references before putting them back together to create something of an altogether different flavor. Battlefields extend into the realms of fantasy with depictions of mythical scenes and creatures, while Arcadian landscapes darken to a degree that renders them apocalyptic. These improbable hybrids are further spiced by the introduction of elements from punk rock and heavy metal cover art, graphic novels, science fiction and MTV. But rather than resolving all of these influences, Munro allows the opportunities provided by the friction between them to create a thoroughly contemporary take on history painting. "I want to excavate this sediment of history, these layers of forgotten meanings," explains Munro; "[when] working on a picture based on Delacroix's *The Death of Sardanapalus*, once I've copied it into its confined space I'll expand the scene according to my own imagination."[1]

The paintings are full of the contradictions expected from the displacement of so many sources. Members of the nobility are not seen in their drawing rooms but are presented in caves surrounded by stalactites or next to ornate Indian temples. A king sits on his throne crowned with the laurel leaves of a Roman emperor and cloaked in the ermine of Henry VIII, his webbed feet protruding from beneath his robes. The keen eyed observer will also recognize a torso drawn from Ingres, or a heroic scene by the Baron Gros. His figures and sources become almost cinematic in their refusal to revere any symbolism so that they become actors in fictitious roles, demanding the viewer to suspend disbelief. In Munro's world, the old is reconstituted into something timely, a profane archaeology that unearths the treasures of the past and the present. **P.F.**

Battle of the Hydaspedes, **2005**
oil on linen, 72" × 96"

opposite:
The Vision of Saint Eustace, Master Hunter, **2005**
oil on linen, 60" × 48"

1 Munro, JP, interviewed by David Rimanelli in "Artist Spotlight: JP Munro: discovering an artist while the paint is still wet," *Interview*, May, 2002, p. 46.

Laura OWENS

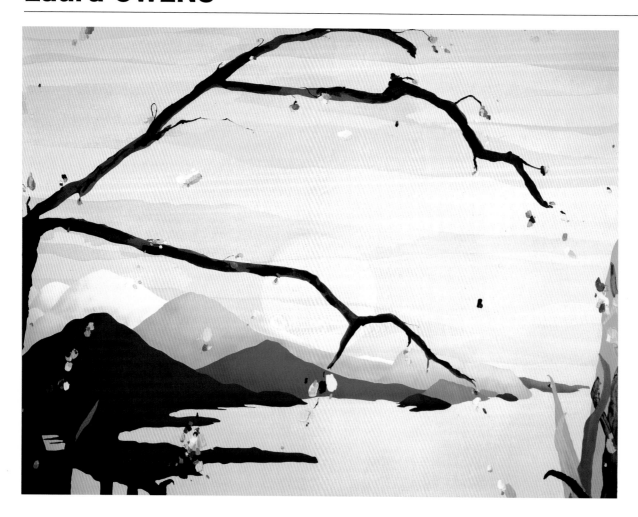

Laura Owens's painterly oeuvre lingers between figuration and abstraction, with playful works that subvert the traditional discourses surrounding heroically scaled oil painting. This subversion is not due to irony or angst but is instead the result of her engagement with fantasy and gaiety. Her work covers a large amount of subjects including cavorting monkeys, knotted and gnarled trees, kissing couples, casually doodled shapes and a plethora of flowers. Some are painted in a combination of bold strokes and light washes that soak the canvas, reminiscent of the work of the color field painters Helen Frankenthaler and Jules Olitski, while others reference the *japonisme* contours of Toulouse-Lautrec. The references, however, are not limited to the history of fine art; Owens also demonstrates an interest in craft/design based pattern and decoration, utilizing the motifs found in floral Marimekko textiles and geometric Shaker ornamentation.[1]

 Her signature lyrical use of paint is the overarching theme among works that range from entirely abstract compositions such as *Untitled*, 1998—a flat and almost entirely empty canvas interrupted by two spirals of paint squeezed straight from the tube—to representational pieces like *Untitled*, 2004, depicting a tree laced with spider webs and an assortment of perched animals. The more recent series is whimsical and atmospheric, combining the childlike imagery of Disney-esque caricatures with the compositional devices of Chinese screen painting. Playing with the conventions of landscape painting from both Eastern and Western traditions, Owens creates fictional environments that engulf and engage her viewer. Furthermore, having gleaned much from the installation art of her contemporaries, Owens doubles this effect in the display of her work. Not only do her paintings fill a wall from floor to ceiling, but she intentionally places gaps between pieces to place the viewer inside the space of the painting. This investigation of context and presentation is made all the more evident in her site-specific works such as an untitled landscape of 2000, created for the Inverleith House at the Royal Botanic Garden in Edinburgh. **O.F.**

Untitled, 2000
Inverleith House,
Royal Botanic Garden
Edinburgh, Scotland
acrylic and oil on canvas,
110" × 144"

1 Hoptman, Laura, *Drawing Now: Eight Propositions*, New York: Museum of Modern Art, 2002, pp. 31–32.

Lari Pittman's large scale paintings rework libraries of motifs, resulting in a dense and raucous mixture resembling over-elaborate comic book pages. As in typography, his obsessively and smoothly finished canvases are often subdivided by grids, producing a shallow, architectural, confined space, with occasional open vistas. His subject matter varies as his work oscillates between abstract forms and representation; however, the overarching theme is the urgent struggle for identity within a visually over-saturated world. Hailed as Los Angeles's most successful gay artist, his paintings often make reference to his sexuality without relying on stereotypically gay iconography.

Pittman's career spans a quarter of a century, developing from his works of the early 80s, defined by an aesthetic reminiscent of the early Jackson Pollock, to his signature elaborate collage-like works of the early 90s and today, with numerous subtle shifts throughout. In 1985 Pittman suffered a bullet wound to the stomach. This near-death experience provoked a change to his style of painting which began that year where his flat symbols and signs were slowly replaced by more personal imagery. *Plymouth 1620*, for example, shows an energetic breakthrough and establishes Pittman's very particular voice. The 80 inch square painting is dominated by two apostrophes chasing each other's tails, forming a large number 69. The bold numbers are in a bright cerulean blue with dark brown green bellies, as if cut out from the horizon of a landscape. This number appears often in Pittman's work representing speech or thought and comes from his *Counting To* series.

Recent work represents a departure from the large tableaux. His series from 2004 and 2005 feature interiors and landscapes juxtaposing threatening objects such as medieval weapons, axes, knives and scissors with delicate, decorative items, with their symbolism being more theatrical than in the earlier works. Pop aesthetics have given way to a more sombre, almost Victorian feel, his colors returning to the earthy tones of his earlier work with deep primaries and web-like ropes that link and separate objects, crisscrossing the paintings and reinforcing their Gothic stained glass character. **C.A.**

Untitled No. 8, **2004**
alkyd, acrylic and
enamel on gessoed
canvas, 40" × 52"

Mark Ryden's paintings are not for the faint of heart. His paintings confront the viewer, using laughter as a cause for anxiety and offering contemplations on mortality, as fuzzy bunnies are ripped in half with blood rushing forth. Ryden's carnivalesque aesthetic is developed from subtle amalgams of many sources; from psychedelia to the Vienna School of Neon Park and Ernst Fuchs to Ingres, David and other French classicists. Along with these fine art sources, Ryden also draws his inspiration from anything that will evoke mystery; the treasure of old toys, books, photos, anatomical models, stuffed animals, skeletons and religious ephemera found in flea markets.

The imagery Ryden uses triggers a warped *déjà-vu* where childlike kitsch turns into a nightmarish yet humorous parallel universe comparable to the raucous scenes of Pieter Bruegel. Furthermore, the perception of an idealized fairy tale dreamscape is methodically inverted as Ryden serves to remind us of the violence behind the surface of life. "It is," explains the artist, "[the] things I find to be 'strange' I also often find to be elevating."[1] Center stage in much of Ryden's work are party hats and cuddly plush pets, while political emblems and hints of alchemy lurk in the periphery. There are gold leafed Buddhas protecting the decency of Snow White (*Snow White*, 1997) and miniature Abraham Lincolns about to be culled by a butcher bunny (*The Butcher Bunny*, 2000).

According to the Russian author and literary critic Mikhail Bakhtin, there are three forms of carnivalesque art—the ritualized spectacle, the comic composition and various genres of billingsgate (foul language)—all three of which are interwoven in Ryden's work.[2] Take, for example, *Ecstasy of Cecelia*, 1998, in which an Alice-like figure in a Vermeer-esque room is depicted through the eyes of Saraceni's 1610 composition *St. Cecelia With an Angel* (the ritualized spectacle). Ryden hints at both the (darkly) comic and the (self) abusive by depicting a little girl staring glassily back at the viewer despite being under attack from the giant springing jack-in-the-box. Her blank expression is potentially due to her having imbibed the SSS blood purifier (a 70–90 percent alcohol tonic given to girls with "Spring and Summer Sickness" at the turn of the century), as inscribed on the side of the piano. **P.F.**

left:
The Ecstasy of Cecelia,
1998
oil on canvas, 26" × 31"

right:
Puella Animo Aureo,
2001
oil on canvas, 18" × 36"

opposite:
***The Creatrix,* 2005**
oil on canvas, 60" × 90"

1 Taken from Mark Ryden's artist's statement printed in Debra J. Byrne, Mark Ryden, et al, *Wondertoonel*, Pasadena: Museum of California Art, 2004, p. 7.
2 Byrne, *Wondertoonel*, 2004, p. 12.

For over two decades, Jim Shaw has produced work that draws on a wide variety of visual sources, both high brow and low brow, in a range of media including painting, sculpture, photography, video, and especially drawing. He mines the detritus of American vernacular visual culture, finding inspiration in comic books, pulp novels, rock albums, protest posters, thrift store paintings and advertising. At the same time, his work enters into a dialogue with "high" art, incorporating historical and contemporary references and styles. He also looks inward, to his own life and dreams for source material. Shaw presents us with images that look familiar, though strangely altered, thereby forcing us to challenge our assumptions about contemporary visual culture.

Shaw explores these themes in series that he works on for many years, often simultaneously. *My Mirage*, a series produced between 1986 and 1991, tells the story of Billy, an average kid born in 1950s America, who serves as Shaw's alter ego. Chronicling his coming of age in the 1960s and 70s, these drawings depict a typical adolescence of this period and are rendered in an array of styles taken from the popular culture of the day.

In 1992, Shaw began creating drawings of his dreams, now numbering in the hundreds. Since these are a record of his actual dreams, their content ranges from the mundane to the fantastic, referencing comics, monsters, religion, animals, art, thrift stores, current events, and Shaw's own life and friends. Originally produced in pencil on 12 × 9 inch pieces of paper, they are divided into sections like a comic book or a storyboard and span visual styles from cartoon to hyperrealism. *The Dream Drawing* series now includes *Dream Objects* that incorporate other media such as sculpture. Shaw does not edit his dreams, but presents them matter-of-factly with all the awkwardness and strangeness that characterize his subconscious, as well as ours.

One of Shaw's most recent engagements with the myriad forms of visual culture is his creation of the religion of O-ism, complete with its history, rituals, and artistic production. "Born in the Finger Lakes Region of upstate New York in the mid 1800s," reads Shaw's origin myth, "O-ism's beliefs included the notion of a female deity, of time going backwards, spiritual transience, and a prohibition on figurative art." Presented with a good amount of irreverent humor, his O-ist works deal with this schism between representational and abstract, low and high. His source paintings for O-ist film posters feature meticulously rendered heads of O-ist leaders floating on an abstract background. He has exhibited figurative paintings as supposed remnants from O-ist thrift stores, (not surprising since he has been collecting thrift store paintings since the 1970s) and also staged an exhibition of abstract paintings from an imagined purist O-ist painter, who secretly worked as a commercial illustrator and collected volumes of images from popular sources. Instead of trying to reconcile the numerous strands of available artistic styles, Shaw celebrates the fractured nature of contemporary visual production. **M.S.**

*Dream Object
(I dreamt up an image
of a yellow walled
city with a yellow kid
sticking his finger in
the outer wall)*, 2004
acrylic on muslin,
22' × 38'
photo: Josh White

opposite:
*Dream Object
(I think I was half
awake when I thought
of this upright piano
modelled after the
cave monster from* It
Conquered the World,
*using an old piano
with keys sawed off to
make the mouth...)*,
2004
mixed media,
94" × 70" × 30"
photo: Josh White

**Dream Object
(I dreamt of this of this
movie poster painting
with overlays in the
corner), 2004**
acrylic, ink, oil crayon on
canvas with silicone and
cloth element, 60" × 80"
photo: Josh White

opposite:
**Dream Object
(I was looking through
dream drawings to
find Fodder and in
more than one found
comic book covers of
Hawkman in a sky
of green snakes & a
golden rip in the sky),
2004**
ink and gouache on
board, 21" × 16"
photo: Josh White

Text Imag

and
e

John BALDESSARI
Hillary BLEECKER
David BUNN
Mary KELLY
Raymond PETTIBON
Ed RUSCHA
Frances STARK
Wayne WHITE

John BALDESSARI

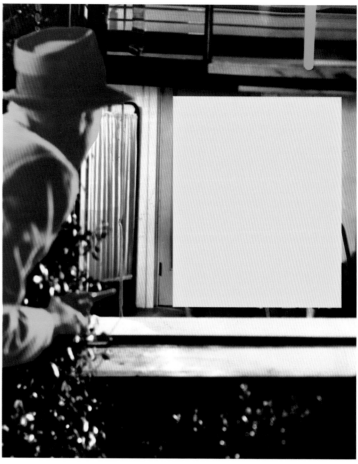

John Baldessari is a canonical figure within West Coast art and also a pivotal figure in the legacy of conceptual art from the late 1960s onwards. A prolific artist, he has worked in painting, photography and video, challenging the limits of all these areas in a distinctively deconstructive fashion. In the late 1960s Baldessari became dissatisfied with the conventions of painting and began to use language not as visual material but as actual information, producing a series of works from text-book sources on art history, how-to-paint manuals and art criticism (he directly quotes Clement Greenberg, Barbara Rose and Max Kozloff)—playing a humorous game with the pompous language of formalism in works such as *Everything is purged from the painting but Art, no ideas have entered this work*, 1967/1968.

In the early 1970s he worked primarily with video, using it to both test the barriers of philosophical-system-based art in *Teaching a Plant the Alphabet*, 1972, and as a performance documentation tool in his *I Am Making Art*, of 1971—an absurdist piece where he repeats the title's phrase while holding different bodily postures in an updated Dadaistic gesture.

As well as working with time-based media Baldessari has looked at the way television and film narrative is produced through the assemblage of familiar, recycled objects and scenarios. Using juxtaposition and free association, resembling the techniques of the Surrealists and the indeterminate strategies of John Cage, Baldessari's work from the 1980s onwards is epitomized by a balanced conflict of harmony, chaos and hilarity in photo-works that multiply, crop and obscure in order to reveal other latent narratives and implications. Drawing on photographic material from natural history to B-movie romance, Baldessari has developed a free-wheeling language of pop-conceptual imagist interventions that dissects a generation's mediated hopes and dreams and resurrects them as a patch-work quilt of obsessions, desires and motivated clichés.

His most recent work continues this strategy, with *Large Glass (Orange), and Person*, 2004, demonstrating his trademark flat-color masking of appropriated photographs, the blank spaces denying the viewer access to one level of the image (its direct original meaning), while opening a new abstract structure of associative reading. **F.S.**

left:
Eights Lines; with Persons, Black and White, 2004
digital archival print on Sintra, 138" × 22" × 2"
photo: John Berens

right:
Blockage; with Person with Gun, 2004
digital archival print with acrylic paint on Sintra, Dibond and Gatorfoam panels, 71" × 75"
photo: John Berens

opposite top:
Large Glass; And Person, 2004
digital archival print with acrylic paint on Sintra, Dibond and Gatorfoam panels, 84" × 60" × 4"
photo: John Berens

opposite bottom:
Blockage; with Person, Oar and Rope, 2004
digital archival print with acrylic paint on Sintra, Dibond and Gatorfoam panels, 71" × 106"
photo: John Berens

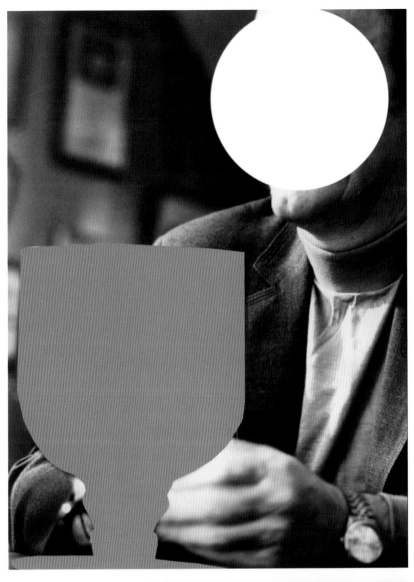

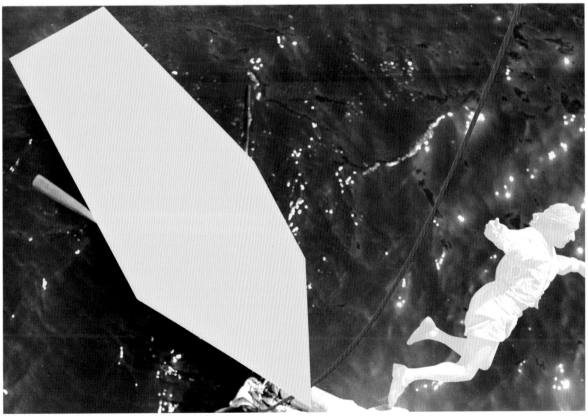

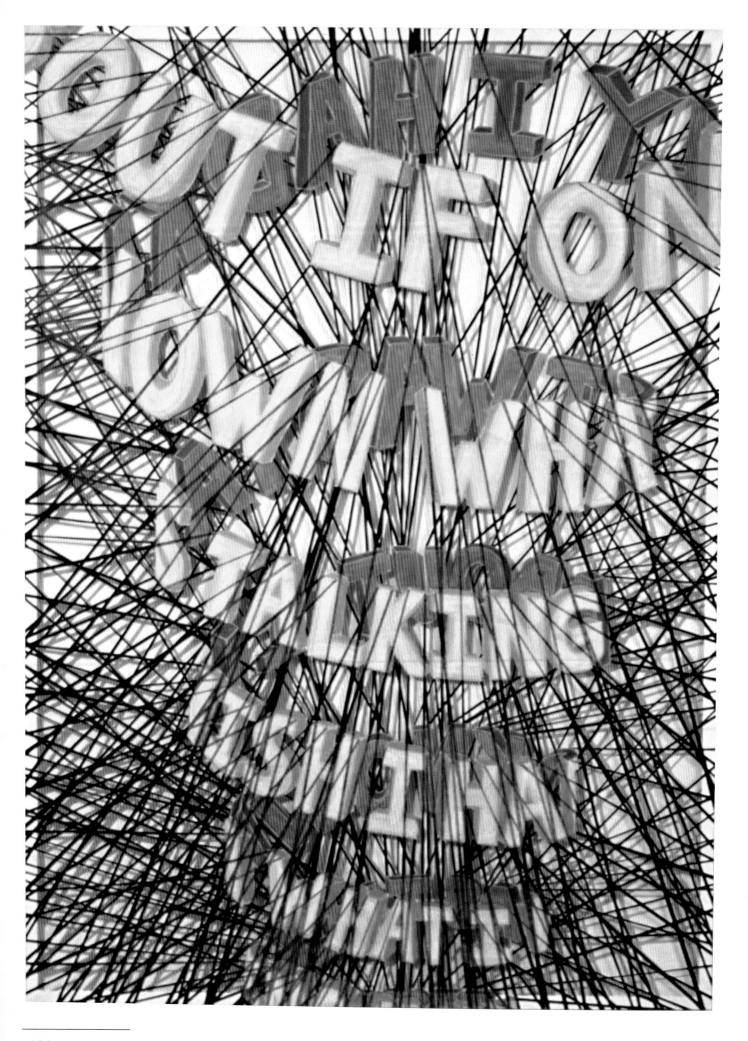

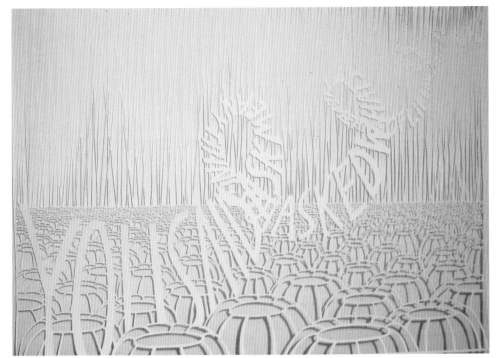

left:
The Meaning of Life,
2004
cut paper, 20" × 28"

right:
Fuck Drawing, **2004**
cut paper, 19" × 24"

opposite:
If Only, **2004**
acrylic and colored
pencil on cutout paper,
80" × 57"

The starting point for Hillary Bleecker's 2004 series of works on paper is language, be it the nagging thoughts of regret that circulate in the mind in *If Only* to the weightier philosophical question "What is the meaning of life?" The delicacy and detail with which Bleecker treats her interior monologue, by painstakingly cutting out the negative spaces around words and lines, echoes the complusiveness of the thought pattern, yet the artist finds catharsis in her practice. This is in part due to her diverting and intense creative process, but it is also because she imbues her melancholy cerebral ramblings with a sense of humor, rendering them into ephemeral and often illegible forms. Take for instance her piece *Meaning of Life*, which literally transforms the impenetrable and heavy question of how to define and value existence into a pourous sheet of paper that can just barely be read when placed against a wall, the cast shadows making visible the gaps between twisting lettering and abstract forms.

Bleecker's pieces of perforated and painted paper become objects rather than drawings. It is in this aspect of her work that she differs from the surge of contemporary artists, including LA contemporaries Russell Crotty and Nick Lowe, who use drawing as the final mode of expression. Rejecting the flatness of the medium's past, she hangs her works inches from the supporting wall. The expansive typography of *If Only*, for example, is outlined by empty spaces revealing the surface underneath that glows with a subtle orange, a reflection of the florescent hue on the back side of the paper. *Fuck Drawing*, a piece made about the sex act, expresses a frustration with the medium and demonstrates that paper can be more than a surface for sketching. **O.F.**

David BUNN

```
THE THING
THE THING
THE THING
THING, A MODERN SEARCH FOR ADVENTURE
THE THING ABOUT CLARISSA
THE THING ABOUT JOE SULLIVAN
THE THING AT THE DOOR
THE THING AT THE FOOT OF THE BED
THE THING AT THEIR HEELS
THE THING CONTAINED
THE THING DESIRED
THE THING FROM THE LAKE
THE THING IN KAT'S ATTIC
THE THING IN THE BROOK
THE THING IN THE NIGHT
THE THING IN THE WOODS
THE THING ITSELF
THE THING KING
A THING OF BEAUTY
THE THING OF IT IS
THING OF SORROW
A THING OR TWO ABOUT MUSIC
THING TO LOVE.
```

David Bunn's work is a reflection upon collecting, re-writing, authorship, and obsolescence, having focused on the deactivated card catalog of the Los Angeles Central Library since 1990. His permanent installation in the passenger elevators of the New Central Library East Wing, *A Place For Everything And Everything In Its Place*, 1993, utilizes 9,506 of the roughly seven million cards. Bunn states: "The elevators and the card catalog together form a kind of 'core sample' of the library. As the catalog dutifully classifies and finds a place for every book, so the elevators travel deep through the center of the building, encompassing and accessing all the building's holdings."[1] His work comments on the futility of any attempt on the Library's part towards completeness, not to mention accuracy in their method of classification. In subsequent chapters of this project Bunn made typewritten poems based on the archive, adding himself as an additional author held in the library's collection. Additionally he uses the cards in ways completely unrelated to their original function including emphasizing the random stains and marks found on specific cards. He scans and then enlarges these imperfections, revealing an uncanny connection between mark and text that suggest an otherworldly influence.[2]

His work later incorporated the library card catalogs of the Liverpool Central Library in a project entitled *Here, There, and Everywhere* that resulted in a limited edition artist's book, *The Sea is a Magic Carpet*, 1997. This connected Los Angeles and Liverpool through reading two distinct histories that focus on the exchange of music, using the sea as a link from shore to shore. *The Sea is a Magic Carpet* consists of four books in an edition of 100 copies that list the titles of the books held in each library about the famous musicians each city is known for ("B is for Beatles" and "D is for Doors"). **A.V.**

1 Los Angeles Public Library, 2004, www.lapl.org.
2 Bunn, David, *Subliminal Messages*, Cologne: Verlag Buchhandlung Walther König, 2003.

***The Thing (from Double Monster)*, 2000**
typewriter ink on paper,
12" × 9"

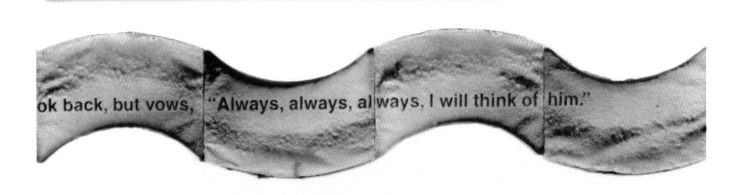

The Ballad of Kastriot Rexhepi, 2001
detail and installation view at the Santa Monica Museum of Art, Santa Monica
compressed lint, perspex, wood frame, 206'

Mary Kelly's work over the last three decades has engaged with issues of identity, memory, history and language, employing conceptual and process-based strategies to present evocative and complex installations. From her early politicized artworks such as *Women and Work: A Document on the Division of Labor in Industry*, 1975, Kelly became increasingly interested in modes of presentation, classification and documentation. Her seminal *Post-Partum Document*, 1973–1979, ensured her status in the history of both conceptual and feminist art, with her documentation of her relationship with her son Kelly from birth to his acquisition of language presenting a provocative mediation on the role of the mother, maternal fetishism and the impact of language on the development of identity.

During the 1980s Kelly continued to work on large scale installation works that combine psychoanalytic theory with a politics of representation that takes apart both visual and textual modes of expression. Works such as *Interim*, 1984–1989, combine personal texts with oblique imagery, evoking the body without ever picturing it directly, deconstructing the complex codes with which individual and collective subjectivities are held in place. During the 1990s, Kelly has worked a number of projects that consider the impact of war, starting with *Gloria Patri*, 1992, a meditation on masculinity against the background of the Gulf War. Since 1996, Kelly has utilized a technique of printing text or images onto the lint gathered on the filter in a domestic clothes dryer. The labor-intensive process of drying thousands of pounds of clothes to create these stenciled black, white and gray texts and images produces an equivalent to the constant filtering of events through the media. The small panels of lint in *The Ballad of Kastriot Rexhepi*, 2001, are joined together to form undulating waves, telling the story of a toddler in Kosovo who was twice found and abandoned, based on a story Kelly read in a newspaper. The culmination of the text recounts the boy's first word: "Bab," Albanian for Dad. In the ballad, narratives of cultural, national and individual identity are intertwined with language: both in the boy's speech, the presentation of his story in the media and his re-naming by the different parties who rescued him. By using the ballad form, Kelly's text turns this one small boy's story into a heroic and elegiac tale, critiquing the media's presentation of such human interest stories as ways to justify nationalism and war. As part of this work, Kelly commissioned the composer Michael Nyman to create a score that was performed by the soprano Sarah Leonard at the opening of the exhibition at the Santa Monica Museum of Art. By elevating this moment in a child's history, Kelly questions how our histories are recorded and remembered, examining both our individual and collective responsibilities. **C.G.**

Raymond PETTIBON

I'VE OFTEN LAMENTED AT THE THOUGHT THAT THE ART OF PAINTING IS MADE SO LITTLE USE OF TO THE IMPROVEMENT OF OUR MANNERS.

Disenchanted with the empty individualism of the 1960s but enamored of the rock subculture which that decade begot, Raymond Pettibon bubbled up into the artworld through the underground labyrinth of zines and independent record labels.

Stylistically consistent throughout his career, Pettibon works almost exclusively in ink and watercolor, churning out stacks and stacks of brushy drawings redolent of the twisted narratives of film noir and classic comic books. These images, incorporating phrases from sources literary, cinematic and imaginary, often star one of the anthropomorphic mascots Pettibon has adopted over the years, notably Gumby, from the late 1960s American claymation of that name, and Vavoom, an onomatopoetically christened character from the world of *Felix the Cat*.

A series of images from 2004 illustrates the full range of Pettibon: ironic comments on the fine arts in *Untitled (In a word)*; an improbable worst case scenario in *Untitled (The paper cut)*; a crossing of sexual desire and musings on an artist's duty in *Untitled (That which honor)*, and a comment on America's perennially poor acceptance of its citizens of African origin in *Untitled (To make him)*. Here Pettibon reflects ruefully on the inability of whites to truly accept African Americans unless they lie dead on the battlefield, drafted by circumstance into another unjust foreign conflict.

It is with his character Vavoom that Pettibon feels comfortable revealing his full range of interests, including the yearning to create enormous amounts of drama and majesty in a relatively small space. In *Untitled (In a word)*, Pettibon contrasts Vavoom's sublime, almost transcendentalist isolation with the described social life of Yorick, a character from Laurence Sterne's experimental eighteenth century novel, *Tristram Shandy*. Yorick, who Sterne claims is descended from the Yorick of Shakespeare's *Hamlet*, is as much a pop device as Andy Warhol's soap box, both being entities recontextualized to surprise the viewer and make him or her question their expectations—in this case, to subvert the stasis of literary personages. As such, his invocation, side by side with Vavoom, seems to be a meeting of two puzzling totems across centuries and art forms—a classic Pettibon conundrum. **E.L.**

Untitled (I've often lamented), **2004**
ink on paper, 15" × 22"

opposite top:
Untitled (That which honor), **2004**
ink on paper, 13" × 30"

opposite bottom:
Untitled (In a word), **2004**
ink on paper, 17" × 21"

That which honor and virtue forbade, are never far off my mind in some shape or form.

WHILE THE ARTIST HAS PAPER TO EXPRESS HIS FEELINGS AND THOUGHTS.

VA-VOOM

IN A WORD, THOUGH HE NEVER SOUGHT HIS AUDIENCE, YET AT THE SAME TIME, AS HE SELDOM SHUNNED OCCASIONS OF SAYING WHAT CAME UPPERMOST AND WITHOUT MUCH CEREMONY, HE WAS NEVER AT A LOSS FOR WORDS, THE CHANCES WERE TOO MANY, THE TEMPTATIONS TOO GREAT, OF SCATTERING HIS WIT AND HIS HUMOUR— HIS GIBES AND JESTS ABOUT HIM—THAT THEY WERE NOT LOST FOR WANT OF GATHERING, THEY CERTAINLY WERE NOT—THEY WERE EVERYWHERE.

Untitled (To Make Him Decent), 2004
ink on paper, 14" × 17"

DECENT.

Ed RUSCHA

Because I love the language. Words have temperatures to me. When they reach a certain point and become hot words, then they appeal to me... Sometimes I have a dream that if a word gets too hot and too appealing, it will boil apart, and I won't be able to read or think of it. Usually I catch them before they get too hot.
–Ed Ruscha[1]

Known for his bold and playful use of iconic imagery and words, and for his systematic documentation of the LA urban landscape, Edward Ruscha is widely recognized as one of the most important American artists of his generation. His career defies easy categorization, spanning photography, drawing, painting and film.

In a series of "artist's books" produced in the 1960s and 1970s, he recorded the desolate roadside architecture of Southern California, using dramatic diagonals and bold composition. Celebrating the overlooked accretions of big-city sprawl, books named *Every Building on the Sunset Strip*, 1966, and *Thirtyfour Parking Lots in Los Angeles*, 1967, delivered exactly what they promised. Wordless narratives, ripe in dark humor and photographed starkly with a snapshot aesthetic, they were pivotal in the development of both pop art and conceptualism.

In the late 1960s, making a bold conceptual move, Ruscha started to paint words and phrases. Using non-traditional materials such as gunpowder, he created deadpan and demotic works such as *Lisp, Rancho* and *Pool*—each word painted, says the artist, "like flowers in a vase; I just happened to paint words like someone else paints flowers."[2]

Isolated on the canvas and stripped of their usual context, Ruscha's "liquid word" pieces are nevertheless rich in subtext and evocation. They can be approached as pictorial forms, typographic objects or semantic units of meaning, but it's the way in which these different modes of perception rub up against each other that gives them their force. A 2004 series of paintings depicts the words "The End" against scratched, acetate-like backgrounds reminiscent of old film reels. The phrase itself, rendered in various typefaces suggestive of old westerns or Gothic horror movies, is a deadpan reminder of the historic punchline to countless cinematic experiences, as well as an apocalyptic provocation that could come straight out of modern Hollywood's disaster-fixated movie industry. **G.S.**

1 Pindell, Howardena, "Words with Ruscha," *Print Collector's Newsletter 3*, no. 6, January–February, 1973, p. 126; reprinted in *Leave Any Information at the Signal*, ed. Alexandra Schwartz, Cambridge: MIT Press, 2002, pp. 55–63.
2 Ruscha, Ed, quoted in Kathan Brown's *Ink, Paper, Metal, Wood: Painters and Sculptors at Crown Point Press*, San Francisco: Chronicle Books, 1996, p. 112.

Scratches on Film, **1968**
acrylic on canvas,
36" × 72"
Collection of the North Carolina Museum of Art, Raleigh, Art Trust Fund

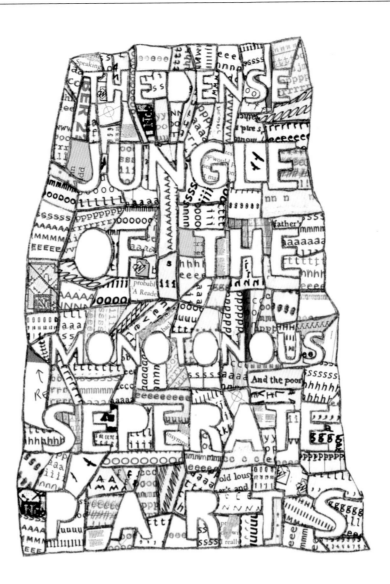

*The Dense Jungle
of the Monotonous
Seperate [sic] Parts,*
2004
carbon/ink on paper,
11" × 8 ½"

Frances Stark's works on paper pay homage to paperwork. The flotsam of an office becomes concrete poetry as junk mail and invitation cards find their way into her drawings, while her collages of the last ten years have elevated everyday ephemera into poignant images. Delicately shaped scraps are adorned with found text from a wide variety of sources including Emily Dickinson, the Beatles, and Goethe. Strings of repeated letters and numbers are carbon-transferred onto small pieces of paper, and then assembled into flowers, branches, words, birds, or even the shape of the United States. The relationship between these parts and their larger conglomeration is unmistakable in *In-box*, 2004, in which words and bits of data combine to form an in-box piled high with paper.

Like fellow Los Angeles-based artists Ed Ruscha and Raymond Pettibon, language is central to Stark's creative endeavor. All three employ brief enigmatic phrases that call a picture's meaning into question. Pettibon's and Stark's work investigates the relationship between image and text, and the differences between visual and verbal narrative. Moreover, Stark was featured in a film by Raymond Pettibon in the role of Yoko Ono. This humorous casting choice connects Stark with Yoko Ono's linguistic experiments of the Fluxus movement.

Many of Stark's works contain evocative phrases that point toward but do not directly reveal their meaning, such as "The Furniture Of My Mind Is All Undusted Still." There is often a tension between the repetition of a single letter or number and a more resolved image. This tendency is particularly evident in *The Dense Jungle of the Monotonous Seperate [sic] Parts*, 2004, in which the artist provides a glimpse into her working process of accumulation arrangement. The words drawn, surrounded by bits and pieces of repeating letters, become a patchwork quilt of color and line. Each individual part is monotonous, but together they form a dense jungle which congeals into an intriguing whole. Finally, we see the forest for the T's the R's the E's the E's and the S's. **M.M.**

Wayne WHITE

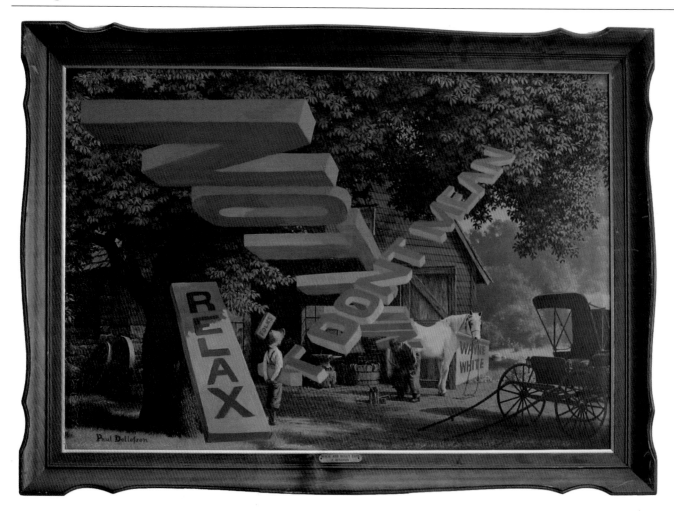

Wayne White works as a painter and sculptor, often incorporating pastoral landscapes with his own blend of absurdist humor—the idyllic and the surreal. White alters thrift store lithographs of landscapes by painting three-dimensional text into the scenes and assembling the finished works as diptychs or triptychs. Using single sentences to suggest larger, and as yet unknown, narratives with titles such as *All My People Sleep In A Mountain*, 2005, and *They Used to Put Me Down In The Seventies*, 2005, White hints at a bizarre present and past that unfolds as the text is read in relation to the landscape. Dominating the paintings, the letter-forms share much of the original lighting or detail that may have been given to the trees, sky and water—in *The Big Dangerous Baby*, 2005, the text casts a shadow on a beach lit by the rising sun. The text in White's earlier paintings was often readable, moving along a horizon or space already established in the original lithograph, the title repeated within the landscape. His current work is predominantly illegible, containing words that exist as more of a presence, shapes that expand and twist around one another, suspended.

In May through June 2005, The Western Project Gallery presented a solo show in Culver City, CA of Wayne's altered lithograph paintings entitled *Organic Remains of a Former World*. The title offers White's own remaking of the past both through his repeated use of mass produced material on which to paint his text and his own tweaked interpretations of history and Americana also present in his sculptures—elaborate, animated diorama constructions. His use of titles as ongoing narratives thus refers to both the nature of his chosen medium and the setting he intends to create for the work itself. This process of naming to selectively control elements of a work is most evident in *Southern Daddy Shame Ray*, 2004; a six foot tall round black box containing a coin-operated tableau with the title painted across the exterior. The title refers to a "look of judgment" that may come from any number of Southern male authority figures evoking in the recipient a feeling of either guilt or pride, and also applies to the role of the viewer in looking at the artwork. **A.V.**

Relax Folks It Don't Mean Nothing, 2004
acrylic on offset lithograph, framed, 29" × 40"

opposite top:
Big Dangerous Baby, 2005
acrylic on offset lithograph, framed, 28" × 44"

opposite bottom:
Then You Just Don't Get It and You Never Will Look, 2004
acrylic on offset lithograph, framed, 25 ½" × 52"

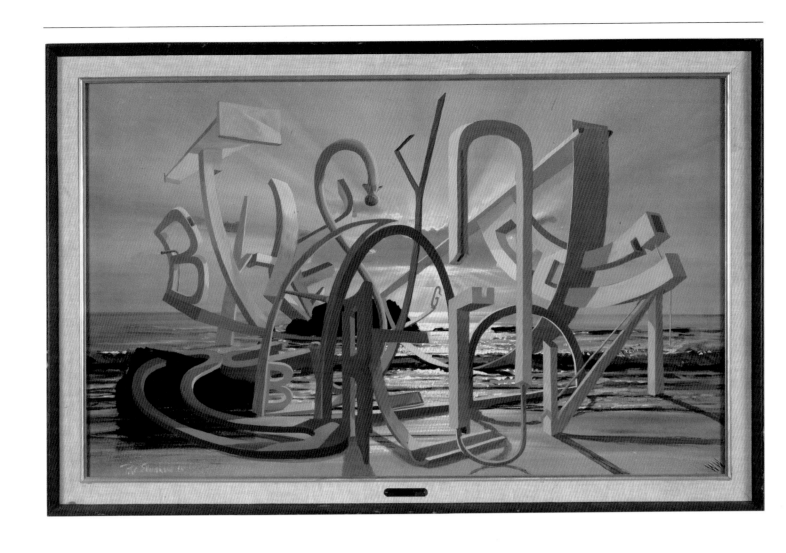

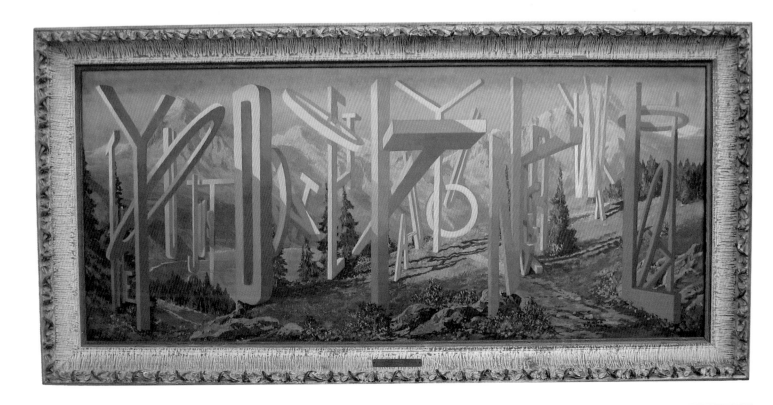

Constructing Identities

Amy ADLER
Delia BROWN
Jeff BURTON
Sharon LOCKHART
Daniel MARLOS
Catherine OPIE
Dean SAMESHIMA
Ed TEMPLETON
Kerry TRIBE

Amy ADLER

Amy Adler's technique of destroying the drawing and negative that her photographs are based on has provided the conceptual framework for much of her practice since the mid 1990s. The process behind her unique cibachrome prints is one in which an aggressive act of destruction follows the slavish attention needed to render the initial photographs in her generic, but distinctive style in pastels or pencil. Early series focused on Adler's own photographic archive, with the disturbing *What happened to Amy?*, 1996, and *Once in Love With Amy*, 1997, depicting the artist as a child and a teenager respectively. Her face becomes familiar when looking across her work, as her depiction of celebrities including Jodie Foster and River Phoenix have an uncanny similarity to her self-portraits. In 1999 Adler undertook a shoot with the teen idol Leonardo di Caprio, with the resulting series of pastel drawings turned into photographs titled *Amy Adler Photographs Leonardo di Caprio*. This prosaic explanation of the project points to the importance of the artist photographing, as much as the actor being photographed.

Recently, Adler has begun to explore painting, making works on canvas that are displayed as small series, appearing almost as disjunctive frames of film. In the series *Virgin Sacrifice*, 2004, Adler returns to her own photographic archive, reproducing images of herself and a friend as teenagers, dressed up in Gothic make-up, mugging for the camera. The desiring gaze of the young Adler draws attention to the sexual element of her work, from the ambiguously sexual actors she chooses to draw, to her centerfold for *Artforum* in 2003, which shows the artist naked, stroking her cat. Her centerfold series includes a number of tongue in cheek images of the artist semi-naked, referencing both softcore porn and Cindy Sherman's centerfolds from the mid 1980s.

Adler draws on media images that are selected for their mobility, appropriated in the manner of artists such as Richard Prince in the resignification of their apparently bland press material. Adler's position within the making of these images, as a fan obsessively redrawing a magazine photograph, is formalized in the process of destroying the image. In her paintings, Adler moves away from the process behind the final image and engages more with the narrative presented within the work, one that moves between her personal history, the cult of celebrity and the presentation of the self for the camera. **C.G.**

left and right:
Virgin Sacrifice, **2004**
acrylic on canvas,
30" × 40"

opposite top:
Centerfold, **2002**
cibachrome print,
48" × 82"

opposite bottom:
Centerfold, **2002**
cibachrome print,
48" × 96"

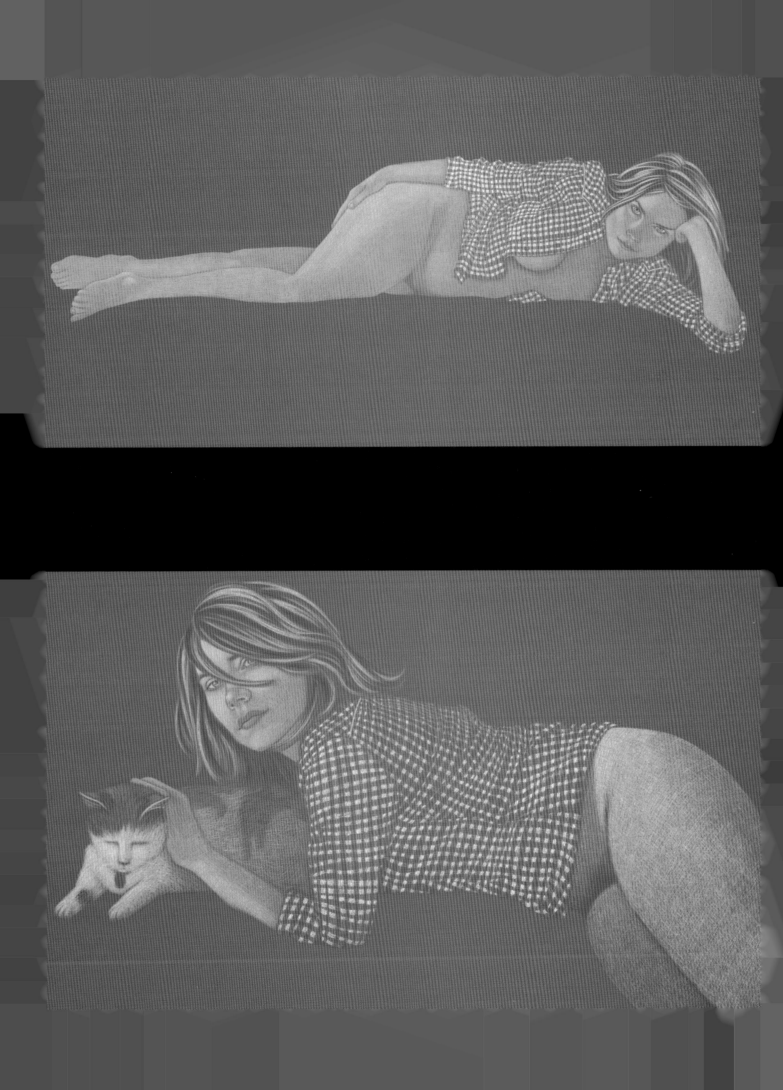

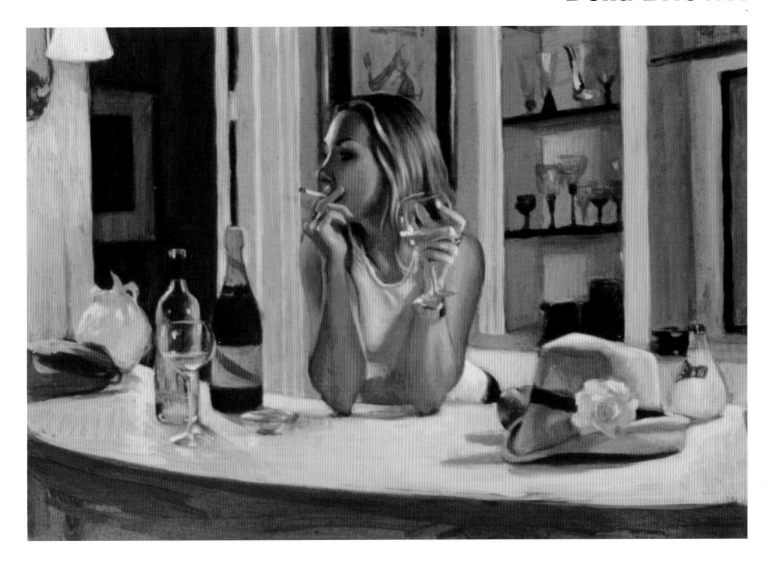

Delia Brown leaped to fame in 2000 when, just after graduating from the esteemed MFA program at UCLA, she landed her debut exhibition at D'Amelio Terras in New York entitled *What, Are You Jealous?*. In the series of oil paintings and watercolors that she presented, titled slyly after an 1892 Gauguin work of the same name, Brown depicts herself and friends sitting poolside and topless soaking up the California rays, "dripping with bling."[1] Conjured up scenes of the young, wealthy and restless quickly became the most well known trope of her early work. In subsequent exhibitions, whether representing herself poised at decadent VIP coke parties, or lounging comfortably at home as the daughter of her LA gallerist, Margo Leavin, Brown's witty self-conscious parody of envy and exclusion is over-the-top and in your face. She fleshes out her provocative fantasies in paint, taking an ironic stance on the vacuous superficiality of both the Hollywood dream and many artists' artworld ambitions. At first glance these images seem bold and blatant, but are in fact charged with the subtleties of awkward human interaction in addition to being equipped with discreet art historical references.

Brown's place and identity as a painter (within the continuum of art history) seems to be an increasing concern of her current work, despite her recent foray into filmmaking with *Pastorale*, 2002. Her series of easel-scale oil paintings from 2004 play with the historical conventions of portraiture, still life and interiors and draw attention to her skillful prowess as a figurative painter. Depicting herself in a paint-splattered tank top and jeans, staring out confrontationally at the viewer from the confines of her white-walled studio, in the cleverly titled *Blank Canvas*, 2004, Brown demands the viewer to question this representation of her self along with all the others she previously provided. In her 2005 exhibition at Galerie Emmanuel Perrotin in Paris, she turned the gallery into a functional studio. Making public the acts normally confined to isolation, including her relationship to her models as she paints them, Brown offers an even more intimate glimpse of herself in the role of "Painter." **O.F.**

Leisa Behind Bar,
2002
acrylic on board, 7" × 10"

opposite:
Blank Canvas, 2004
oil on linen, 42" × 40"

1 Gell, Aaron, "Bad Bad Delia Brown," *Elle*, December, 2004, p. 72.

Jeff BURTON

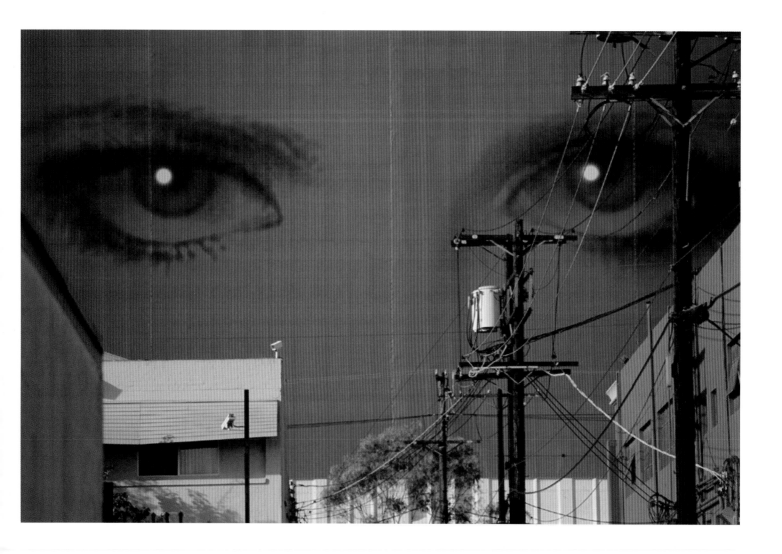

The porn industry is as much part of the Los Angeles film scene as Hollywood, and is the "dreamland" in which Jeff Burton has been making his photographs since the mid 90s. Stemming from his job as a stills photographer on porn sets, Burton's photographs are both seductive and surprising. By focusing on details—discarded clothing, kitschy mirrors and knick knacks, odd parts of the actors limbs—he creates photographs that appear to be fragments of narratives, dreamlike combinations of objects and bodies. In his recent photographs, sex acts are the blurred backdrop to foreground mundane details, as in *Untitled No. 176 (rods and clamps)*, 2003, where a constellation of clamps used for holding backdrops in place frame two men having sex.

Burton is interested in breaking down the barriers between fine art, fashion and pornography, with his photographs creating a vocabulary that explores the desire and fantasies promoted by both the porn industry and Los Angeles in general. Accompanying his shots from porn sets are landscapes from around Hollywood, with the Hollywood sign itself being a reoccurring motif in his work. Whether barely visible in the background to a shot of a graveyard, to its iconic form dissolving in an inked up plate ready to be printed, Burton is interested in what Hollywood signifies in everyday situations. Burton's landscapes, such as the surreal close up of Buffy's eyes from a huge poster, dwarfing the houses and telegraph poles before it, seem to present fantasies come to life, so that the mundane becomes extraordinary, and the exotic is made banal. When seen in series, the glamour of a sequin curtain reflected in a pool echoes with the sequins on an actress's revealing top, so that the scenes from which these fragments are shot multiply in the viewer's mind. **C.G.**

*Untitled No. 172
(Buffy's eyes)*, **2003**
cibachrome print,
27" × 40"

opposite:
*Untitled No. 176 (rods
and clamps)*, **2003**
cibachrome print,
27" × 40"

overleaf:
*Untitled No. 175
(Hollywood od)*, **2003**
cibachrome print,
27" × 40"

Sharon LOCKHART

After graduating from Art Center College, Pasadena, in 1993, Lockhart began to make highly detailed photographic portraits, incorporating the clinical gaze of medical photography within the conventions of the portrait. One of her first films, *Khalil, Shaun, A Woman Under the Influence*, 1994, featured a boy on whose body lesions bloom before the camera, transitioning from medical ailment to horror movie sequence. The *Audition* series, also from 1994, continued her exploration of documentary and staged encounters, in which she asked pairs of young children to enact a first kiss taken from a scene in Francois Truffaut's *L'argent de poche* (*Small Change*), 1976. While enacting the film scene, the photographs also document the children's awkwardness in performing the intimate encounter.

Lockhart's most well-known body of work is *Goshogaoka Girls Basketball Team*, from 1997, which consists of a suite of photographs and a 60 minute film. Choreographed movements of a Japanese girls' basketball team are recorded before the camera, as their gymnasium becomes a theater, their movements somewhere between minimalist dance and "real" basketball moves. In the accompanying photographs the girls were encouraged by Lockhart to take up positions of their basketball idols, again occupying an uneasy balance between documentary reportage and staged fantasy. Lockhart is interested in anthropology and the documentary gaze, often taking small moments from film or art history as a way into a collaboration with her subjects. Working with her teenage subjects in the Japanese school, Lockhart was interested in the way in which basketball signified as "American" as well as considering the ways in which narratives of orientalism would be contained by the stylized dance sequences.

In her 1999 project *Teatro Amazonas*, Lockhart created an audience in the Teatro Amazonas opera house in Manaus that accurately represented the city's population. She then filmed the audience, with the accompanying score climaxing in silence—so the viewer is left looking at the audience, the sounds of their shuffling and whispering the focus of attention. In recent years Lockhart has continued to explore the interface between documentary and art history, including photographic series taken in art galleries, with attendants and technicians appearing as if they themselves were the artworks. **C.G.**

Teatro Amazonas,
1999
35mm film, color/Dolby
SR sound, 39:59 minutes

opposite top:
***Audition Three,
Amalia and Kirk,* 1994**
ektacolor print, 48" × 60"

opposite bottom:
***Audition Four,
Kathleen and Max,* 1994**
ektacolor print, 48" × 60"

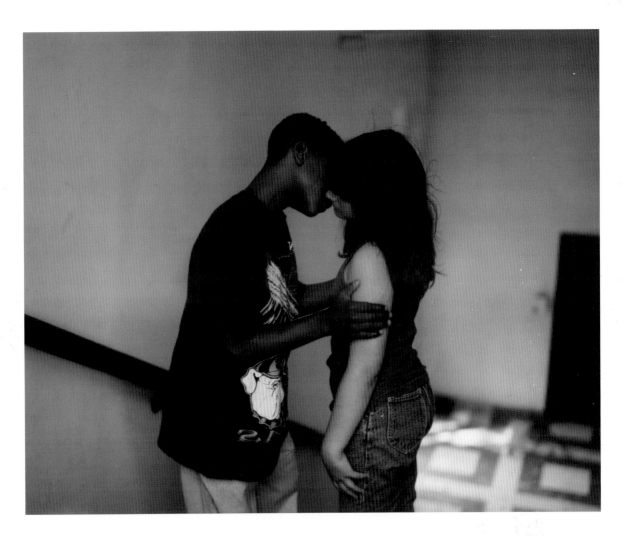

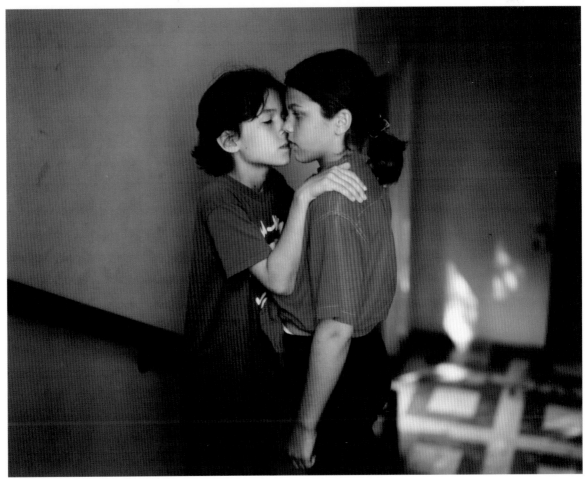

Daniel MARLOS

Daniel Marlos has been pointing his camera at the people and places of Los Angeles for nearly 25 years. For his mammoth project entitled *Timeline*, which is still in progress, Marlos constructed a portrait of the city and its inhabitants, a meditation on contrast, difference, the diversity of architecture and people as well as an attempt or organize the seemingly endless sprawl of the metropolitan area. It is a series of diptychs, each one consisting of a photograph of a person and another of a location that bears a house number corresponding to every year since the city's foundation in 1781 to the present day. In its final presentation, photographic pairs are presented linearly along the gallery walls in date order from 1781 to 2005, not chronologically in that they do not reflect the order they were actually taken. Marlos incorporates many of the shortcuts, mistakes and anomalies that occurred while attempting to create this numerical archive:

> *1861 appears twice, once right-side-up and once up-side-down, because the project was extended beyond the original plan to be a millennium project on the twentieth century. Once the camera malfunctioned, but the mistake is included, allowing the diptych to extend beyond the parameters of a single frame.*[1]

Because of these tactics and blunders, Marlos has been dubbed "The World's Sloppiest Structuralist," an appellation he embraces.

Marlos's 1997 installation, entitled *Rudimentary Particles*, named after the building blocks of speech, is a photographic exploration of language and a reflection on the subtle fallibility of the medium of film, specifically what is lost in between frames. The piece consists of kinetic sculptures of four alphabets: English (*The Alphabet*), Spanish (*El Alfabeto*), Norwegian (*Alfabetet*) and Japanese (*Hiragana*) as well as framed photographic pieces that accompany them. The photographs are of the eyes and mouths of people sounding out each sound in their native tongue's alphabet. These are framed in holders reminiscent of old-fashioned kinoscopes and when they are rotated the "it becomes animated, recreating the illusion of the motion that still photography has removed from life's experience." **O.F.**

The Alphabet, 1997
chromogenic contact print
5 ½" × 54"

opposite top:
El Alphabeto, 1997
kinetic photo-based
sculpture, 10" × 9" × 8"

opposite bottom:
Timeline, 2001
installation at LACE,
Los Angeles

1 All quotes are from Daniel Marlos's 2005 artist's statement.

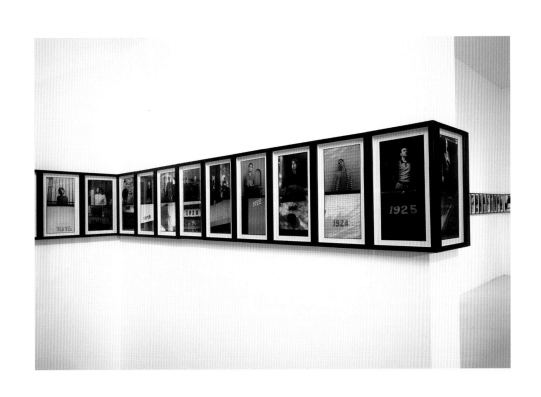

Catherine OPIE

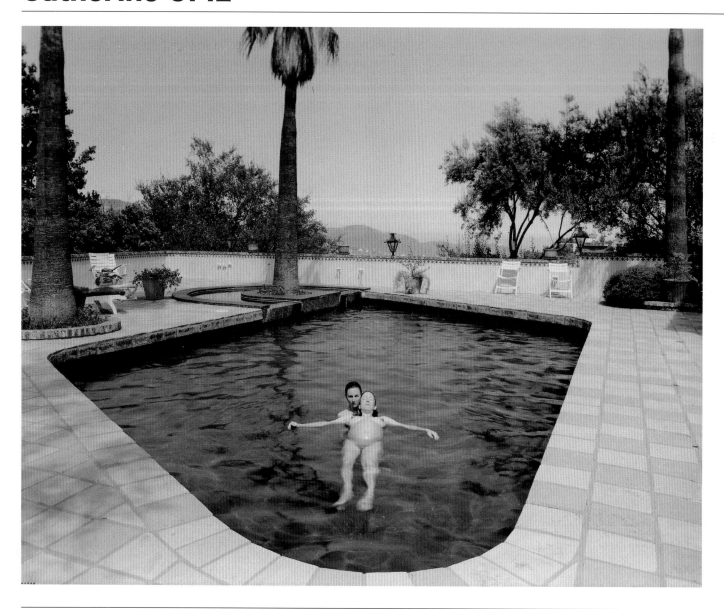

Catherine Opie gained international success in the early 90s with her lush portraits of her friends and acquaintances in the leather and queer communities of San Francisco and Los Angeles. Drawing on her training as a documentary photographer, Opie's portraits have an opulence and grandeur that echo the formal beauty of Robert Mapplethorpe's photographs, with her subjects staring back at the viewer, posed against Opie's signature colored backgrounds.

In her subsequent work, Opie has combined a more naturalistic style of documentary with landscape photography, including her series on lesbian families, from 1999, for which she travelled around America in an RV for two months, taking large scale color portraits of the families she visited, combining these with still lives of her subjects' domestic interiors. Opie has completed a number of projects that expand on her interest in American architecture and its influence on cultural identity, including her series on freeways, 1994–1995, turning this everyday architecture into poetic, abstracted compositions; brightly colored, sprawling Los Angeles mini-malls, 1997–1998; deserted images of Wall Street, 2001, and her work in Minnesota on two very different architectural environments, entitled *Skyways and Icehouses*, 2000–2001.

Opie sees this work as part of a wider documentary project, continuing concerns with the American landscape and the creation of communities that she began to explore in her graduate work, following on from great documentary photographers such as Lewis Hine, Walker Evans and Berenice Abbott. In her project on surfers, Opie traveled up and down the West Coast, taking photographs of the surfers on the sea, imaged not as sexy hunks catching the waves, but as small, indistinct figures adrift in the blue grey water. Opie then paired these minimal seascapes with portraits of surfers, who stare dreamily into her camera, dripping wet after emerging from the grey sea framed behind them. Recently, Opie has returned to her earlier studio format for a series of photographs of children, re-introducing her iconic colored backgrounds to situate these intimate, hyper realistic portraits. **C.G.**

Miggi & Ilene, **2003**
chromogenic print,
40" × 50"

opposite:
Jesse, **2004**
chromogenic print,
20" × 16"

overleaf left:
Nick, **2003**
chromogenic print,
31" × 24"

overleaf right:
Untitled 13 (surfers),
2003
chromogenic print,
51" × 41"

Dean SAMESHIMA

Dean Sameshima belongs to a current generation of photographers who combine sexy conceptualism with frottage politics—using in particular appropriation and seriality—in order to explore sexual desire and underground culture. As much informed by the West Coast photographic practice of John Baldessari and Catherine Opie as by the provocative writings of Michel Foucault and Ronald Camus, Sameshima sidesteps the modernist reverence for originality and flouts puritanical dogma by asserting a specifically queer way of borrowing and re-presenting images. Though Andy Warhol, Richard Prince and even Sherrie Levine may seem like obvious precursors, Sameshima's found pop pictures are neither peppy nor cold. They are not self-consciously critical of art canons and media theories either; his concern is of a more perverse but highly coded language. In the past he has re-photographed images culled from fashion magazines and appropriated "self-portraits" from amateur websites.

In his first UK solo show at Alison Jaques Gallery in 2004 which referred to John Rechy's *The Sexual Outlaw*, 1977—a book that recounted the author's three-day sex binge in LA—Sameshima presented two groups of work further continuing his interest in the notion of a specifically gay sexual dialect. In the first series entitled *Deaf Dude*, the voice's obliteration in the deaf guy echo the interesting paradox in which the mainstream gay culture has come into widespread social acceptance while the queer outsider gets silenced—a silence multiplied by re-photographing the image of a deaf gay man from an 80s softcore porn magazine. While a certain melancholia is apparent in the subject-image, his use of sign language for homosexual purposes (signs include "asshole" and "blowjob") is a glorious indication of possible resistance to normative behavior and surveillance. In the second series, the artist again explores the impending disappearance of queer spaces and sexual banditry as evidenced by the closure of several local gay establishments as well as "no cruising" signs plastered around the area. *Gauntlet II* is a group of photographs depicting an LA leather bar shot in daylight in order to show the seeming banality and normalcy of the space. **Y.B.**

Gauntlet II (O Daddy), **2003**
from *Outlaw*
c-type print, 16" × 19"

opposite from left to right:
Deaf Dude, **2003**
from *Outlaw*
Fuji-Flex prints,
14" × 11"

Untitled (Testicles);
Untitled (Mutual Blow Job);
Untitled (Mutual Masturbation);
Untitled (Penis);
Untitled (Screwing);
Untitled (Climax);
Untitled (Erection);
Untitled (Well Hung);
Untitled (Blow Job)

Ed TEMPLETON

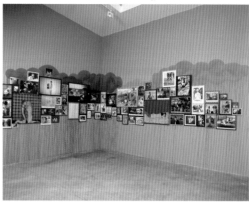

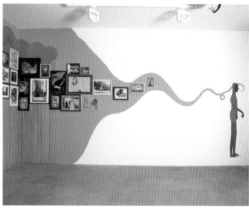

Outside of the artworld, Ed Templeton is well known as a pro skateboarder, running the Toy Machine Bloodsucking Skateboard Company. Since 1990, Templeton has made graphics for skateboards, becoming more involved in artmaking since the mid 90s, mixing his paintings with photography and text. His installations are like a teenager's bedroom, with sketchbook drawings, photographs and stories chaotically spilling over the gallery wall. Templeton incorporates the individual elements into one sprawling collage that flows around the viewer, binding the disparate media with wall drawings and the repetition of scenes from his life and the people around him. This approach to the gallery is shared by a number of other artists coming from skate and graffiti scenes in and around LA, such as Barry McGee or Chris Johanson. In recent years their cool outsider art has been embraced by the contemporary artworld, with exhibitions such as Jeffrey Deitch's *Session the Bowl* show in New York, where a skate bowl was the central attraction.

Templeton has predictably been compared to Larry Clark and Nan Goldin, due to the autobiographical nature of his work and the incorporation of the people around him into his art, and Templeton himself acknowledges the importance of Clark's book *Teenage Lust*. Templeton's book *Teenage Smokers*, 2000, is indicative of his straightforward approach—the book presents portraits of young kids smoking, with the repetition of the subject matter lending a certain pathos to the cool poses and stares of these tiny rebels with attitude. Now in his early 30s, Templeton is growing away from his teenage subjects, but he still enjoys the access to a younger generation that his skate graphics give him. As the artworld continues to embrace his slacker subjects and low-fi compilations of images, it appears that Templeton is managing to successfully combine his dual roles as pro skateboarder and new generation outsider artist. **C.G.**

The Judas Goat, **2005**
installation at Modern Art, London, UK
mixed media, dimensions vary

Kerry Tribe works mainly with video, film and installation, exploring the relationship between subjectivity and representation. She investigates the gray area between the authentic and the scripted, the collective and the idiosyncratic. For her single channel video work *Double*, 2001, Tribe confronted how she is perceived by others. She placed an advertisement for actresses that fit her physical description, inviting them to audition to play the role of "video artist." Providing the actresses with personal information, ranging from her first impressions of Los Angeles to autobiographical details about her background and family, as well as the concepts behind her current art project, Tribe asked the actresses to play her on camera. The resulting documentary style monologues form a uniquely self-conscious self-portrait presenting the artist's identity as interpreted by the actresses including whatever stereotypes they associated with the role of "video artist." Tribe herself never appears in the final video, rather she presents her life and work as they are interpreted by others, calling attention to the chasm between authenticity and performance.

For her 2002 piece *Here and Elsewhere*—a video installation consisting of two synchronized videos projected side by side—Tribe transforms a conversation between the British film critic Peter Wollen and his ten-year-old daughter, Audrey, into a meditation on memory, history and desire. From off screen the father interrogates Audrey with existential questions loosely based on Jean Luc Godard and Anne Marie Miéville's 1978 video series *FRANCE/TOUR/DETOUR/DEUX/ENFANTS*. As the interview unfolds, with Audrey offering unscripted answers, we see images of her in two separate but aligned projections. This format "serve[s] as a structural score for ideas addressed… such that the continuity, friction, gaps and overlaps that result from their simultaneity underscore the girl's desire to speak a coherent articulation of time, space, image and identity."[1] Through this crossover experiment between documentary and fiction, the artist presents us with a character whose indeterminate innocence challenges our certainty of whether she being herself or acting out a role. These very questions about the nature of identity are again emphasized

top:
Here & Elsewhere, 2002
stills from an installation

Build
the
Absu

Liz **CRAFT**
Meg **CRANSTON**
Evan **HOLLOWAY**
Terence **KOH**
Liz **LARNER**
Jennifer **PASTOR**
John **PYLYPCHUCK**
Jason **RHOADES**
Shirley **TSE**

Liz CRAFT

Liz Craft's sculptures are fantastical creations, melded from an array of Californian influences including hippie culture, psychedelia and cowboys, alongside more generic fairy tale fare, including mutant bodies, witches, unicorns and dwarves. Often related to the earlier scatological sculptures of Paul McCarthy, in Craft's work an iconography of the female body takes the gross-out factor in a new direction—with her scrawnily sexual *Venice Witch*, 2003, or her semi-self portrait *Foxy Lady*, 1999; a multi-limbed dog-woman whose leash becomes a magical lasso appearing to define both time and space.

Craft works in a variety of media, from realistically painted fiberglass, to found objects worked into complex installations, to the most traditional of sculptural formats: bronze. Whereas the subject matter of her work appears to be culled from dreams, hallucinations and the drugged out street culture of Venice Beach, her technique is glossy and perfectionist, a Disney-esque rendering of the underbelly of the Hollywood dream. Craft's sculptural characters appear as if they have been conjured from an aggressive, freaked out brainstorm, with her 2002 exhibition *A Real Mother For Ya*, in London, bringing together a bronze motorbike made of desert flotsam, a skeleton rider, a treasure map showing the journey from LA, and a private view card depicting the artist astride the plaster cast of the motorbike, wearing a Native American costume and a seductive, challenging look. The conflation of icons—from the machismo of the cowboy, to grand equestrian sculptures cast in bronze, to fantasies of sexually easy biker chicks juxtaposed with some kind of cute Native American character—render a narrative around national and sexual identities that finds an equivalent in the work of Sarah Lucas. Both artists use their specific milieu combined with broader cultural fantasies to create comic, frightening tableaux that challenge both their viewer and the homogeny of international biennial style art. **C.G.**

Treasure Chest, **2002**
wood, steel, leather,
plaster, bronze, velvet,
43" × 33" × 41"

opposite top:
The Pony, **2003**
wood, steel, leather,
plaster, bronze, velvet,
43" × 33" × 41"

opposite middle:
Venice Witch, **2003**
bronze, stainless steel
and Venetian beads,
63" × 16" × 84"

opposite bottom:
Venice Witch, **2003**
detail

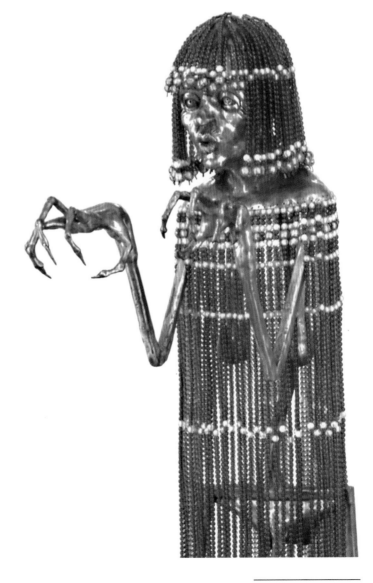

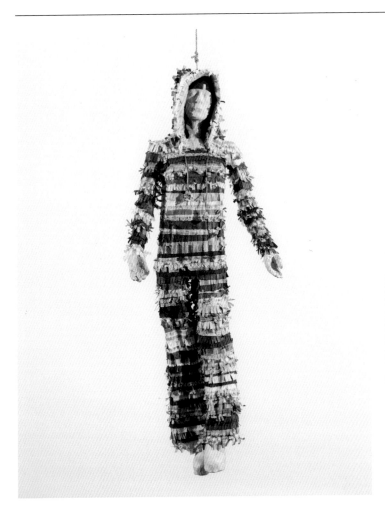

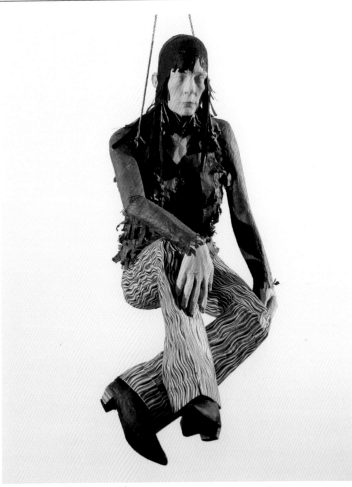

Magical Death (with open arms, 2003
papier mâchè, paper,
74" × 34" × 48"

Magical Death (with striped pants), 2003
papier mâchè, paper,
74" × 34" × 32"

opposite top left:
Yellow Donkey, 1999
papier mâchè,
68" × 30" × 39"

opposite top right:
Blueberry Hill, 2002
papier mâchè, paper,
20' × 18'
photo: Doug Parker Studio

opposite bottom:
Volcano, Trash and Ice Cream, 2005
paper, video, 15' × 25'
photo: Robert Wedemeyer

Meg Cranston is a writer, sculptor, painter and performance artist. Originally trained as an anthropologist, her work is influenced not only by aspects of ethnography (namely how artefacts can be read differently according to their cultural setting) but also by the way in which scientists make assumptions about societies based on groupings of objects. Her 2002 work *Magical Death*, for example—which featured five life-sized piñatas, manufactured in Guadalajara, Mexico, and modelled in her own image (all sporting her signature bangs and long dark hair)—is a "rehearsal for death" influenced by Napoleon Chagon's film about the Yanomamo Indians.[1] These sculptures, hung in the gallery, implore the audience to batter and destroy both the work and, ultimately, herself, in an attempt to experience first hand the rejuvenating effects of the shamanic ritual.

Her hand-made sculptures, which have been a major strand in her diverse practice of recent years, are built out of chicken wire and newspaper, often gaudily painted in the manner of a school art project. These deceptively simple objects continue the double take that can be found across her practice, as meaning is twisted and represented in humorous and critical ways, as in a hot air balloon filled with the amount of air that would be required to recite the entire works of Jane Austen or *Palace of Olympus*, 1994, when Cranston transported some snow from the top of Mount Olympus, allowing it to melt into containers to become disappointingly normal looking water. Cranston has also curated exhibitions which reflect her interest in listing and categorizing, often to absurd levels, as with *100 Artists See God*, traveling 2004–2006, which was co-curated by John Baldessari, and invited 100 artists to present their image of the divine. **J.B.**

1 From an interview with Meg Cranston by Sara Cembalisty, www.uniteddivas.com/meginterview.html.

Evan HOLLOWAY

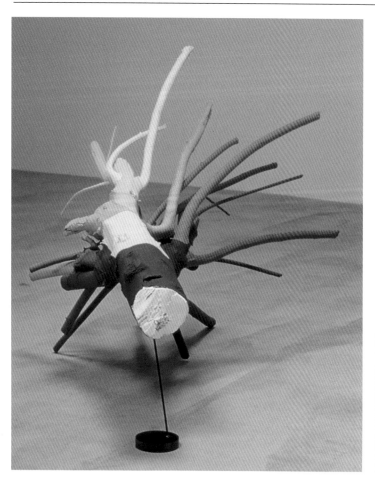

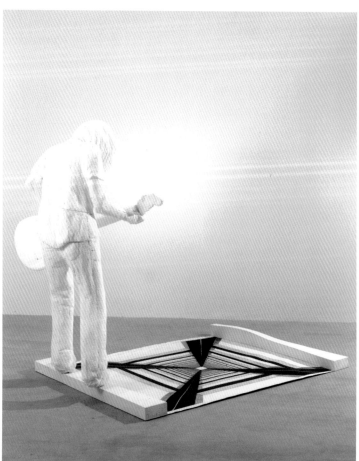

The playfully manipulated sculptures of Evan Holloway navigate a course through recent art history and idiosyncratic pop culture references. Holloway offers a kind of renegade hospitality or small utopic gesture that encourages an informal interdependency between object and viewer, rewarding assiduous looking with surprising details. Color codes, for example, appear in various combinations from one work to the next, suggesting almost, but not quite, a rainbow. In the sculpture *Color Stick Theory*, 2000, tree branches are painted with a color spectrum, warm tones on the branches of one side of the trunk, cool ones on the other, creating a semi-functional color wheel or a cataloged anatomy of a tree branch.

Holloway uses loose frameworks from which he plots a way through a mesh of formalism and figuration, modernism and the corporeal. Like the title of his recent show at the Approach gallery in London, Holloway is resolutely part of the *Analog Counterrevolution*. His manipulations of nature and artifice, seek in part to re-examine the way we relate to the dichotomous forces of the formal and the organic, the urban and the natural. He asserts the primacy of the physical over the purely information based, the digital. Batteries are rendered redundant, imbedded in plaster in *Power*, 2004, leaking a toxic residue, staining the whiteness of the plaster.

The chain of production is another recurring theme in Holloway's work. *Capital*, 2005, features a large group of naked people linked together in a hierarchical tree of excretion and consumption that is almost Swiftian in its satire. In *Equity*, 2004, a similar group of figurines form a three layer latticework cube. Yet another piece, *The Sculpture That Goes With the Bank*, 2001, is poking fun at the chain of production associated with the modernist (public) sculpture of someone like Alexander Calder or Richard Serra. Throughout all his work, Holloway engages with the way different kinds of space relate and how these interactions may be materialized and presented, in turn mocking modernist sculptural paradigms. **P.F.**

left:
Color Stick Theory,
2002
wood, acrylic and metal,
70" × 42" × 44"

right:
Left Handed Guitarist,
1998
foam, paper, plaster,
graphite, 63" × 62" × 52"

opposite:
***Capital,* 2005**
steel, rigid polyurethane,
celluclay, paint, graphite,
73" × 47" × 50"

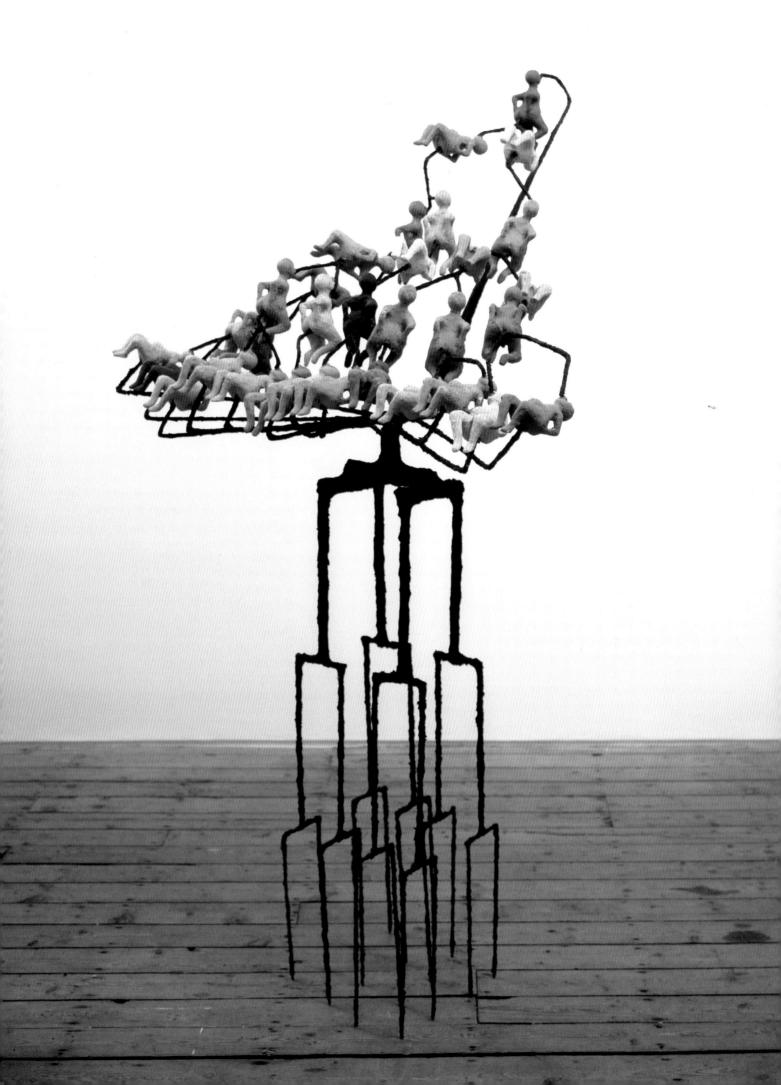

Terence KOH

Terence Koh's prolific output includes books, installations, websites and performances, in which seduction and desire are tirelessly charted and mobilized. Working for almost a decade under the alias of Asianpunkboy, he achieved notoriety for his self-titled books and website, which Koh describes as "filled with an infusion of gentle surfaces, dissident eruptions, haikus, mapped pictures, dirty illustrations, moist cum, decadent artificial words, love and all manners of faggy filth."

Since 2003, the year Koh killed off Asianpunkboy "somewhere in a secret park," he has produced numerous installations and sculptures. Typically shrouded in a signature white powder, his sculptures riff on themes of queer sexuality, mortality, the morphing of high and low culture and the evanescent substance of an individual personality. For *gone, yet still*, 2005, Koh constructed a room in which he could live for the remainder of his life. He created over a hundred glass vitrines, filled with found and made objects such as Michael Jackson figurines, busts of Pope John Paul, myriad children's toys and ceremonial African masks. The collection of objects is suffused through with symbols and imagery of gay sexuality, and also with the ritualized imagery of death and transcendence. Everything is cloaked in white, a color with potent significance (depending on one's culture) as a symbol of death, of purity, of virginity or of mourning. A note on the wall, described by the artist as a type of "jisei"—a farewell poem composed by Zen monks or samurai in the seconds before their death—lends the installation its name: "gone, yet still/i lie in bed/watching the stars."

Koh's extravagant performances, such as enacting a "Chinese opera" in the street, are often an integral part of his sculptural installations. Two all-white, pearl-encrusted drums and a low-hanging chandelier constructed using shards of broken mirrors were the basis of a recent performance, in which a pair of boys played the drums while Koh sang and shrieked in an invented language. In a subsequent installation Koh presented all-black versions of the drums and chandelier, which he attempted to have sex with—using an over-sized dildo—again singing and screaming in the same bizarre tongue. **G.S.**

> *'Zen and cum aesthetic' makes it sound like I do work that would entice rich Beverly Hill's women who do yoga, practice s/m, decorate their backyards with pretty Japanese stones or phallic water fountains and who also collect art. Actually that pretty much describes my ideal collector. I think my work is particularly well suited to be installed within the backyards of LA.*
> – Terence Koh[1]

1 Koh, Terence, in an interview with Ana Finel Honigman, "The Bunny with Bite," *Artnet Magazine*, 2004.

left:
These decades that we never sleep (drum set), **2004**
drum set, plaster, paint, wax, pearls, rope, fur, fabric, plastic,
4' × 7' × 17'

right:
50 star machine of drowning boy, **2004**
chandelier, metal, wire, string, plastic, glass, paint, wax, mirror, cotton, 30" × 30" × 69"

Liz LARNER

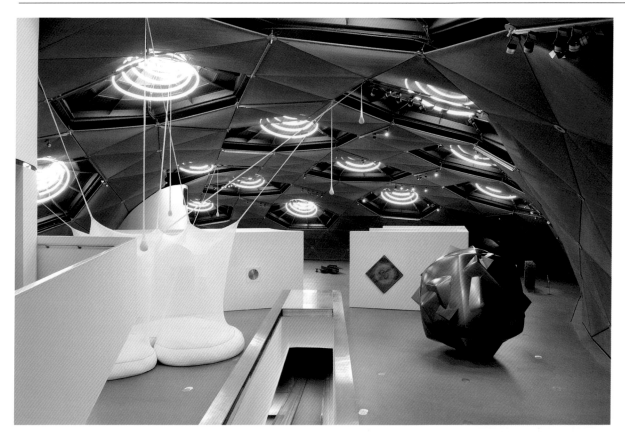

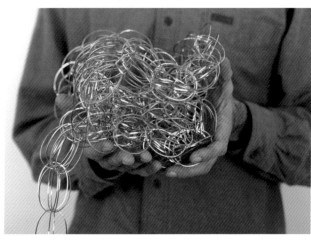

top:
2001, 2001
installation at
Kunsthaus Graz
mized media,
dimensions vary

bottom:
Guest, 2004
gold plate on bronze,
dimensions vary

In Liz Larner's 1988 piece, *Corner Basher*, a ten foot swinging ball contraption rhythmically demolished a section of the gallery, presenting a dynamic environment, and making the viewer aware of their own relationship to the wrecking ball in no uncertain terms. Larner continued her exploration of environments in flux in *Untitled*, 2001—a 12 foot diameter fiberglass and steel structure covered with a multi-toned iridescent car paint. This piece combines a sphere and a cube in metamorphosis, presenting a changing object as the viewer moves around it. The choice of materials and method of construction are those used in a high-tech car factory, yet the effect is one of organic change; the piece was devised from a series of three-dimensional computer animations showing the crystallization of a sphere into a cube. In her 2001 Los Angeles Museum of Contemporary Art retrospective, two-dimensional wall-based images completed the installation, showing forms and colors in regular patterns, suggestive perhaps of the changing view seen through a kaleidoscope. This glossy and decorative aesthetic seems a world away from her earlier stark, conceptual work, yet as with *Corner Basher,* it is the viewer's engagement with the artwork and space around that is highlighted. In a similar way, but on a less monumental scale, *Guest*, 2004, presents a changing sculpture consisting of bronze, gold-plated elliptical loops in an interlocking form that creates a type of open three-dimensional surface. This can be draped over a pedestal, hung on a wall, held in the hands, or even worn, so that with no fixed context, experience and engagement constantly change. **K.M.**

Jennifer PASTOR

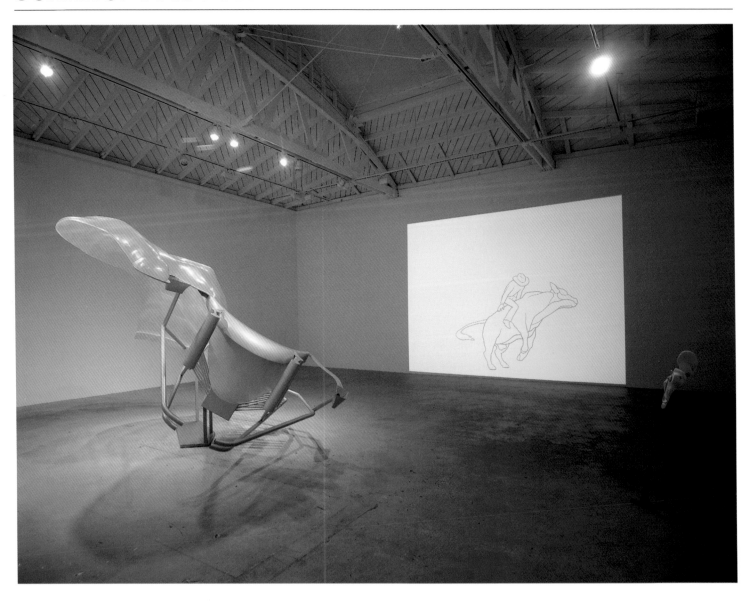

Jennifer Pastor works in a prolonged and calculated manner. "I've developed" she explains "this voracious hunger for research, almost a fetish, where I don't want to miss anything."[1] To date she has created a body of work consisting of less than a dozen objects in as many years. Since her work began to be shown internationally in 1994, Pastor has spent massive amounts of time on research, travel and preliminary drawing for each project. Pastor's intense and methodical research into the conceptual strategies and poetics of her work position her, along with Charles Ray, at the forefront of an intellectually challenging, science savvy movement within current LA sculpture. However, Pastor approaches her work with an intriguing defiance towards categorization. Her works, most recently *The Perfect Ride*, 2003—and notable earlier ones *Four Seasons*, 1994–1996, and *Christmas Flood*, 1994—tend to be reinterpretations of strangely common yet disparate subjects refusing to exclude the modest and ordinary. Perfectly fabricated with a craftsman like touch, she fuses representation and abstraction to create objects as exquisite as her research is fastidious.

 The Perfect Ride consists of three elements: a sculpture of the Hoover Dam, an animated and projected line drawing of a rodeo bull ride and a sculpture of the inner ear. Like all of her work, Pastor focuses on the entropy of closed systems where an unbridled energy is channelled from one source to another and the viewer is asked to make the circulatory links between the component elements. The movement of the bull, within the delineated aspect ratio of the projector, relates to the water circulation system of the dam, which in turn relates to the absorption of energy—in the form of sound—of the ear. These circuitous passages from one piece to the next are intent on creating a poetic space, or internal analogy, between the similarities and differences of the armatures that connect the piece as a whole. **P.F.**

The Perfect Ride, 2003
dam: steel, aluminium and plastic; ear: polyurethane and steel; line drawing animation, dimensions vary

1 Pastor, Jennifer, interviewed by Jan Tumlir in "1000 Words," *Artforum*, vol. 41, no. 10, Summer 2003, p. 154.

John PYLYPCHUCK

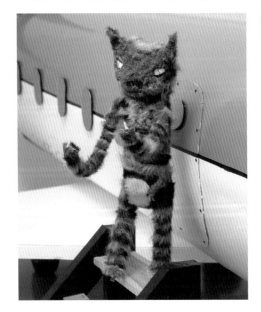

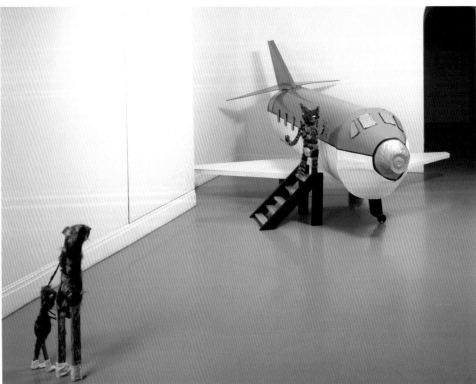

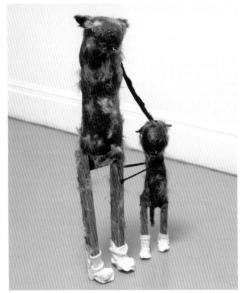

"These days are curses and your thoughts are like angels," runs one of the ennui-soaked fragments that trail from the mouths of Jon Pylypchuk's recurring cast of abject, anthropomorphic creatures. Pylypchuk's characters, first introduced in the form of collages and mixed media paintings and then more recently in large scale sculptures, occupy a forlorn world of pathos and loss. His collages, which are fashioned from low-end materials such as artificial fur, glitter and matchsticks, hot-glued onto plywood in a chaotic cut-and-paste style, depict crude figures such as velvet hearts and matchstick children in a welter of unhappy situations and relationships to one another. The snatches of dialogue, rendered in crabbed, miniature handwriting, often provide a title to the works, as in *nothing can be as lonely as you / I will lose two friends today then*, 2000, and *no actually, I would describe your life as failure*, 2004.

This atmosphere of failure and loss also pervades Pylypchuk's sculptural works. Fashioned out of similar materials, such as artificial fur, cardboard, felt and glue, they typically feature his signature animals—scrawny, spindly-legged "pathetic creatures" (in the artist's own words) with relationships that range from unstable to sadistic. *You left me no other action / cool off whiner*, 2004, depicts a horse and two cats, one trussed in bandages and moping on a plank of wood, the other standing on a table. A conversation between the horse and the sitting cat is interrupted by a flow of urine from the feline above. And the sexual relations of the creatures are as melancholic and gloomy as any other: *Erections pointing at stars and angels*, 2004, shows three cats, two flat out on their backs and one standing, their blue-tipped, erect penises straining to pick out the forms of two angels above. Pylypchuk's creatures inhabit a somewhat merciless world, in which yearning and individual struggle can bring only loneliness and alienation. **G.S.**

only now do I have the time to fully neglect you, 2004
details and installation view, Alison Jacques, London
mixed media,
228" × 116" × 68"

opposite:
You left me no other action/cool off whiner, 2004
detail and installation view, Alison Jacques, London
mixed media,
60" × 48" × 48"

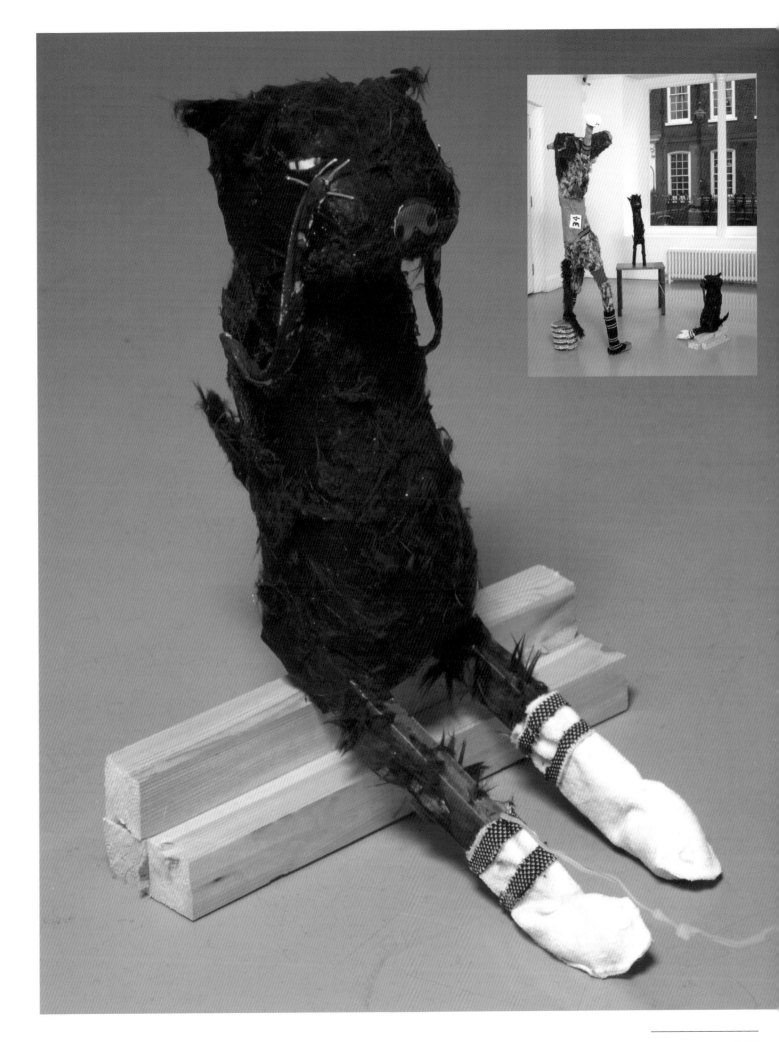

Jason RHOADES

To see one Jason Rhoades piece is to glimpse the discarded guts of the ones that went before. His assemblages of junk and recycled structures are always in flux, being made or unmade, as he zeros in on his particular vision of American society: a macho, commodified and materialistic world. For instance, fecal matter collected from public toilets was reconstituted into *Shit Plug*, a 2002 collaboration with Paul McCarthy; two years later, the pair would use sheep fat, wool, caustic soda and dirt to cast *Sheep Plug*. Hundreds of the sculptures—in the shape of butt plugs, scaled up to a capacity of four gallons—were produced, and the detritus of their quasi-industrial production was then exhibited alongside them in the gallery space.

In his recent series of evolving installations, Rhoades has sighted the entangled targets of sex, religion and consumerism. *Meccatuna*, 2003, has at its center a one third scale model of the Kaaba, Islam's most venerated shrine and the focal point of prayer for Muslims worldwide. Situated in Mecca, the real Kaaba is a cube-shaped structure with an oval corner-piece—the Black Stone—believed by some Muslims to cleanse the sins of all who touch it. Constructed over the course of the exhibition out of a million Lego pieces, Rhoades's Kaaba is surrounded by over 500 neon signs, each a slang term for the female genitalia. Ranging from affectionate to morbid—"Honeypot," "Bitch Ditch," "Badly Wrapped Kebab"—the incantatory excess of the display suggests a devoutness of feeling, if not worship, directed at the female sex organ. In place of the Black Stone is the "Mecca Vulva," made out of polished aluminum and resembling both a stylized vagina and a gaping fish head. Lining the room are various junk-like sculptures, many recycled from previous installations, and largely modeled in "PeaRoeFoam," a signature Rhoades concoction of frozen peas, salmon roe and foam pellets. Rhoades plans to build a center for his work in Mecca, California, a self-described "ermitage" that will house his recent works. **G.S.**

Meccatuna, 2003
detail
mixed media,
dimensions vary

opposite top:
Meccatuna, 2003
installation view, David
Zwirner, New York
mixed media,
dimensions vary

opposite bottom:
*PeaRoeFoam Abstract
Sculpture The Yellow
Belt*, 2003
nine Ivory Snow
PeaRoeFoam Kits; one
virgin bead barrel; three
pairs of used yellow boots;
purple plexiglas corner;
yellow plastic strap; empty
PeaRoeFoam boxes,
70" × 30" × 30"

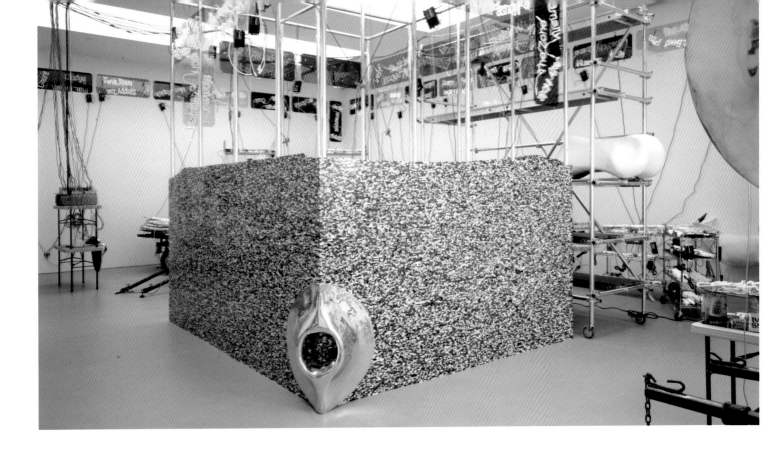

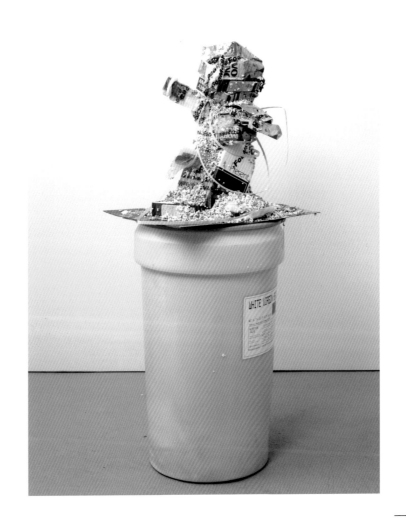

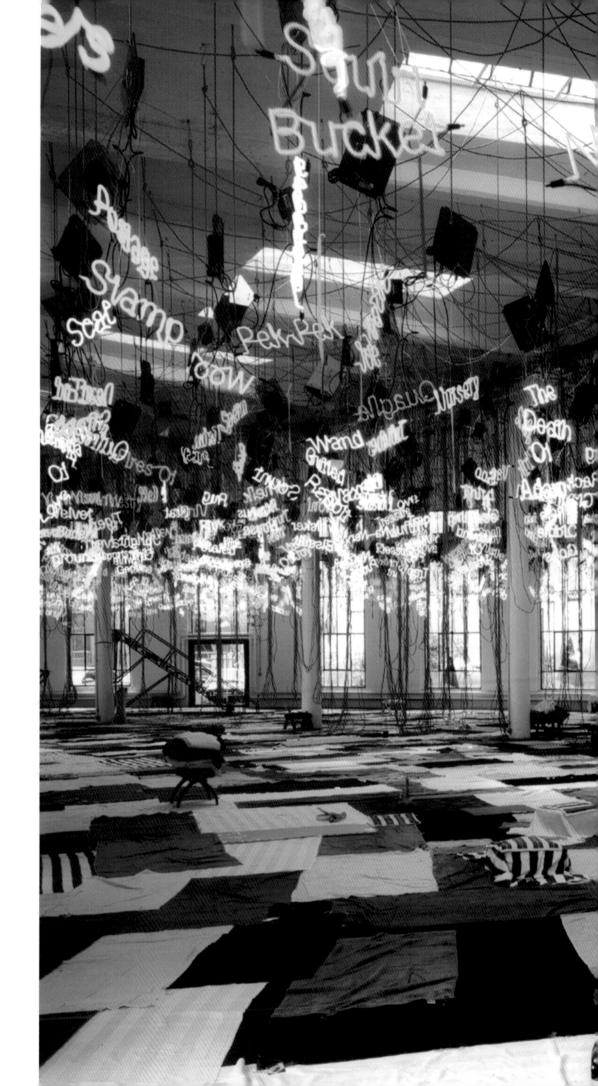

My Madinah: in pursuit of my ermitage..., 2004
installation view at Sammlung Hauser & Wirth, St. Gallen
mixed media, dimensions vary

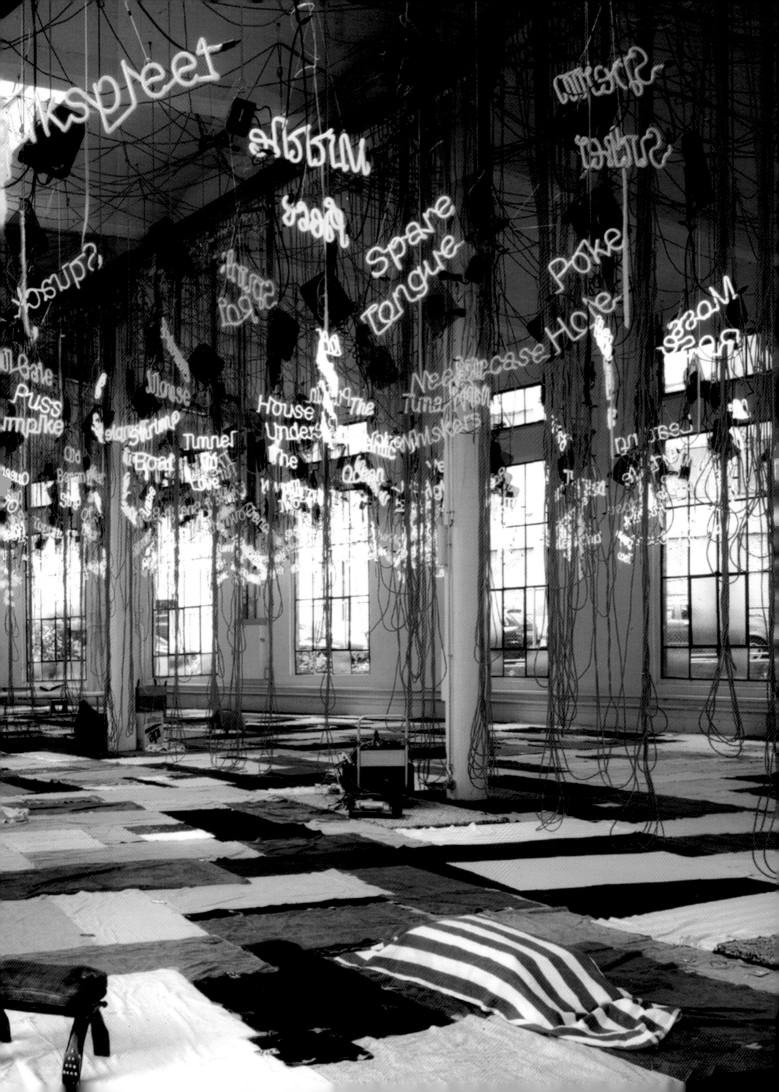

Diaspora? Touristry?
No. 5, **2000**
ilifochrome, 26" × 40"

opposite top:
Musical Straws Meets
Power Tower, **2004**
high density polyethylene,
therapy silly putty,
found plastic, height: 12'

opposite bottom:
BionicPak, **2001**
polystyrene,
15" × 48" × 33";
31" × 48" × 33"

Shirley Tse isn't put off by plastic. What many of us might be repulsed by, feel threatened by, or see as the symbol of impending environmental collapse, she recognizes as a potential matrix for philosophical discussion. Some of her most haunting work to date manages to remind us of the things we like or find most useful about plastic: the skin-like suppleness of high quality latex, for example, or the sturdy smooth surface of an injection-molded tub or sink. In wall hangings like *Recircle*, 2002, Tse makes a compelling case for the innocence of plastic, whatever its well-documented crimes. Like any material, it is beautiful when finely produced and crafted, a transformative endeavor which Tse obviously relishes. In works such as *Transmutation*, 2003, she speculates on the manufacture of plastic items using plastic tools, suggesting a process by which humans obtain some needed tool or item and plastic quietly regenerates.

Tse brings the positive side of plastic's innate flexibility to the fore in her artistic practice, constantly playing with our perception of this chameleon-element that so dominates our lives. In *Diaspora? Touristry?*, 2000, she takes her sculptures on the road, capturing key encounters in ilifochrome. The title clues us in to the questions Tse would like to examine more deeply, *vis a vis* her chosen material. Are these plastic forms, which she seems to anthropomorphize with the series title, spreading out and engaging with new landscapes on a permanent basis; or are they simply visiting, absorbing knowledge of the natural world that is at once their evolutionary predecessor and their contemporary environment? In short, what does it mean that plastic is *everywhere*? Tse poses a sculpture by the side of a highway, inviting contrast between the cerulean of the sky and the slightly more intense azure hue of her plastic creation. The sculpture seems at once alien and utterly benign, which can only mean one thing: further experiments are needed. **E.L.**

Re-figuring Abstraction

Mark **BRADFORD**
Jane **CALLISTER**
Kim **FISHER**
Jeremy **GILBERT-ROLFE**
Mark **GROTJAHN**
Sandeep **MURKHERJEE**
Monique **PRIETO**
James **WELLING**

Mark BRADFORD

Mark Bradford, a graduate of CalArts, creates an unsettling tension between street culture and Greenbergian formalism in his mixed media collage on canvas works. His paintings are both beautifully designed and obsessively crafted. Yet there is always a nagging sense of social conscience. A South Central Los Angeles beauty salon, where the artist worked, proved to be a primary source of inspiration. End papers from the perm process quickly found their way into his pictures. Hair culture is at odds with "high" culture, but Bradford manages to coax the viewer into a vexing examination of this dichotomy. An historical precedent would be Kurt Schwitters, who created an endless collection of "Merz" (detritus deemed to have aesthetic value). In addition to the salon refuse, Mark Bradford has made use of bits of flyers and billboard advertisements.

While *Potable Water*, 2005, is in itself a good thing, the assertion raises a slew of doubts about safeguards generally taken for granted. This collage resembles a seascape in appearance, but is subjected to the jarring surrealist tactic of using an incongruous title. *Blue*, 2005, on the other hand, is a collage worthy of Klee in its simplicity and attractive use of repeated geometric form. But closer examination of the canvas reveals a bird's eye view of an urban sprawl.

Bradford's art is never completely removed from the experience of African-American neighborhoods. But instead of simply retelling a stereotypical story, it suggests the possibility that our perception could be reshaped. Bradford was included in The Studio Museum of Harlem's 2001 exhibition *Freestlye*, featuring artists whose works are part of a phenomenon deemed "post-black" by curator Thelma Golden. This suggests that a widened range of approaches exists today in which artists can confront the complexities of race. Bradford's work draws the viewer into the conundrum of elevating the gritty LA streets into the purer pastures of high modernism. **M.M.**

Potable Water, **2005**
mixed media collage on
canvas, 196" × 130"

With her *Liquid Landscape* series of 2003, Jane Callister has taken artificial cartoon-candy colors and pushed them (and her viewers) to the limit. She creates a parallel world where her viewers, sometimes safely enclosed in a topography they can understand, suddenly lose their footing and slip-slide down into an abstracted world of drips, dribbles and spills.

In her work Callister fuses together historical academic landscape painting and popular culture, allowing a terrain to emerge within an enormous and indigestible mass of sickly abstraction. Callister takes on a space and floods the gallery walls and floor with marbleized paint, sometimes including three-dimensional protrusions which act as platforms for a small group of inhabitants. In doing so Callister creates a miniature universe and then undoes the illusion by quite clearly demonstrating that the reality of her work is just paint, bound by gravity to trickle down the walls. The *Expanded Sticker Project*, a room sized installation of paint, vinyl stickers and sculptural elements made in 2003, saw Callister inserting inch high models of people (and other animals) into the scenery. They stand surveying a lunar vista of pale pinks, pistachio greens and peachy oranges, overwhelmed by color and virtually lost to the viewer.

Art critic Colin Gardner observes that Callister's paintings walk the fine line between the monstrous and the beautiful, pushing the boundaries of conventional good taste, transforming the clichéd formalist strategies of high modernism into an eclectic pastiche of postmodern kitsch. "With their synthetic day-glo palette," Gardner continues, "... her works often mimic food-related surfaces such as cake frosting, whipped cream and chocolate sauce."[1] There is certainly something unwholesome about Callister's work: digesting it leaves one feeling as queasy as a child would feel after a day in an unattended sweet shop. **J.B.**

left:
***Expanded Sticker Project*, 2003**
detail
poured acrylic on
adhesive vinyl on wall,
dimensions vary

right:
Callister pouring on canvas, 2004

1 Gardner, Colin, "New Work by Jane Callister," essay written to accompany the exhibition entitled *Vitamin P: New Work by Jane Callister* held at the University Art Museum, UC Santa Barbara, CA, in 2003.

Kim FISHER

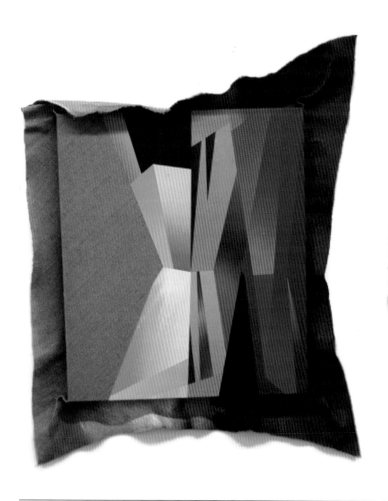

Kim Fisher's paintings are the result of her search for absolute beauty by overlaying the vocabulary of glamour and fashion upon the highly structured framework of minimal abstraction. She works within the history of formal abstraction (most notably color field painting), and enlivens it with symbols of desire, thereby offering a path to a new kind of abstract painting.

Fisher's work is influenced by artists Ad Reinhardt and Robert Ryman as much as designers Pierre Cardin and André Courrèges. She applies carefully hued layers of paint to stretched brown linen, often leaving areas of the canvas untouched to serve as a contrast to the lushness of the oil paint. Onto this surface, she incorporates elements from the world of luxury and fashion. Early on, her work consisted of the logos of famous design houses floating on monochromatic grounds: the "AC" of space-age designer Courrèges on rich red, Tiffany & Co. on Tiffany's trademark light blue, Chanel on white. Despite their origins in haute couture, "they're not really supposed to be ironic," Fisher states, stressing that she appropriates these icons for their formal appeal.[1]

More recently, her paintings have been influenced by the refraction of light within precious stones, and even take their titles, such as *Beryl 11*, 2001, and *Carbon 17 (Bort Diamond)*, 2004, from the names of gemstones. Rigid planes of subtle color gradations characterize these works, in which she uses simplified monochromatic palettes, reminiscent of Josef Albers. The color schemes are always painstakingly selected, ranging from sky blue and aqua to ultramarine in one work as well as marigold and pumpkin to cherry red in another. Fisher also allows ruffles of excess linen to stick out from the sides of these paintings, extending the color fields onto them, thereby challenging the strict modernist emphasis on purity and flatness. **M.S.**

1 As quoted in "Vintage Chic," *The New York Times Magazine*, pt. 2, October 13, 2002, pp. 96–102.

left:
Study for Gemstone,
2004
oil on linen, 21" × 17"

right:
Labradorite, 31, 2004
oil on linen, 80" × 70"

opposite:
Beryl, 2001
oil on linen, 29" × 29"

top:
**The Way Birds Use
Gravity, 2002**
oil on linen, 66" × 69"

bottom:
**Deliberate (Courbet),
2001**
oil on linen, 67" × 67"

160

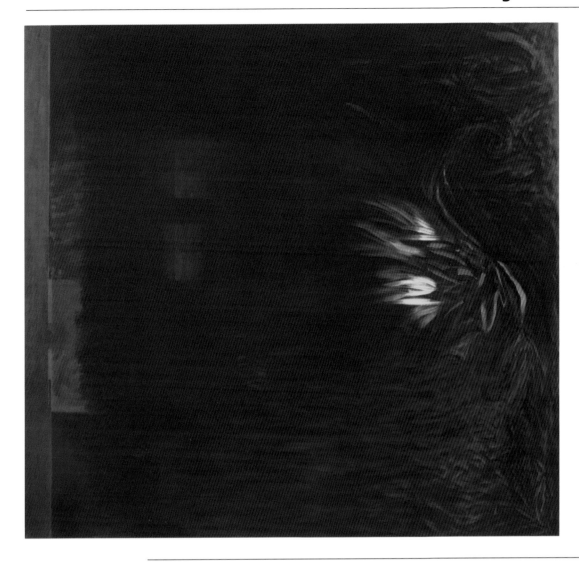

Jeremy Gilbert-Rolfe is a veteran artist and critic with several highly acclaimed books (notably *Beauty and the Contemporary Sublime*, 2000), as well as various awards in recognition of his significance as a painter. Known in the 1980s for his seductive metaphysical paintings made up of clustered vertical stripes in primary colors and black, Gilbert-Rolfe weathered the storm which saw the, now notorious, near death of painting. A review of his work in 1984 opened: "The question about Jeremy Gilbert-Rolfe's new abstract paintings is not whether they're good or bad, but whether or not it is valid to make them today."[1] Able to express himself not just as a painter but also as a critic, Gilbert-Rolfe was an influential and energetic voice in the defense of painting, and furthermore in the defense of beauty. In the artist's words: "The history of beauty is a history of reason feeling threatened by it. The beautiful has always been irredeemable... it persists in being resistant to (whatever) power that seeks to administer it...."[2]

It comes as no surprise then that Gilbert-Rolfe's work 20 years later is both visually arresting and highly painterly. The geometry present in his earlier work which had invited comparisons to the work of Kasimir Malevich and the Russian Suprematists has become less rigorous and applied with more economy and sometimes humor, while his palette has softened and his brush strokes are more tactile and indulgent. *Owl's Happiness*, 2003, is a sea of rich royal blues out of which an owl's wing materializes as if its flapping causes the stir and currents within the waters. To the left of the picture is a vertical strip of grey which in conjunction with the hard edge of the canvas introduces an abstract element and creates a new dialogue within the painting. Gilbert-Rolfe's controlled application of balance and color, the result of his knowledge of composition and the medium of painting, juxtaposed against a freshness, sense of freedom and experimentation makes these recent paintings a successful culmination of experience and spontaneity. **J.B.**

Owl's Happiness (King of the Wends), **2004**
oil on linen, 66" × 70"

1 Kuspit, Donald, "Review, John Weber Gallery, New York," *Artforum*, vol. 23, October, 1984, p. 92.
2 Gilbert-Rolfe, Jeremy, "Beauty," *X-tra*, vol. 2, no. 3, Spring 1999, p. 4.

Mark GROTJAHN

Mark Grotjahn approaches abstract painting with a conceptual freshness. A self-confessed appropriator, the painter has positioned himself in fertile ground, able to pick and choose from endless styles and periods of art. He couples this scavenging opportunism with an effective ability to edit his work down, sacrificing layer upon layer and only allowing the faintest traces to peek through as testament to the transformation the painting has undergone.

Lately Grotjahn has taken to carving his initials into the surface of the painting to allow a small window into the painting's past-life. Fellow painter, Delia Brown, claims to have "misunderstood" Grotjahn's paintings as "strictly formal" until she noticed the carved out letters:

> More than a signature, the letters intrude on the composition, becoming perhaps its most important element—a self-conscious disclosure of authorial ego. This split came as a gift, allowing me to transcend my distrust of the 'pure' painter and indulge with him in enjoying the wonderful physicality of paint.[1]

This practice of signing his work demonstrates Grotjahn's interest in playing with the concept of authorship and resonates with his earlier practice of making copies of hand written signs he saw in bars and restaurants around Los Angeles. Grotjahn would then exchange his copies for the original signs made by the proprietors of the bar, again sensitively toying with notions of originality and the artist's hand by forging otherwise anonymous signage.

A small survey of Grotjahn's recent work includes *Mask*, 2004, a cartoonish face with awkward lumpy features painted onto a trashy cardboard box; *Untitled*, 2004, immaculate spectrums of color radiating from one or two points of origin and *Untitled (face)*, 2004, a crazily abstracted face overworked and over-detailed where previously the paint is apparently slapped on carelessly. The difference in level of finish between the pieces varies greatly, emphasizing Grotjahn's determined tactics of stylistic and conceptual appropriation. **J.B.**

left:
***Untitled (black butterfly)*, 2002**
colored pencil on paper, 24" × 19"
Private Collection
photo: Josh White

right:
***Untitled (face)*, 2004**
oil on board, 21" × 17"
Private Collection
photo: Josh White

1 Brown, Delia, "Top Ten," *Artforum*, vol. 41, no. 5, January, 2003, p. 41.

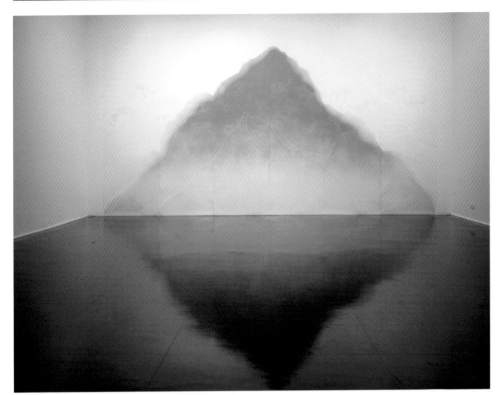

left:
***Untitled*, 2004**
installation at Pomona
College Museum of Art,
Claremont, CA
acrylic, colored pencil
and needle on duralene,
111" × 36"

right:
***Untitled*, 2002**
acrylic and colored
pencil, 85" × 36"

Sandeep Mukherjee paints and draws iridescent abstracted landscapes and self-portraits which glow in brilliant hues. His images are vibrant and sensual, celebrating touch, texture, light and color. These works are created in a laboriously delicate process as Mukherjee caresses and gently scores the surfaces of duralene (translucent, vellum-like paper) with scribing tools in a kind of tender sadomasochistic act. His expertly rendered self-portraits, sometimes full frontal body compositions but more often a simple torso emerging and disappearing into the painted ether, show an exploration of the self. By piercing and slicing the surface of the image, Mukherjee literally dissects himself before the viewer.

Born in India and raised in Los Angeles, Mukherjee creates work as a meditation on his own cultural heritage, spirituality and self-examination. What in today's climate may be read as an act of self-mutilation, harks back to the fourteenth century Indian tradition of piercing drawings, when an apprentice would trace the master painter's image with the use of faint pinholes.

Mukherjee further fuses together influences and cultures by using the languages of both Asian landscape painting and modern American abstraction, as demonstrated by a sublime and moving installation of a purple-tipped mountain, *Untitled*, 2004. In this work, a simple triangle fading from violet to yellow creates a geometric pattern as it reflects on the slick black gallery floor, the overpowering effect of color reminiscent of the sensations experienced before a Rothko. An illusion of distance and perspective is created by the join between gallery floor and walls that becomes a horizon line, and the image reads as a mountain situated on a lake. It becomes increasingly difficult to understand the true scale of the work as one begins to conceive of this image as a monumentally scaled mountain confined within the gallery walls. **J.B.**

Monique PRIETO

Using her finger on a laptop touch pad, Monique Prieto prods and nudges fields of pastel color on the computer program "Painter 3" before amplifying and painting this image on a much enlarged canvas. The "accidental" digital image, much like a Rorschach ink blot, prompts the artists subjective interpretations and associations. The resulting paintings give insight into Prieto's sense of humor and the latent meaning found in the play between abstraction and figuration. By putting herself at a remove from the creative process of painting, "muffling the prowess and intentionality of the artist's hand," Prieto's works have invited comparisons to the color field painters of 1950s and 60s America and reignited interest in formalist values.[1]

 With the titles of her paintings, Prieto gives the viewer a way to make sense of them, as with *Blue Kiss*, 2002. Immediately on reading the title this becomes a painting of a pair of blue lips. In doing this Prieto injects humor into her work by playing with the accidental. With *Revenge*, 1998, she sets the scene of a sickly comical murder: the triumphant Fat Yellow Blob stands at the top of Pale Blue Mountain looking down at the corpse of Thin Green Blob. It is a naughty image, as if a child had devised this murder scene which is made all the more witty by the inappropriateness of the materials and colors. **J.B.**

1 Relyea, Lane, "Virtually Formal," *Artforum*, September, 1998, p. 129.

Blue Kiss, 2002
acrylic on canvas,
40" × 50"

Welling is a much written about photographer. This abundance of literature is due to his elusive coherence as an artist, his characteristic unpredictability. Welling's photographs range from deadpan realism to romantic abstraction and encompass much that lies between. He produces photographs in a variety of ways and shows them in conjunction with one another. He is courted by modernists and postmodernists alike but with his work Welling seems to render barriers carefully erected by academics and writers as both trivial and redundant. It is not only impossible to categorize his work, but also pointless.

What seems to interest Welling is photography's inherent nature. "From the beginning," he writes, "there was a dichotomy: the shadow of the object, and the representation of the object, the two great historical poles that are photography's foundation."[1] On these foundations, Welling has created a number of platforms on which he builds his work, expanding his oeuvre "not in a linear and continuous progression but laterally and from many points at once."[2] On the one hand, Welling takes the tenets of modernism to their ultimate end by having the meduim of photography "reassert itself" over its content, however, he considers his work to be a form of ventriloquism, appropriating the concerns of modernism as one option of many.[3]

Welling plays with the natural and the illusional, often carefully manipulating color and controlling the level of blur, sometimes until the image is no longer detectable (or indeed relevant). In his *Flowers* series, 2004, Welling creates beautiful silhouettes of living things and juxtaposes the organic against the artificial by saturating the silhouette with incredible color and placing it against a clinically white background. In other works, such as his *Screens* series, 2003–2004, Welling floods his image with rich glowing tones, blurred until the original image is totally obscured. As with much of his work, these prints, given only a number by which to distinguish one from another, downplay the importance of the individual image over any real significance to his body of work as a whole. **J.B.**

left:
***Untitled Curvatures,
2004***
unique type c-print,
23" × 19"

right:
No. 11, 2004
chromogenic print,
42" × 35"

1 Welling, James, quoted in Lynne Tillman's, "James Welling," *Artforum*, May, 2001, p. 139.
2 Relyea, Lane, "James Welling: Wexner Center for the Arts, Columbus, Ohio," *Artforum*,
vol. 39, no. 1, September, 2000, p. 171.
3 Welling, James, in an interview with Jan Tumlir, "James Welling Talks to Jan Tumlir,"
Artforum, vol. 41, no. 8, April, 2003, p. 217.

Popu-
the

Andrea **BOWERS**
Sam **DURANT**
Dave **MULLER**
Kaz **OSHIRO**
Mungo **THOMPSON**

Andrea BOWERS

Andrea Bowers is an interdisciplinary polymath, having worked in areas as diverse as documentary film and interactive software. Most recently she has concentrated on photo-realist drawings and video, performing a reading of formalist art history alongside pressing concerns of contemporary resistance politics in work where the social body and the aesthetic share the same uneasy space. Deconstructing and recomposing events, histories and objects, Bowers works to join the dots of some previously unmapped social psychology. Some of her earlier work looked at the themes of mass identity, media culture and the relationship between the observer and the performer, with subjects as diverse as portraits of people in crowds (such as the precisely rendered *Study for Crowd Drawings (Soccer Fans in the Sun)*, 1999, or videos of karaoke, in her *I Love You Fuckin' People*, 2000. Utilizing strategies of applied appropriation she has opened up a critical dialogue with the issue of media identification and its concurrent activities: imitation, derivation and exchange. An important part of this is her use of media close to hand—the video camera, the pencil—to portray the subtly shifting and sliding lines of mass-cultural desire.

More recently she has looked at the current culture of protest within the vocabulary of minimalist aesthetics. Her most recent projects evoke the dance of the Judson Dance Theater and the work of such artist-performers as Yvonne Rainer. Her video *Non-Violent Civil Disobedience Training*, 2004, is a documentation of a lecture and demonstration of non-violent protest techniques, with the limp bodies of the participants being dragged across the church hall floor uncannily mirroring experimental dance from the 1960s while being imbued with an urgent contemporary agenda. Accompanying this video Bowers has created a series of drawings based on photographs of the Abalone Alliance, an environmentalist activist group from the 1980s. Such drawings as *Non-Violent Protest Training, Abalone Alliance Camp, Diablo Canyon Nuclear Power Plant, 1981*, 2004, posit retrospective views of protest alongside a precise yet fugitive drawing technique, framing her figures whose movements follow the delicate lines of abstract dance within the simple economy of direct action. **F.S.**

Nonviolent Protest Training, Abalone Alliance Camp, Diablo Canyon Nuclear Power Plant, 1981, 2004
graphite on paper, 38" × 50"
Collection of Steven Perelman for The Whitney Museum of American Art, New York
photo: Herman Feldhaus

opposite:
Nonviolent Civil Disobedience Training: Resisting Arrest Exercise, Going Limp 2, 2004
photograph, 16" × 20"
photo: Deanna Erdmann

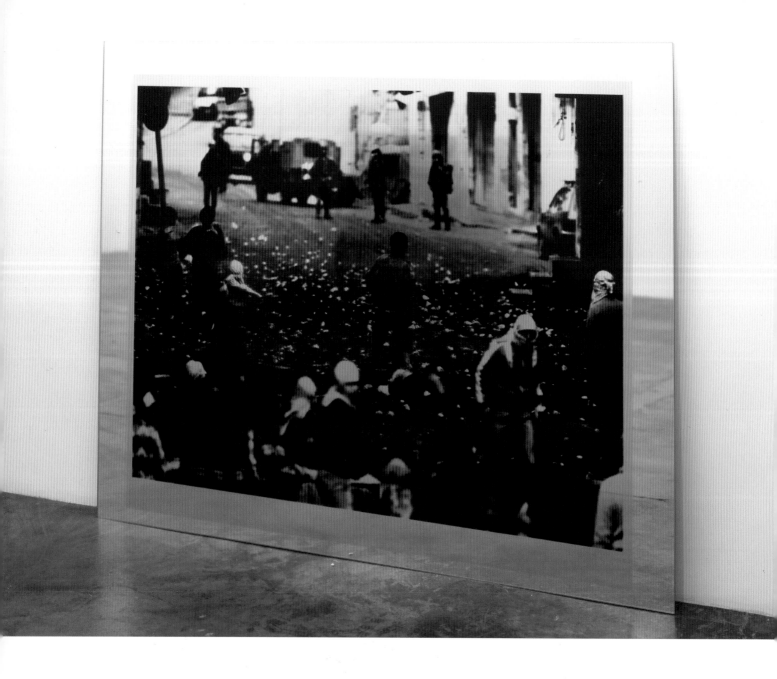

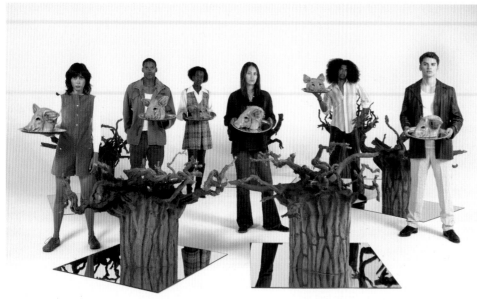

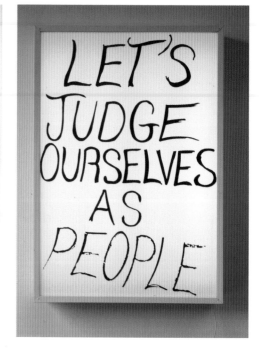

Altamont, **1999**
installation view
mirror and felt,
60" × 324" × 8"

opposite top:
***Gaza City, Palestine,
1988*, 2004**
lambda print, mirror,
53" × 68"

opposite bottom left:
***Landscape Response
(pig heads)*, 2002**
c-print, 50" × 60"
Private Collection

opposite bottom right:
***Let's judge ourselves
as people*, 2002**
vinyl text on electric
sign, 69" × 48"
Private Collection

Sam Durant's entropic revisionism looks at the disintegration of 60s idealism and the decay of modernist utopias. Reworking the strategies of such influential artists as Robert Smithson in the light of a contemporary loss of faith in politics and institutions, Durant re-ignites the cinders of Smithson's notion of entropy as institutional critique. Whereas Smithson's intention was to dissolve the walls between protected realms of disciplines and culture, Durant extends this dissolution into the realms of cultural ideologies and social practices. Approaching the lost idealism of a certain politicized era from the vantage point of someone who was too young to have witnessed the events, Durant stages his works as the meeting of different hopes, dreams and losses (often seen through a distancing window of "time-past"); debates and questions which he re-animates to ask both "where did it go wrong" and "what can we do now."

Early works, such as *Altamont*, 1999, pitch Robert Morris-esque felt lettering with Smithson-esque displacement mirrors against footage from the Rolling Stones's fateful concert at Altamont where several fans died, one stabbed by the Hells Angels who were supposedly acting as security. Re-reading the apocryphal end of the hippy dream in terms of post-minimalist aesthetics, Durant produces a mixture of decomposed and recomposed structures from, and in the face of, the archive.

More recent works, such as his exhibition *Involved*, 2004, continue this strategy of archival excavation and re-reading, looking at historical photographs of rock throwers. Reproducing images of small groups of projectile-hurling protestors (often in the face of a menacing uniform line of soldiers or police) from a range of sources—the upheaval in Paris in 1968, children in the Gaza Strip in 1988, Civil Rights protest in Jackson, Mississippi in 1963—Durant plays formal games of art history with political events in history. Taking the staple weapon of the disaffected but mobilized protestor and the totemic object of Land Art, Durant conflates both activities within an attack upon the ideological imperatives that attempt to quell and dampen dissent. **F.S.**

Dave MULLER

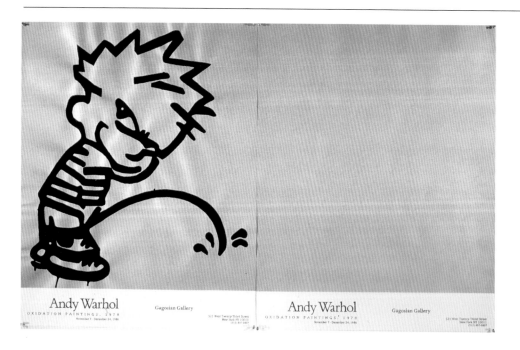

Well known internationally for the artist-curated *Three Day Weekend* shows, Dave Muller—like Joseph Beuys before him—believes that art is big enough to let everyone in. Posters for these events appear in his more traditional gallery shows, pastiches of arty album covers or just any picture he thinks might "look good on a T-shirt." In Muller's hands iconic images can either come away clean or end up looking like the victims of a teen scribbling spree. Take his treatment of Kraftwerk's *Tour de France* album cover, produced for the Whitney Biennial, 2004. The bikers, instead of maintaining the stoic silence usually imposed during the long sprint through the Pyrenees, scream, *This show sucks! Change it!* It's the perfect invitation for an event that is aimed to engage the public while poking fun at a gallery culture that aspires to be hip without ever actually relaxing.

It only stands to reason, as the impresario (and DJ) of some of the artworld's best-enjoyed *fêtes-galantes*, that Muller is well known for the influence popular music has had on his work. But like Elizabeth Peyton, who made her name painting luscious glazed portraits of rock luminaries, Muller doesn't want to talk about music, *per se*—he wants to talk about love. Muller introduces himself to the viewer the way many of us try and present ourselves to the world, by listing the things we like, the things we love. In works like *B2*, 2003, he offers up his record collection bit by bit, photorealistically rendered to the last serif on a Bix Biederbecke boxset sleeve. Whether it's the random sample of this painting (grabbed from the shelf in a chunk from Ba–Bt) or the clear-cut self-presentation of "Dave's Top Ten," Muller doesn't make any huge effort to polish up his taste before revealing it to an audience. After all, this is an artist who knows we don't choose the culture we're born into, or grow up around. When it works, Muller goes for it, even if he knows the audience will be shocked when confronted with a juxtaposition of Warhol's *Oxidation Paintings* and the truck-stop icon "pissin' Calvin." In the end, he cares about our reaction without being self-conscious about the result—a crucial distinction in life and art. **E.L.**

top:
He could sell ice to...,
2000
acrylic and aluminum
paint on paper, 40" × 60"
Private Collection

bottom:
Record Exchange
Listening Unit, **2003**
records, plywood
furniture, stereo
equipment and acrylic
on paper, 21" × 65" × 38"

opposite:
B-1, **2003**
acrylic on paper,
43" × 35"

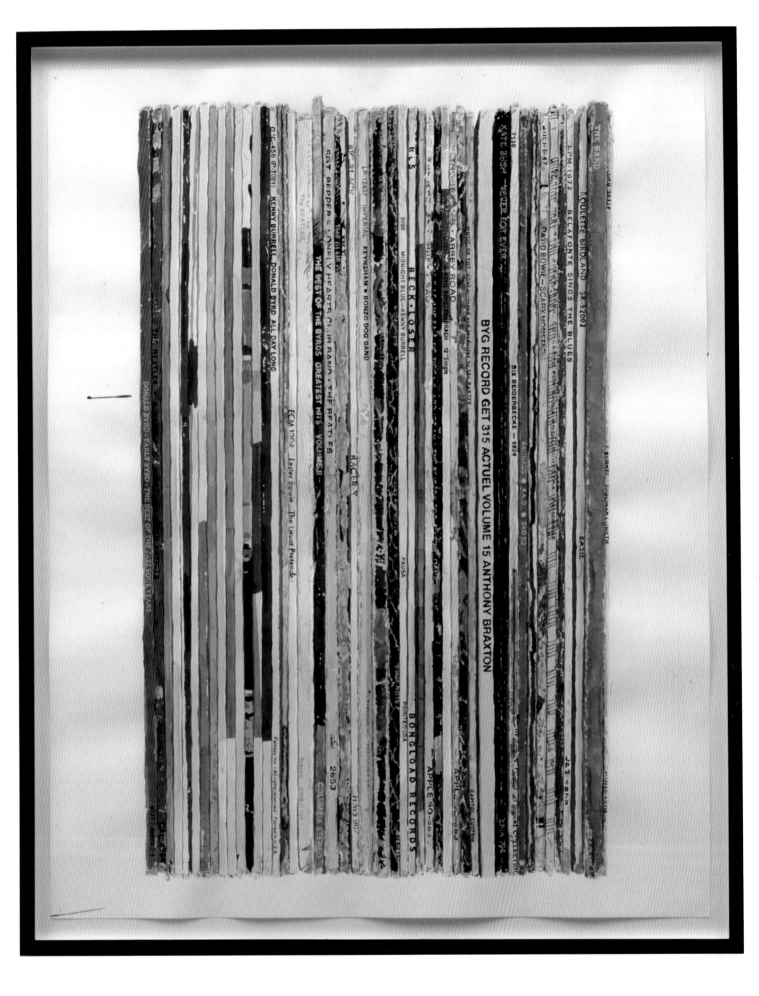

Kaz OSHIRO

top:
Kitchen Project,
2003–2004
acrylic on stretched
canvas, 7' × 13' 3" × 18' 3"
photo: Douglas M. Parker

bottom:
Microwave Oven
(Marilyn Manson),
2003–2004
acrylic and bondo on
stretched canvas,
15 ¾" × 23" × 16"
photo: Douglas M. Parker

opposite top:
Peavey Stack, 2003–2004
front and back
acrylic and bondo on
stretched canvas,
81" × 76 ¾" × 15 ¼"
photo: Douglas M. Parker

opposite right:
Pink Marshall Stack
Wall (Three Marshall
Double Stacks),
2003–2004
front and back
acrylic and bondo on
stretched canvas,
72" × 90" × 14 ¼"
photo: Douglas M. Parker

opposite bottom:
Marshall Amp (Freak),
2000
acrylic and bondo on
stretched canvas,
18 ½" × 21 ½" × 9 ½"
photo: Douglas M. Parker

Kaz Oshiro's work exists in the space between painting and sculpture, the ready-made and geometric abstraction, deception and sincerity. His facsimiles of everyday objects at first appear to be simply what they represent: amps, appliances, kitchen cabinets, and fast food trash bins. Upon further viewing however, it becomes clear that they are carefully constructed from acrylic and bondo on canvas stretched over wood. They function as silent stand-ins for commonplace things, evoking a collective memory based in suburban adolescence.

Although deceptively simple looking, Oshiro's work draws on numerous sources from the art of the last 50 years. As he notes, "I hope to create post-pop art that juxtaposes Pop and minimalism with the flavor of neo-geo, appropriation, and photorealism, and present them as a still life of my generation."[1]

With their mass-produced origins, hard edges and commercial surfaces (bondo is used in car restoration), Oshiro's pieces share a minimal, industrial aesthetic with works by his predecessors like Donald Judd and Ed Ruscha. The influence of Pop manifests itself in the bright colors and corporate logos found in his work, as well as in his sense of appropriation. Despite this, these are not impersonal, generic objects. He has painstakingly reproduced specific details: stickers, scuff marks, spilled food, even the faux wood grain. The painted stickers, many for bands like the Dead Kennedys and the Grateful Dead, reflect the influence of rock and punk music. They also connect his work to an earlier generation of punk-inspired LA artists, including Raymond Pettibon, whose sticker for the band Sonic Youth, Oshiro paints onto one of his kitchen cabinets. These specific details, as well as the amps' silence and the trash bins' disuse, heighten the works' sense of absence and isolation. **M.S.**

1 Oshiro, Kaz, "2003 Summer Program," press release, New York: Apex Art, 2003.

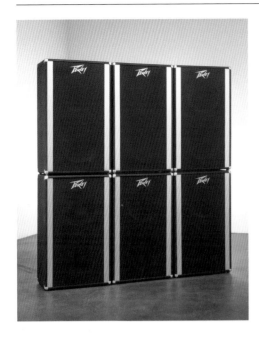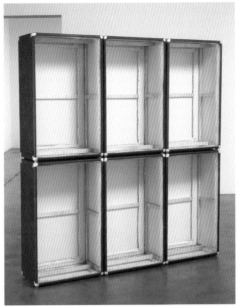

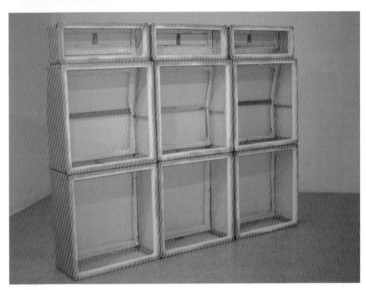

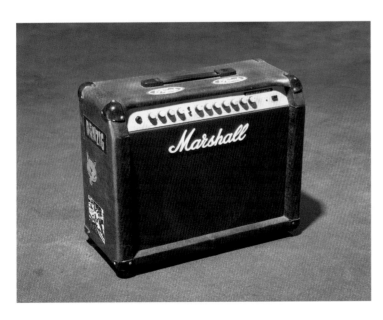

Mungo THOMPSON

With an output that includes but is not limited to drawing, installation, sculpture, film, video and sound pieces, Mungo Thomson uses the language of mass culture to explore issues of authenticity, cultural appropriation, American identity and institutional critique. His works often focus on the in-between spaces of culture and media, exposing that which lies under the surface. They also convey a sense of quiet disappointment and ennui, albeit humorously.

Thomson's sound works take as their subject the extraneous noise and ambient sounds of performance and art. *The Collected Live Recordings of Bob Dylan 1963–1995*, 1999, is nothing more than the sounds of crowd applause in between songs at the titular performances. The eager anticipation of waiting for a performance to start, quickly turns to confusion and disappointment the longer it remains unfulfilled. Bus shelter posters and billboards that advertise the piece whenever it is exhibited contribute to this sense of expectation. His ongoing audio project, *The Bootleg Series*, consists of recordings of the ambient noise at art-related functions such as openings. It stands as a humorous attempt to capture the essence of high art, by listening to the sounds of its institutional viewing and reception. Similarly 1998's *Room Tone* tries to shed some light on the mystery of artistic creation by replaying the noise of the artist's empty studio.

Thomson's film and video work also explore the mechanics of artistic perception, focusing on the framework of cinema, instead of the narrative. *The American Desert (For Chuck Jones)*, completed in 2002, compiles scenes from classic *Road Runner* cartoons created by the famous animator. Thomson has removed all of the characters from the scenes, instead leaving barren images of the American West. From a popular American cartoon, he creates a contemplative, yet lonesome landscape, speaking to our fractured national identities.

Everything Has Been Recorded, 2000, is a book Thomson produced in the manner of free religious texts given out in public places. As Thomson notes, "*Everything Has Been Recorded* pairs my drawings of cosmic, apocalyptic, and mundane scenes with excerpts from my graduate school journals that dramatize the peaks and valleys of my own art practice as a religion unto itself."[1] Distributed in public places, the work serves to disseminate art to a broader public than would normally be exposed to it. Fusing the language of evangelical religion with DIY artmaking, the work highlights the transcendent potential of art to go beyond the gallery and exist in the world. **M.S.**

1 From Thomson's description of his work on www.JohnConnely.com.

The American Desert (For Chuck Jones), **2004**
video, 34 minutes
Collection of the Orange County Museum of Art, Los Angeles, gift of Lois Outerbridge

opposite:
Tapestry, **2005**
hand-woven Ecuadorian wool, 10' × 10'

LA Artland

Shift Scale

ing

Chris BURDEN
Won Ju LIM
Pauline Stella SANCHEZ
Paul SIETSEMA

Chris BURDEN

My work has gone from dealing with personal issues of power to external issues of power.
–Chris Burden

Chris Burden catapulted to fame in 1971 with the Aktion-inspired performance *Shoot*—of which there is little documentary evidence, apart from a few indistinct photographs and this perfunctory description: "At 7:45 p.m. I was shot in the left arm by a friend. The bullet was a copper jacket 22 long-rifle. My friend was standing about fifteen feet from me." A vital figure in the development of body art and performance, his early work was consistently aggressive, dangerous and physical. He shot at airplanes, crawled through glass, and even received a near-lethal electric shock from electrodes implanted in his chest.

From 1975 onwards, however, he made fewer performances, instead working on sculptural and engineering projects such as *B-Car*, 1975, an idealistic vehicle "able to travel 100 miles per hour and achieve 100 miles per gallon." Burden's fascination with the relation of the individual to an urban, technological society would result in a sizeable body of work focused on utopian systems of transportation and architecture, exemplified in recent pieces like *Small Skyscraper*, 2003, and his series of stainless steel bridges, in construction since 1998. Built entirely out of replica steel erector set pieces—a popular toy for boys at the turn of the twentieth century—and coming in a range of sizes and shapes, the bridges reflect Burden's interest in children's toys, engineering and urban design. The largest, *Curved Bridge*, 2003, is a gleaming 32 foot long arc, and unlike the other bridges in the series it has no counterpart in the real world. *Curved Bridge* functions as an abstraction, condensing the space-defying and space-creating qualities of a bridge into an idealized, simple structure. All of Burden's other models are meticulous scale replicas of existing structures, such as Gateshead's Tyne Bridge and the Hellgate Bridge in New York. One of his future plans is to build an actual 300 foot long bridge, over a ravine on his property in Topanga Canyon, Los Angeles.

More immediately, he is using this property as one of the sites for his *Small Skyscraper*, a structure he designed as a functional, cheap and speedily assembled domestic living space. LA's building code allows for structures to be erected without a permit, provided they are less than 35 feet high and under 400 cubic feet in volume. Fitting these requirements precisely, Burden created a five-storey mini-scraper, which could be erected efficiently and "quasi-legally" on any piece of land in the county. His deadpan description of the piece as "kind of like a modern-day log cabin" conveys some of the Walden-esque spirit of self-sufficiency evoked by the structure, but also something of its utopian absurdity in a world where Walden Pond might well be overlooked by high-density urban housing developments. **G.S.**

Curved Bridge, 2003
stainless steel
reproduction Mysto Type
I Erector parts, wood,
32' 6" × 57" × 96"

opposite:
Hell Gate, 1998
metal Meccano and
Erector construction
parts, wood
28' 3" × 7' 5" × 40"

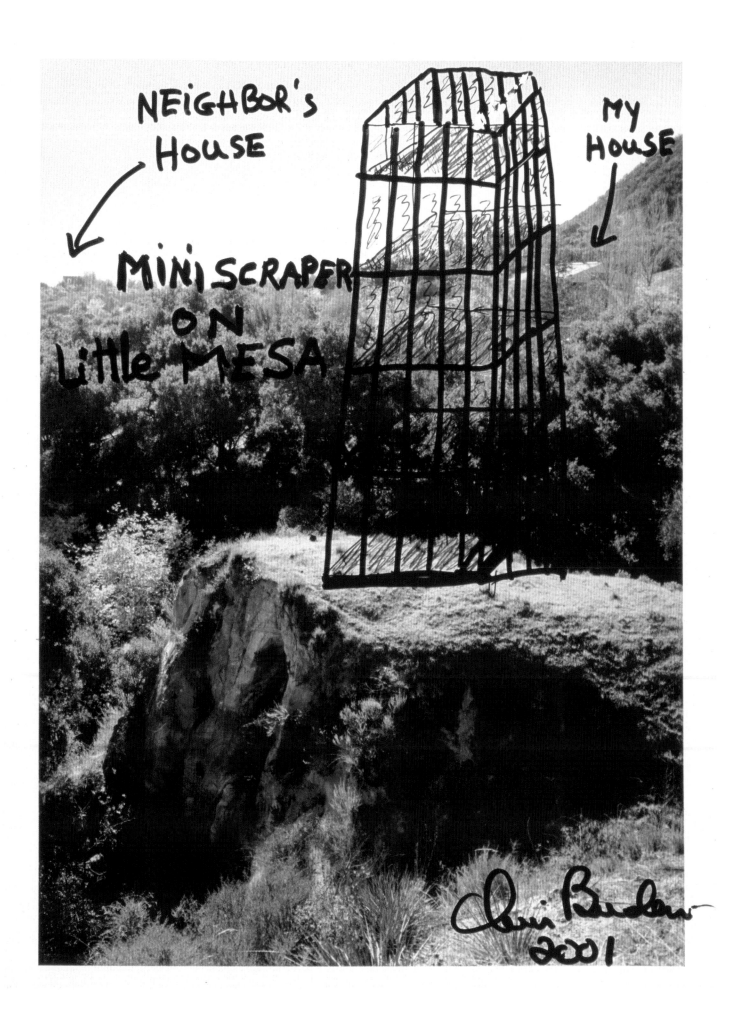

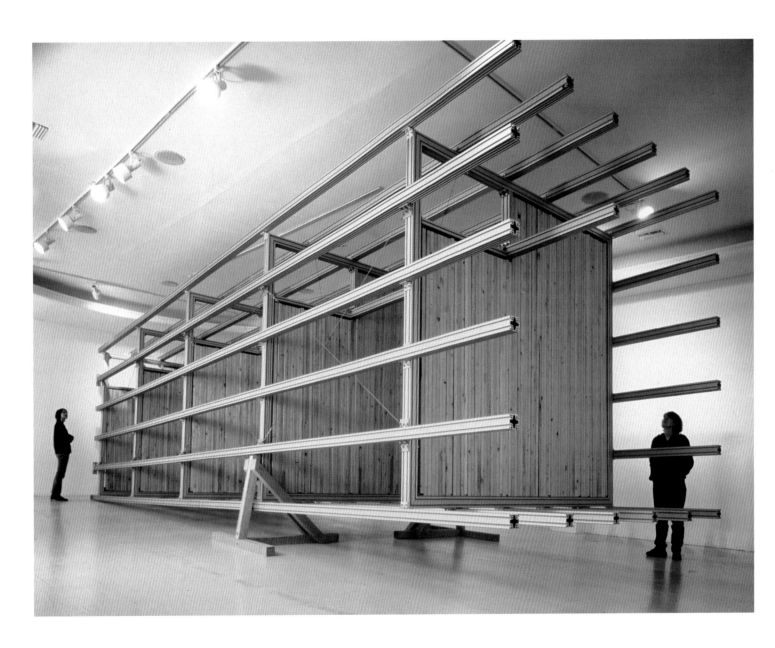

Small Skyscraper, 2003
structural aluminum
framing, wood, stainless
steel cable, turnbuckles,
clips and angles, t-nuts,
bolts, 10' × 10' × 36'

opposite:
**Mini Scraper on Little
Mesa, 2001**
black and white
photograph with ink
sketches, 8" × 10"

Won Ju LIM

The architectural constructions of Korean-born artist Won Ju Lim mobilize the familiar and iconic imagery of the cityscape to investigate physicality, space, memory and artifice. Her room-sized installations, constructed from densely interlocked groupings of plexiglas and foam core, are illuminated within and without by light sources and projections from various angles, evoking the impression of what she terms "futuristic ruins": a vision of the urban, post-industrial landscape "synergizing the classical past and Hollywood fantasies of the future."

Lim often utilizes mythic or historical contexts to provide an ironic counterpoint to the present-day targets of her work. *California Dreamin'*, 2003, a Plexiglas construction lit by lamps, with picture postcard slide projections and a video of Los Angeles, was apparently inspired in part by the sixteenth century historical fiction of a paradisiacal island named California, populated by women warriors. The commingling of mythical allusions with a (quaintly) futuristic aesthetic drawn from films such as *Blade Runner* and *Logan's Run*, gives Lim's work an unsettling indeterminacy as to the actuality of the familiar urban vistas presented.

This dissonance is explored further in Lim's recent project *Memory Palace*, 2003. A departure from her more typical room-sized installations, the work features numerous light boxes, of varying sizes, within which are placed opaque and translucent objects in the form of stairwells, columns, balconies and terraces. The pieces are backlit against a frosted Mylar screen, creating hazy and evocative panoramas that are oddly familiar, yet impossible to place in either space or time. The architectural shorthand is deliberately vague, such that the viewer is left unsure what exactly is being depicted, whether future or past, wasteland or utopia. The title of the series nods to the medieval mnemonic device of mentally constructing an architectural interior, which can then be filled by imagined objects as an aid to memory—fitting, given that in Lim's imaginary spaces, the projection onto the work of the viewer's memories and preconceptions is as vital as the projection of light coming off it. **G.S.**

Terrace 49 (No. 8), **2003**
mixed media,
30" × 80" × 20"
photo: Fredrik Nilsen

opposite:
California Dreamin',
2002
installation at Galerie
Max Hetzer
plexiglas, foam core
board, DVD and still
projections, and lamps,
dimensions vary

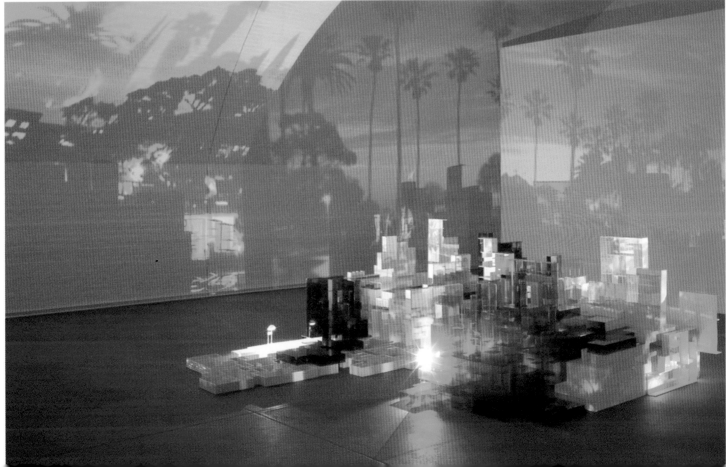

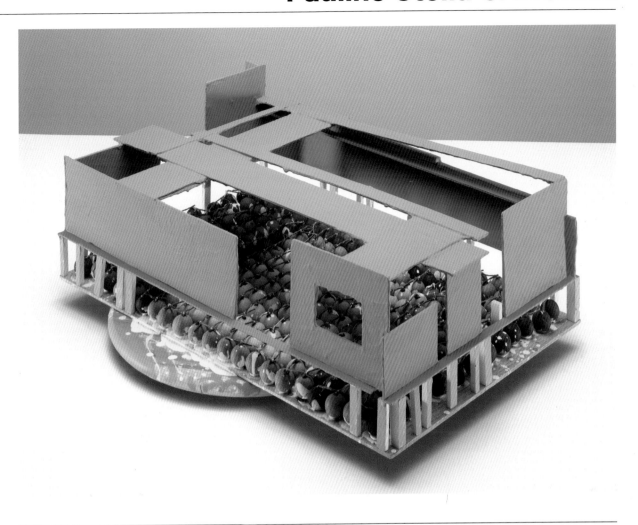

Gone Mad Blue/Color Vaccine Architecture or 3 state sculpture: before the event, during the event, and after the event. Seen here in before the event stage, **2004** installation view and detail at Rosumund Felsen Gallery, Santa Monica temperature, cartoon color, neo-plastic memories, glue, dominant cinema notes, color balls, wood, resin, string, meta-allegory of architecture as body, 10" × 19" × 25" photo: Douglas M. Parker Studio

The result of years spent traveling though global sun-worship sites, the mixed-media oeuvre of Pauline Stella Sanchez shows a resolute interest in solar supremacy.

In her *Gone Mad Blue/Color Vaccine* series, 2004, Sanchez presents us with a fully responsive sun-architecture, built, at least in maquette form, to change with each phase of solar events. These vibrant temples, reminiscent of Mies van der Rohe's *Farnsworth House* after some extensive roof redevelopment, come splashed with Yves Klein blue and what the artist calls "cartoon color" or "surrogate sun yellow," whose presence evokes the touch of the sun on these structures, within and without. Inside, smoke bombs carpet the floor as if waiting for ignition by sunbeams streaming in through the cantilevered roof above. In gallery installation, Sanchez pairs this work with a projection of color photographs from *The New York Times*. Once known as "the Grey Lady," the paper has now bowed to the modern demand for color in all media, corroborating Sanchez's belief in the powerful role of rainbow hues and CMYK in shaping our realities.

These models contrast greatly with her previous *Sun porn* series from 2001. In these earlier works Sanchez eschews her trademark palette altogether to create sculptures approximately one third of adult height that evoke the beautiful chaos of a building falling down, or a breeze blowing through a stack of papers. Cascading planes tipping inward and outward create chiaroscuro spaces that call to mind the bas-reliefs of Louise Nevelson, though without the rigid order. Sanchez calls these items "accent furniture," though they seem to accept a domestic role only with sullen resignation, and speak more of destruction or dissolution than of traditional homemaking. In opposition to the brash environment of the *Gone Mad Blue/Color Vaccine* series, which seem to burn with the manic energy of a cult on the brink of mass suicide, these items speak of a world ending in ice, not fire. **E.L.**

> [T]he most important realization for me is that art seems to be a series of structures and constructions that interlock and have a multiplicity of social and political reverberations. With this in mind it is important to realize that as an artist I am the spectator/viewer and structures of space and light and language are episodes of investigation for me.
> –Pauline Stella Sanchez

Paul SIETSEMA

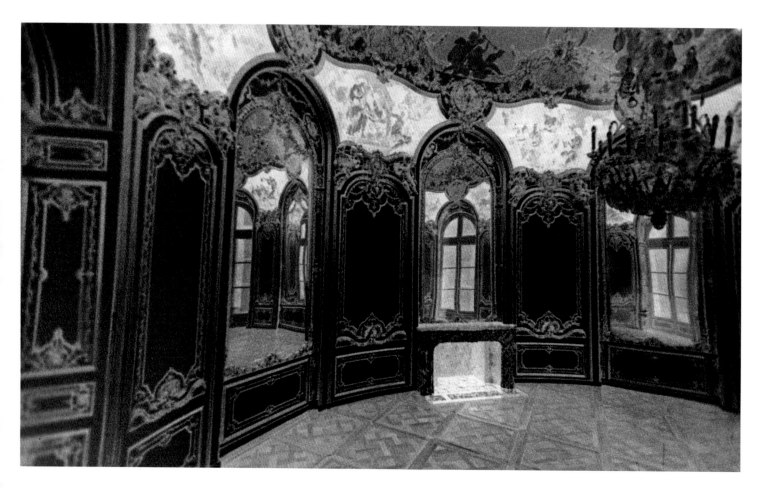

Paul Sietsema is known for his innovative films of sculptures and drawings addressing the themes of temporality and spatial perception. He first came to prominence with *Untitled (Beautiful Place)*, 1998, in which eight painstakingly crafted paper models of flowers were filmed for two minutes apiece. Four years of work went into the making of his next and most recent work, *Empire*, 2002, a 16mm film that explores the various forms of space in which objects can exist; the architectural space of Clement Greenberg's living room is reconstructed in miniature from a 1964 *Vogue* magazine spread of the art critic's apartment. Projected in negative, with a red sepia cast, the formalist space is contrasted with the eighteenth century rococo grandeur of the Hôtel de Soubise in Paris. A grasshopper on a branch, constructed from paper and wire, fades in and out of view against a grainy black background. Like the Hollywood sets and props that embody a certain conception of Los Angeles on film, the objects on view are *trompe l'oeil* facsimiles of reality, buffed and idealized to exacting precision, but the connection between the space they occupy and the space they construct is never very clear. Scale, form and topography shift constantly, as space reveals itself in two dimensions then in three, in macro scale then in micro. The jarring effect of these transitions is heightened by the uncertainty Sietsema provokes about what we are actually perceiving. None of these objects are *real* in the expected sense: like the flowers, they are all sculptures, fashioned by the artist in meticulous detail. The title of the piece nods to Warhol's *Empire*, and in fact it runs to precisely 24 minutes against Warhol's 24 hours. Warhol, however, is just one of a plethora of targets in this extremely rich film. Warhol's *Empire* was shot in 1964, the same year that Greenberg's apartment—the acme of formalist modernism—was photographed, and, according to the sirtist, "the point at which the possibility of an 'avant-garde' was lost completely." Greenberg's conception of art as a vehicle of progress and historical development is deflated by Sietsema, not by mere assertion, but by a visual demonstration of the unique expressive potential of many different spatial models. **G.S.**

*Empire Film Still
No. 8*, 2002
16mm film without
sound, 24 minutes

opposite:
Rococo Room, 2002
mixed media,
120" × 96" × 120"

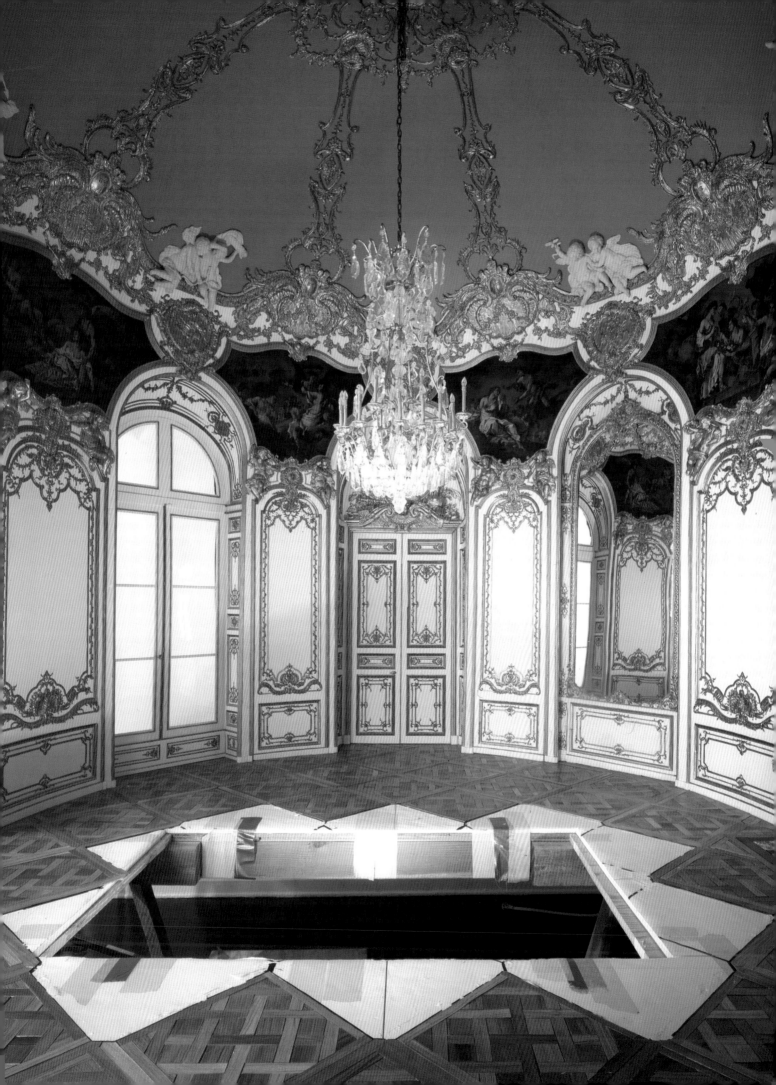

Devia
Ritua

ant

ls

Ron ATHEY
Vaginal DAVIS
Julian HOEBER
Mike KELLEY
Martin KERSELS
LOS SUPER ELEGANTES
Paul McCARTHY
Marnie WEBER

Ron ATHEY

To watch Ron Athey is to bear witness to a body subjecting itself to the limits of its capacity for pain and pleasure. In performance, his body immerses itself in the breach at which these meet. He has permitted himself a consummate knowledge of the ways in which a body can be punctured, forced open, pushed to rapture and on into crisis, and eventually reconciled itself anew. Giving his body up to horror, he explores in the flesh what a body is, what it can and cannot withstand. These explorations are a reflection of Athey's "fundamentalist Pentacostal upbringing, a decade of drug abuse" and finally the massacre that came with the spread of the AIDS virus.[1]

 In works such as *Martyrs & Saints*, 1992, Athey challenges the purported sanctity of the body, and specifically the meanings and values that claim sovereign command of it through religious and other disciplinary logics. In works such as *Four Scenes in a Harsh Life*, 1994, Athey explores the relation between body and text in the context of his experience of drug abuse and HIV infection, rehearsing the emergence of verbal testimony within the register of physical crisis. In his latest performance *The Judas Cradle*, 2005, a collaboration with the soprano Juliana Snapper, Athey's body undergoes the withdrawal of the word from signification but not from meaning or purpose, undoing the work of culture to the brink of rupture. Having been prone to speaking in tongues since an early age, Athey uses this guttural language ("glossalalia") in collision with his 2005 practical operatic training in this performance. Here, these two voices are used to test, and irreversibly extend, his vocal capacity, mirroring the threat he poses to his body throughout his performance practice. The central image of the piece is his harrowing anal impalation on a large wooden pyramid, a structure modeled on the medieval torture instrument whose name he borrows for the title. Baptized in pain, Athey's body pleads in the blood, reclaiming the instruments of torture to create personal practices at the limits of the cultural enterprise. So doing, he grants legitimacy to the subject's hope for meaning through self-determination, without the question of wishful salvation being put on every gesture of the body's exposed life. **D.J.**

1 Athey, Ron, "Some thoughts on the politics of the body and the problematics of documentation," *Exposures*, London: Black Dog Publishing, 2002, p. 6.

left:
The Judas Cradle,
2005
performance, 291
Gallery, London
photo: Manuel Vason

right:
The Judas Cradle:
Purse, **2005**
performance, 291
Gallery, London
photo: Manuel Vason

opposite:
The Judas Cradle:
Auto Da Fe
(Glossolalia Scene),
2005
performance, 291
Gallery, London
photo: Manuel Vason

Orifice Descending,
2002
performance,
Visions of Excess,
AKSIOMA /Kapelica,
Ljubjiana, Slovenia
photo: Miha Fras

opposite:
**Manuel Vason and
Vaginal Davis**
Untitled Collaboration,
2005
photo: Manuel Vason

Gender-queer art-music icon Vaginal Davis is an originator of the homo-core punk movement. Her concept bands—including Pedro Muriel and Esther, Cholita! The Female Menudo, and the Afro Sisters—have left an indelible mark on the development of underground music. Set apart from gallery-centered art, and Hollywood movies, and from those systems' necessities of high-polish, low-substance production, Davis's low-budget performance, experimental film and video practice has critiqued exclusionary conceits from the outside. Davis is a prolific producer of club performance, video and Xerox-produced fanzines, and other forms of antagonistic low-cost, high-impact work.

In *Don't Ask, Don't Tell, Don't Care*, 2000, her drag lampooning of Vanessa Beecroft, Davis derails collector-friendly raciness in spectacles of femininity, queerness and blackness. She critiques both the gallery system and the larger cultural trend that it mirrors, with tongue-in-cheek self-exploitation and rude provocations of racial and gender confusion: Davis is the key proponent of the disruptive performance aesthetic known as "terrorist drag." Similarly, in works such as *Orifice Descending*, 2005, Davis continues to disrupt the cultural assimilation of gay-oriented and corporate-friendly drag. Here, Davis brings together catchy songs with unsavory subject matter, video elements and vaudeville antics. Doing so she positions herself at an uncomfortable tangent to the conservative politics of mainstream gay culture, to mine and burlesque its contradictory impulses.

A self-labeled "sexual repulsive," Davis employs punk music, invented biography, insults, self-mockery, and repeated incitements to group sexual revolt, all to hilarious and devastating effect. Her body a car-crash of excessive significations, Vaginal Davis stages a clash of identifications within and against both heterosexual and queer cultures, and Black and Latino identities. Davis' raucous personas reject the internal counter-cultural mandate to refuse self-criticism, instead problematizing the functions and assumptions of normative trends within the margins. By renewing uncertainties within alternative cultures and identities, Vaginal Davis opens up spaces for their continual struggle towards renewed and greater challenges, over and against these practices' timid appeasement and appropriation by the mainstream. **D.J.**

Julian HOEBER

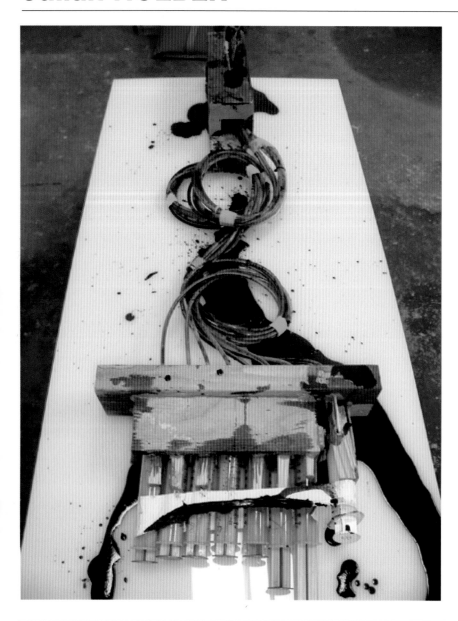

Julian Hoeber's work uses the moribund sensibility of the Gothic and the spiky attitude of punk in a sly, humorous simulacral melting pot. Brechtian techniques of distancing slide into alliance with the mediated and banal horror of serial killers or political (dys)functionaries.

In Hoeber's 2001 video, *Killing Friends*, we witness the seduction and murder of victims by an impassive young man, yet later in the film we see these same victims manning the cameras and other filmmaking equipment. Half homage to the body-schlock horror, half self-referential conceptual art, Hoeber's work looks at our fascination with screen-mortality and its concomitant glamour. Showing an alliance to many of the tendencies associated with West Coast artists, Hoeber combines laconic humor with the death drive in a rose-tinted nihilistic stance. Installing his time-based work in galleries alongside production stills and props, this format offers another relationship to his narrative—producing possible moments of reflexivity, calling up the slick artifice of the production with its beautiful lighting and actors, as well as inviting you to lose yourself in contemplation of its traumatic irony.

His exhibition entitled *I wasn't joking. You were joking. I was serious.* at Blum & Poe gallery in 2005, is an extension of this film and installation dyad. Showing his feature length film, *Talkers are No Good Doers*, alongside a wealth of photographs, drawings and ephemera produced in relation to the film (as both primary material, references and offshoots); his main narrative, concerning a group of young Los Angelenos embarking on a disaffected voyage of self-destruction, can be seen within a network of possible cultural connections and disaffections. Locating his film within the tradition of naturalistic filmmakers like Cassavettes, Hoeber's work continues the interests of other visionary dystopian artists, such as Cady Noland and Larry Clark, who use America and its obsessions (from its own grand narrative to its most banal minutiae) as a sounding board for our moral condition. **F.S.**

Killing Friends, 2001
installation view
mixed media,
dimensions vary

opposite:
Killing Friends, 2001
video, 31 minutes

Mike KELLEY

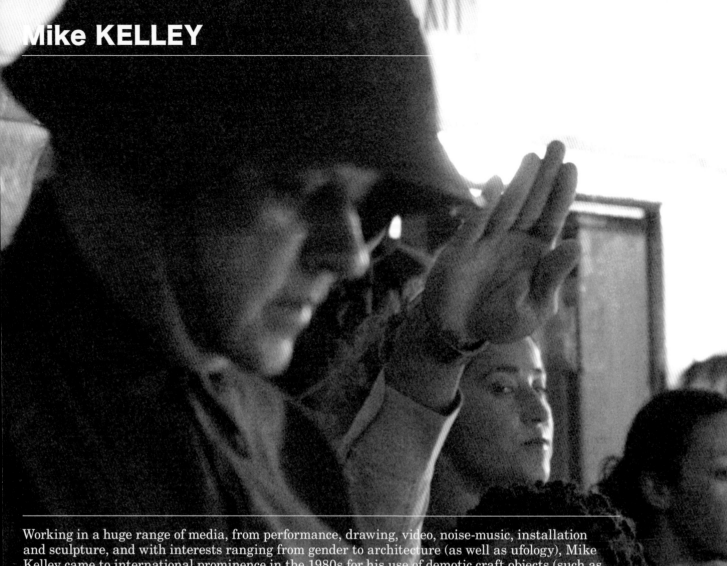

Working in a huge range of media, from performance, drawing, video, noise-music, installation and sculpture, and with interests ranging from gender to architecture (as well as ufology), Mike Kelley came to international prominence in the 1980s for his use of demotic craft objects (such as felt banners) and thrift store toys presented as shambolic totems. His work, although sometimes deceptively simple in its presentation, is never conceptually straightforward, revelling in proliferating complexities and allusions that disturb and deconstruct his appropriated, reworked or collected material in a series of studied cultural collisions.

Much of Kelley's recent work looks at the social pathology of Repressed Memory Syndrome (a pop-psychological idea where forcibly forgotten trauma results in a number of behavioral disorders)—producing fictional re-staging of victimizing or repressed scenarios. Continuing this idea, his current *Extracurricular Activity Projective Reconstruction Series* stems from his collection of year book photographs which depict extracurricular activities with a particular emphasis on "socially accepted rituals of 'deviance,'" ranging from plays to Halloween activities, religious performances and equestrian events. The first piece in this series, *Extracurricular Activity Projective Reconstruction Series No. 1 (A Domestic Scene)*, made in 2000, is a 30 minute video play based on a single ambiguous found photograph. Realized as a darkly hilarious melodrama it brings together the stylistic literary ghosts of Tennessee Williams, Saul Bellow and Sylvia Plath in a clipped story of hysterical homosexual panic and dark paranoia. The next installment of the series, *Extracurricular Activity Projective Reconstruction Series No. 2–No. 32 (Day is Done)*, 2005, brings together a flowing montage of scenarios in a feature-length-musical-meets-gallery-installation with technicolor satanic rituals, thugs and wizards.

Working through collected images and objects, his curatorial project, *The Uncanny*, first shown in 1993 (recreated in 2004), shows Kelley's interest in working through cultural phenomena and the psychology that is lodged in them. Concentrating on the Freudian idea of the return in the adult of psychologically repressed childhood complexes, *The Uncanny* looks specifically at the triggering of confusing feelings by figurative sculpture. This project brings together a vast array of works (and images) from the realms of "high" art (both contemporary and historical) as well as those with other uses, such as the devotional, the erotic and the scientific alongside Kelley's own strangely fetishistic collections of business cards, shot glasses, spoons, album covers and pornography. As a curatorial project *The Uncanny* aptly demonstrates Kelley's working methodology as he rigorously engages with historical and theoretical ideas through experimental reconfigurations and unexpected archaeological excavations through the social fabric. **F.S.**

Day is Done (Extracurricular Activity Projective Reconstruction Series), 2004–2005 images from the Movement Portfolio

Candle Lighting Ceremony color photograph 30" × 23 ½"

opposite: *Exotic Dancer* color photograph 30" × 23 ½"

overleaf left: *May Maenad* color photograph 30" × 23 ½"

overleaft right: *The Wizard* color photograph 30" × 23 ½"

Martin KERSELS

Martin Kersels started his artistic life as a member of the performance group The Shrimps, with whom he worked between 1984 and 1993, before he went back to college to study installation art with the likes of Paul McCarthy and Chris Burden. He is well known for his stature (physical that is) and he uses this considerable size with resounding effect in many of his art pieces—especially those in which he photographs himself throwing and spinning his smaller compatriots about. His work could be defined as unflaggingly boisterous, jumbling conceptual levity with a weighty gravitational pull.

　　Playing on ideas of slapstick comedy, pratfalls and the like, Kersels's work may no longer be performance based, but it still uses many time-based characteristics, for example, sound, mechanized installation and video. An early work that used movement and sound in an unexpected way is *Objects of the Dealer*, 1995, a site-specific installation in which he wired up a gallery dealer's trade tools (computer, Filofax, phone, etc.) to walkmans that splurged out Morricone-esque muzak when used. Other objects that have been subjected to Kersels's tender mercies have been a baby grand piano (wired for sound and dragged across the floor by a winch) and prosthetic legs, which have been wound up until they spastically kick against the wall.

　　Kersels's best-known work is his sculptural installation *Tumble House*, and the accompanying video *Pink Constellation*, both 2001, an homage to the physics-defying frolics of Fred Astaire in Stanley Donen's 1951 *Royal Wedding*. The artist created his own revolving chamber resembling a girl's bedroom (which has been installed in numerous gallery contexts), and shot a video of it with himself and the performer Melinda Ring dancing through the rotating pastel space, until, one by one, the room's furnishings are unleashed. The result resembles a washing machine full of broken furniture, materially and symbolically bringing the illusion of weightlessness to a crushed end. **F.S.**

left:
***Tossing A Friend
(Melinda)*, 1996**
cibachrome print,
40" × 60"

right:
***Pink Constellation*, 2001**
video, 20:16 minutes

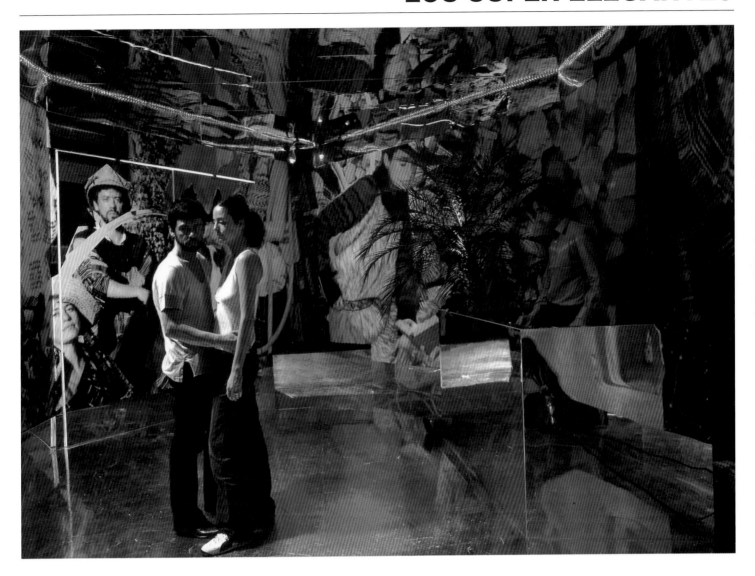

Make it with You: A Slow Dance Club, **2005**
installation, Frieze Art Fair, London
plywood, wallpaper, palm trees, mirror, DJ booth, 20' × 14'

Los Super Elegantes is a collective-pop-mongrel given birth to by the artists Milena Muzquiz and Martiniano Lopez-Crozet. Formed in 1995, three years after their initial meeting and participation in the collective CCSIS (Creative Community Seriously I Swear) in San Francisco, Los Super Elegantes was formed as a one-off performance that grew as the notoriety of their shows spread. Combating their initial inability to perform musical numbers by sheer bravado and natty costumes (with a drag-queen touch here, a brazilio-electro-mexico-clash flounce there) their work has grown to encompass many different musical genres as well as spreading into other media, such as installations, video and photography.

Relocating from San Francisco to Los Angeles (via Mexico City) they have been courted by various music labels, such as BMG and Chrysalis, but the pop mainstream has so far eluded them due to their inability to remain in one musical niche. Constantly shifting and deterritorializing their own audible productions they have moved from mariachi-punk to electronica inspired dance hall, with excursions into traditional Mexican folk music. With participations in 2004 in London's prestigious Frieze Art Fair, the Whitney Biennial and UCLA Hammer Museum's *Mixed in Mexico*, they seem to be building a sure footing in the art establishment as well as the purely musical stage.

Mixing a Warholian deadpan humor with the retarded melodrama of underground artist Jack Smith, along with a dash of the cultural savvy of such art/music crossovers as Fischerspooner, Los Super Elegantes typify a trend in contemporary art that has precipitated a number of mobile art practices that refuse to concretize themselves into critical clichés. They prefer instead to treat art-production as a good night out, favoring a sonically challenged theater of the absurd, privileging ludicrous showmanship and slipshod glamour over the serious business of culture. Revelling in their own amorphousness these artists present a sparkling challenge to the future and a well-deserved hangover for tomorrow. **F.S.**

Paul McCarthy is an artist who is unparalleled in his monstrous literalization of unconscious cultural fantasies and perverted spectacular desires. Emerging from the traditions of the 1960s including experimental film, pop art, minimalism, and happenings, he combines features from these historical-contemporary genres into a mutated hybrid of "quasi-pop-expressionism" where the structural games of the experimental meet the full bodily force of the excremental. Using a series of appropriated stock characters from the Sailor to Santa, or from Daddy to Heidi, McCarthy produces an infantilized political theater in which pedagogical imperatives and social hierarchies are lambasted through a technique of materialist free association, with culturally banal objects and signs (such as ketchup, chocolate or Pinocchio) transformed into abhorrent artefacts with critical use-value. Like a strange game of Chinese whispers, McCarthy's work feeds off a source idea (be it expressionist painting, or a children's cartoons) and through a series of transformational gestures and exaggerations exposes their subliminal (and often sexualized) violence.

His earliest work in the 1970s often played with ideas of spatial perception and experience—a concern that has carried into his recent installations and performances (where boxes, bodies and space intersect), as well as looking at how the body could be used as an object, as in his self-instructional performance for the camera, *Plaster Your Head and One Arm into a Wall*, 1973. His 1974 piece *Sailor's Meat* took this idea of performing for the camera further as he introduced distorted role-play (himself as a sailor in a blond wig and feminine underwear), foodstuffs (raw meat, mayonnaise) and taboo acts (he simulates sex with the meat in a hotel room and eats a urine covered sausage).

Throughout the 1980s he continued to work in performance, and in the early 1990s began to combine performance, video and installation. At the same time sculptures and automated mannequins appeared as durational performance stand-ins for gallery exhibitions (his notorious *Cultural Gothic* of 1992, in which a father teaches his son to have intercourse with a goat is one example; the boy humps away in mechanical obedience). He continues to produce performance videos, including *Piccadilly Circus*, 2003, where performed caricatures of George W. Bush, the Queen Mother and Osama Bin Laden all make an appearance. All of McCarthy's work, from the simplest drawing to the largest installation, is based on the principle of producing a primordial cultural goo through which he wades, bringing us on a journey where play and tyranny are enacted

left:
Piccadilly Circus:
Queens on the Table,
2003–2004
performance, video
photo: Ann-Marie Rounkle

right:
F-Fort Party, 2005
performance, video at the
Haus der Kunst, Munich
photo: Ann-Marie Rounkl

opposite:
Basement Bunker:
Painting Queens in the
Red Carpet Hall 3, 200
performance, video

Marnie WEBER

Marnie Weber's work is a beguiling mixture of performance, song, video and collage, defined by a certain home-spun artifice and laconic pathos. She has developed a complex fairy tale world filled with hobbling bears, human faced flowers and old lady poodles.

Playing in the band the Party Boys she developed her performance work along the musical line, with works such as *Music for Daydreaming*, 1988, featuring the artist in an oversized flowing white dress and matching antlers, strumming a bass guitar. Building her own unique style of poetically oriented narrative, where the viewer could access her stories on many different competing registers, Weber has developed an impressive body of work that weaves fantasy, irrational images, bucolic tendencies and animal-costumed craziness. Her recorded musical work can be found on CD, such as her *Cry For Happy* (released on Ecstatic Peace! in 1996), featuring such songs as "Happy down the bunny trail" and "The return of her brain" in a drone-filled melancholic soundscape.

During the mid 90s Weber also began to make collages (most famously appearing on the front of Sonic Youth's album *A Thousand Leaves*) which incorporates found imagery from a wide range of sources—often combining naked women (or bits thereof) with hordes of animals in scenarios that are reminiscent of the psychosexual free play of the Surrealists (but as seen through a psychotropically altered position).

Her most recent project, *Spirit Girls, Songs That Never Die*, 2005, is a culmination of many of her performance and collage characteristics—i.e. lo-fi theater, sad songs, and disconnected abstracted associations. It began as an idea for a stage musical where a group of ghost girls came together to put on a werformance in their after-life, relaying their beautiful tales of woe to a group of lost animals. As a development of her vocabulary of illogical images, this new work is produced as a whole environment incorporating the genres of performance art, theater, musicals and traditional collage in an interdisciplinary haze of fairy tale proportions. **F.S.**

Old Lady Poodle, 2002
performance

opposite top:
***Birdcage*, 2005**
production still from
Spirit Girls, Songs That Never Die

opposite bottom:
***Five Spirit Girls*, 2005**
production still from
Spirit Girls, Songs That Never Die

overleaf:
***Sea Spirit*, 2005**
production still from
Spirit Girls, Songs That Never Die

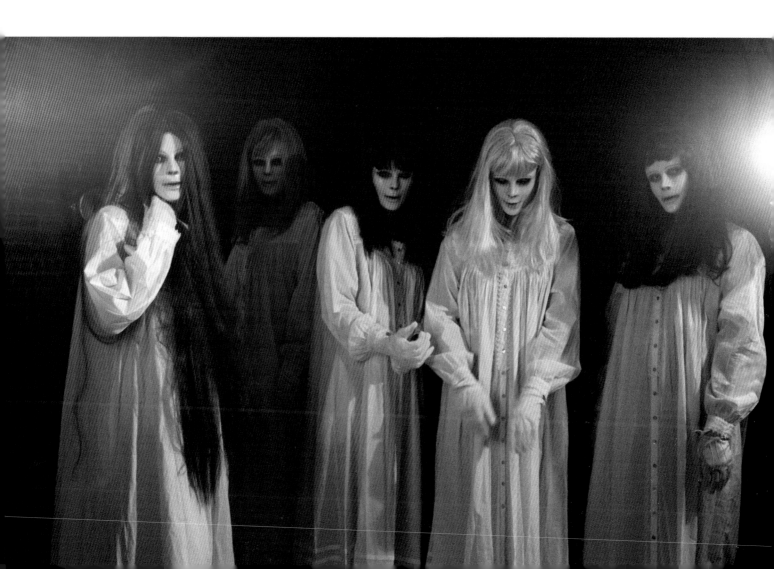

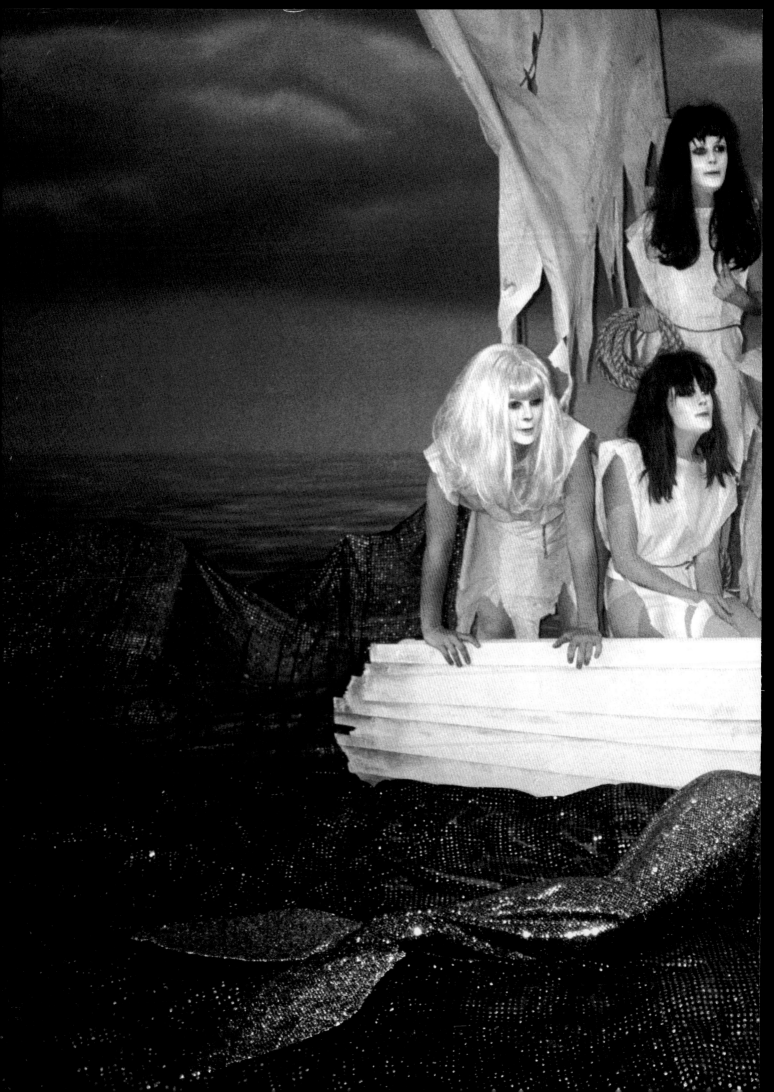

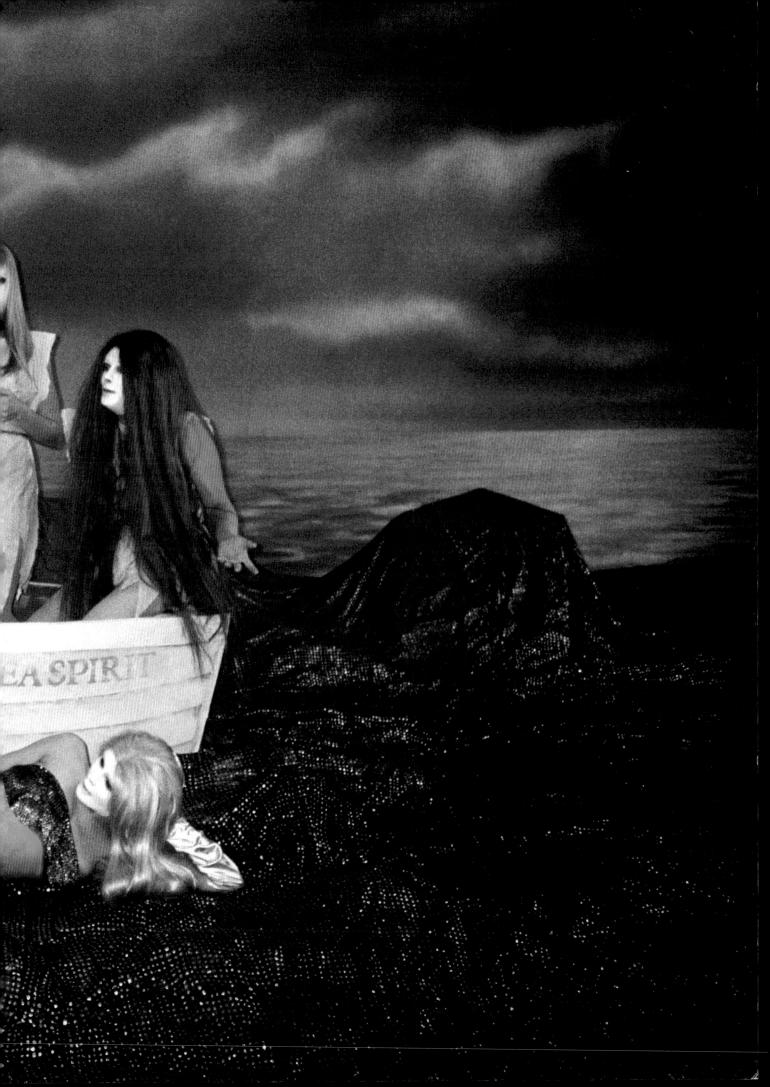

Chris Kraus

Chris Kraus, literary writer and art critic, is the author of a book of essays on the LA artworld entitled *Video Green: Los Angeles Art and the Triumph of Nothingness*, 2004, as well as two novels *Aliens & Anorexia*, 2000, and *I Love Dick*, 1997. Moving from the East Village to Los Angeles in 1995, she taught for seven years in the Art Center College of Design Graduate Fine Arts program. Her books have twice appeared on *Artforum*'s Top Ten lists, and *Index* magazine has called her "one of the most subversive voices in American contemporary fiction."

Jane McFadden

Jane McFadden, Ph.D., is the Associate Chair of Liberal Arts and Sciences and the Director of the Graduate Program in Criticism and Theory at Art Center College of Design in Pasadena. She is an art historian of modern and contemporary art whose work focuses on the interdisciplinary practices of the 1960s. She is currently working on a book on Walter de Maria.

Jan Tumlir

Jan Tumlir is an art-writer who lives in Los Angeles. He is a founding member of the local art quarterly *X-tra* and is regularly published within the pages of *Artforum*, *Flash Art* and *Frieze*. In addition, he has written catalog essays for such artists as Bas Jan Ader, Kevin Appel, Uta Barth, Cecily Brown, David Bunn, De Rijke & De Rooij, John Divola, Jorge Pardo, Jennifer Pastor, Mungo Thomson, Jeff Wall and Pae White. Tumlir teaches critical theory at Art Center College of Design, Pasadena and University of Southern California, Los Angeles.

Biographies

Designing Environments

Jorge Pardo
Born 1963, Havana, Cuba

Jorge Pardo emigrated to the United States in 1969 and began his studies at the University of Illinois in Chicago before finishing his BFA at Art Center College of Design in Pasadena in 1998. Since his first solo show, he has participated in various exhibitions and been part of several permanent projects in Europe and the United States. In 2001 he was awarded the prestigious Lucelia Artist Award in recognition of exceptional creativity by the Smithsonian American Art Museum. He lives in a home that he designed himself as part of a major exhibition of his work at the Museum of Contemporary Art, Los Angeles.

Selected Exhibitions
2005 *100 Artists See God*, The Contemporary Jewish Museum, San Francisco, CA; Laguna Art Museum, Laguna Beach, CA; Institute of Contemporary Art, London, UK; Contemporary Art Center of Virginia, Virginia Beach, VA; Albright College Freedman Art Gallery, Reading, PA; Cheekwood Museum of Art, Nashville, TN
In Situ 2000–2005, Häusler Contemporary, Munchen, Germany
2004 *26 Bienal De São Paulo*, Fundacão Bienal De São Paulo, São Paulo, Brazil

Jennifer Steinkamp
Born 1958, Denver, Colorado

Jennifer Steinkamp began studying Motion Graphics at California Institute of Arts in 1984 and finished her BFA at Art Center College of Design in 1989 with an honors degree in Design and Fine Art. She went on to receive her MFA in Fine Art, also from Art Center in 1991. Her mesmerizing and hallucinatory video and computer animation projections quickly brought her repute and she has since been included in the eighth annual Istanbul Biennial, 2003, and has participated in shows at the San Jose Museum of Art as well as the Seoul Museum of Art. Her video and new media productions have been exhibited throughout Europe and the US.

Selected Exhibitions
2006 *Juniper,* San Jose Museum of Art, San Jose, CA
2005 *Jennifer Steinkamp,* Lehmann Maupin, New York, NY
2004 *Jennifer Steinkamp,* greengrassi, London, UK

Diana Thater
Born 1962, San Francisco, California

Diana Thater received her BA in art history at New York University in 1984, and her MFA from the Art Center College of Design in Pasadena in 1990. She has been a lecturer in New Genres at UCLA and currently teaches at Art Center. Her video and large-format projection works have been exhibited in biennials throughout the world, including Lyon, 1995, Sydney, 1996, Whitney, 1997, and Carnegie International, 1999. Her solo exhibitions have included the Walker Art Center in Minneapolis, The Renaissance Society in Chicago and Witte de With in Rotterdam.

Selected Exhibitions
2005 *Diana Thater. Continuous, Contiguous.*, David Zwimmer, New York, NY
2004 *Friedrich Christian Flick Collection,* Nationalgalerie Im Hamburger Banhof, Staatliche Museum, Berlin, Germany
2003 *Diana Thater: Transcendence Is Expansion And Contraction At The Same Time*, Haunch of Venison, London, UK

Pae White
Born 1963, Pasadena, California

Pae White received her BA at Scripps College in Claremont, CA, and her MFA from Art Center College of Design in Pasadena. She also studied at the Skowhegan School of Painting and Sculpture in Maine. Represented by greengrassi in London, 1301PE in Los Angeles, and Galerie Francesca Kaufmann in Milan, her solo exhibitions have spanned the globe, but she continues to maintain a strong presence in Los Angeles. Unbound by the confines of her studio, White's graphic design work has made its way into numerous publications and advertisements, as well as a rapid-transit bus stop in Los Angeles.

Selected Exhibitions
2004 *Pae White*, Frieze Art Fair, London, UK
Pae White: *Hammer Projects*, UCLA Hammer Museum, Los Angeles, CA
2003 *Dreams And Conflicts: The Dictatorship Of The Viewer*, Venice Bienniale, Italy

Andrea Zittel
Born 1965, in Escondido, California

Andrea Zittel received her BFA in painting and sculpture at San Diego State University in 1988, and her MFA in 1990 at the Rhode Island School of Design. Her office for *A–Z Administrative Services* was founded shortly thereafter in Williamsburg, Brooklyn. This multi-faceted production venue is now based in Joshua Tree, California, and designs a wide range of items including furniture, luxury vehicles, and architectural structures. Her work has been shown around the world in galleries including the Andrea Rosen Gallery, Regen Projects, and Sadie Coles HQ. In 2004 her art was included in the Whitney Biennial.

Selected Exhibitions
2005 *A–Z Advanced Technologies*, Andrea Rosen Gallery, New York, NY
2004 *Western Evolutions*, Regen Projects, Los Angeles, CA
2002 *A–Z 2001 Homestead Units*, Sadie Coles HQ, London, UK

Elaborate Fictions

Anthony Ausgang
Born 1959, Point-a-Pierre, Trinidad and Tobago, West Indies

Anthony Ausgang began studying journalism at University of Texas at Austin in 1978 and in 1981 he transferred to Otis Art Institute in Los Angeles to study fine art under the illustrator and cartoonist Gary Panter. Dropping out to pursue his interest in underground comics, cars and surf films, Ausgang landed his first solo exhibition at Zero One Gallery in Los Angeles and made his first sale to a drug dealer. Current collectors of his work include celebrities such as Nicholas Cage, Perry Farrell and David Arquette. His artistic output ranges from album covers, T-shirts and posters for clients such as David Lee Roth and Tower Records to customized cars, and a miniature golf course hole, as well as commercial merchandise including cast resin figurines and lighters.

Selected Exhibitions
2005 *Surreal Populism*, The Shooting Gallery, San Francisco, CA
2004 *Double Trouble*, Copronason Gallery, Los Angeles, CA
Ausgang, Galerie Rudolfv, Amsterdam, The Netherlands

Brian Calvin
Born 1969, Visalia, California

Brian Calvin earned his BFA from the University of California at Berkeley in 1991 before gaining an MFA at the Art Institute of Chicago in 1994. Staying in Chicago until 1999, Calvin cut his aesthetic teeth playing in his band USA signed to the Drag City label. While working with Chicago music scene luminaries such as Bundy K. Brown and Jim O'Rourke, Calvin was also teaching at the Art Institute and progressing his career as a painter. Upon his return to California, leaving the band behind, his pictures of melancholic and disaffected youth seem to have taken something of this lo-fi indie rock sensibility with them. He is currently represented by Mark Foxx Gallery in LA, Gallery Side 2 in Tokyo and Corvi Mora in London.

Selected Exhibitions
2004 *California Biennial*, Orange County Museum of Art, Newport Beach, CA
Brian Calvin, Anton Kern, New York, NY
2003 *Baja to Vancouver: The West Coast in Contemporary Art*, Seattle Art Museum, Seattle, WA; MCA San Diego, CA; Vancouver Art Gallery, Vancouver, BC; CCAC Watts Institute, Oakland, CA

Carole Caroompas
Born in Oregon City, Oregon

The painter, performance artist, singer and educator, Carole Caroompas received her BA from California State University, Fullerton in 1968, and went on to earn her MFA in Painting from University of Southern California, Los Angeles in 1971. Developing her practice in the midst of the heated feminist movement of 1970s LA, she has become known for her large scale mixed media paintings which tackle romance and gender stereotypes using a myriad of appropriated signs and symbols from literary and art history as well as popular culture. She has exhibited extensively in galleries throughout California and the US. She is the recipient of numerous grants and fellowships including John Simon Guggenheim Memorial Fellowship and National Endowment for the Arts Painting grants. She currently teaches at Otis College of Art where she has taught for 18 years.

Selected Exhibitions
2004 *Carole Caroompas: Psychedelic Jungle*, Western Project, Los Angeles, CA
2000 *Heathcliff and the Femme Fatale Go on Tour*, Mark Moore Gallery, Santa Monica, CA
1994 *Before and After Frankenstein: The Woman Who Knew Too Much*, Sue Spaid Fine Art, Los Angeles, CA

Carolyn Castaño
Born 1969, Los Angeles, California

Carolyn Castaño earned her BFA from the San Francisco Art Institute in 1995 and her MFA from UCLA in 2001, studying at Skowhegan School of Painting and Sculpture during the Summer of 1997. She has exhibited extensively in San Francisco at the Yerba Buena Center for the Arts, the Meridian Gallery and New Langton Arts. In 1987 and again in 1993 Castaño was awarded National Endowment for the Arts grants. She currently teaches at the Otis College of Art and Design in Los Angeles, where she is represented by the Kontainer Gallery.

Selected Exhibitions
2003 *International Paper*, UCLA Hammer Museum Los Angeles, CA
2000 *Sin Titulo; Fragrant Afternoon*, Meridian Gallery, San Francisco, CA
1999 *The Adventures of Betty Ramirez and Little Miss Attitude*, MACLA /San Jose Center For Latino Arts, San Jose, CA

Russell Crotty
Born, 1956, San Rafael, California

Russell Crotty received his BFA in 1978 from the San Francisco Art Institute and his MFA in 1980 from the University of California, Irvine. In the decade after graduating from his MFA at the University of California, Russell Crotty worked predominantly as a painter, teaching intermittently at UCLA. Away from the smog of downtown Los Angeles, he began working on the large scale astronomy inspired drawings for which he is known. On a ridge above the Pacific in the Santa Monica Mountains Crotty has built his Solstice Peak Observatory. A certified documentarian of the Association of Planetary and Lunar Observers, he gained a certificate in 1996 for his observations of Saturn. He has also participated in projects with NASA entitling him to use the 60-inch reflector telescope in the observatory on Mount Wilson in Pasadena.

Selected Exhibitions
2005 *Russell Crotty*, Suzanne Tarasieve, Paris, France
2004 *Russell Crotty*, Shoshana Wayne Gallery, Santa Monica, CA
2002 *Drawing Now: Eight Propositions*, Museum of Modern Art, New York, NY

Nick Lowe
Born 1980, San Jose, California

Nick Lowe studied at UCLA graduating with his BFA in 2002 followed by almost immediate gallery recognition for his meticulously detailed drawings. Along with UCLA contemporary Ry Rocklen (also his partner in rap duo The Bushes) he helped generate the "boy-oh-boy" aesthetic intended to reveal intelligence in "dumb things." Lowe is represented by Black Dragon Society in Los Angeles.

Selected Exhibitions
2004 *Painting*, Black Dragon Society, Los Angeles, CA
Sixth Annual Altoids Curiously Strong Collection, New Museum of Contemporary Art, New York, NY
2003 *International Paper*, UCLA Hammer Museum, Los Angeles, CA

Ivan Morley
Born 1966, Burbank, California

Ivan Morley graduated from the School of the Art Institute of Chicago in 1989 and completed an MFA at the Art Center College of Design, Los Angeles, in 2000. Since graduating he has exhibited his work internationally and is currently represented by Patrick Painter in Los Angeles and Galerie Frehking Weisehofer in Cologne, Germany. He has gained critical attention for his works documenting the imagined histories of mid nineteenth century small-town California among other idiosyncratic half-truths.

Selected Exhibitions
2003 *Ivan Morley*, Patrick Painter Inc., Santa Monica, CA
2002 *Ivan Morley*, Essor Gallery, London, UK
2000 *Paintland*, Lemon Sky Project Space, Hollywood, CA

JP Munro
Born 1975, Los Angeles, California

JP Munro received his BFA in 1997 from UCLA and his MFA from Art Center College, Pasadena, in 2000. He has since gained international recognition for his canvases that fuse classical painting styles and imagery with that of contemporary popular culture. He is represented by China Art Objects in Los Angeles and Sadie Coles in London.

Selected Exhibitions
2005 *100 Artists See God*, The Contemporary Jewish Museum, San Francisco, CA; Laguna Art Museum, Laguna Beach, CA; Institute of Contemporary Art, London, UK; Contemporary Art Center of Virginia, Virginia Beach, VA; Albright College Freedman Art Gallery, Reading, PA; Cheekwood Museum of Art, Nashville, TN
2004 *The Foundation of the Twenty-First Century*, Sadie Coles HQ, London, UK
Torture Garden, China Art Objects, Los Angeles, CA

Laura Owens
Born 1970, Euclid, Ohio

The prolific and influential painter Laura Owens gained her BFA from the Rhode Island School of Design, Providence in 1992. In 1994 she received her MFA from the CalArts in Valencia, followed by a Summer at Skowhegan School of Painting and Sculpture in Maine. The Museum of Contemporary Art hosted a monographic exhibition of Owens's work in 2003, when the artist was only 33, nine years after she first exhibited in Los Angeles. She continues to exhibit her work internationally and is represented by ACME Gallery in Los Angeles, Sadie Coles HQ in London and Gavin Brown Enterprise in New York.

Selected Exhibitions
2004 *Laura Owens*, Museum of Contemporary Art, Los Angeles, CA; Aspen Art Museum, Aspen, CO; Milwaukee Art Museum, Milwaukee, WI; Museum of Contemporary Art, Miami, FL
2002 *Drawing Now: Eight Propositions*, Museum of Modern Art, New York, NY
1998 *Young Americans 2*, Saatchi Gallery, London, UK

Lari Pittman
Born 1952, Glendale, California

Born in California to Columbian parents, artist Lari Pittman completed both his BFA and MFA at the California Institute of the Arts, Valencia, in 1974 and 1976 respectively. He has gone on to achieve worldwide recognition for his densely constructed large scale tableaux dealing with subjects from homosexuality to decoration. Having exhibited extensively around the world for almost 30 years, Pittman has notably participated in Documenta X in Kassel in 1997, as well as four Whitney Biennials. Among other honors, Pittman was awarded National Endowment for the Arts grants three times. He is represented by Regen Projects in Los Angeles, greengrassi in London and Barbara Gladstone Gallery in New York. Pittman currently teaches painting at UCLA.

Selected Exhibitions
2004 *Lari Pittman*, greengrassi, London, UK
1996 *Lari Pittman*, Los Angeles County Museum of Art, Los Angeles, CA; Contemporary Arts Museum, Houston, TX; Corcoran Gallery of Art, Washington, DC
1997 Documenta X, Kassel, Germany

Mark Ryden
Born 1963, Medford, Oregon

Mark Ryden received his BFA from Art Center in Pasadena in 1987 and currently lives in Sierra Madre. Working originally as a commercial artist Ryden built his reputation in the entertainment industry. As his projects began to be noticed by those both inside and outside the art world he moved more exclusively into fine art. In his dual career as artist and illustrator he has produced work for numerous magazines as well as album covers for a list of musicians as eclectic as his paintings, including the Red Hot Chilli Peppers, the Butthole Surfers and Michael Jackson. He has sold to collectors from Australia to Sweden, including many celebrities such as Stephen King, Ringo Starr, Bridget Fonda and Marilyn Manson.

Selected Exhibitions
2004 *Wondertoonel*, Frye Art Museum, Seattle, WA
2003 Blood, Earl McGrath Gallery, Los Angeles, CA
2002 *Bunnies and Bees,* Grand Central Art Center, Santa Ana, CA

Jim Shaw
Born 1952, Midland, Michigan

A formidable figure in the development of West Coast pop, Jim Shaw received his BFA from the University of Michigan and went on to earn his MFA from CalArts, Valencia in 1978. It was in 1974 at CalArts that Shaw met Mike Kelley and formed the influential art-rock band Destroy All Monsters. He has gone on to show extensively worldwide including a 1998 retrospective of his work, *Everything Must Go*, mounted by the Casino Luxembourg which traveled to venues in Europe and the United States. His collection of thrift store paintings was shown at the Institute of Contemporary Art in London in 2000. Shaw currently teaches at Art Center and has taught at both UCLA and CalArts in the past.

Selected Exhibitions
2005 *The Dream That Was No More a Dream*, Patrick Painter, Inc., Santa Monica
2003 *Jim Shaw—Drawings*, Metro Pictures, New York, NY
1998 *Everything Must Go*, Casino Luxembourg

John Baldessari
Born 1931, National City, California

John Baldessari is a key figure in West Coast art, notable for his time teaching at the California Institute of the Arts, Valencia, where he brought key conceptual artists, from Joseph Kosuth to Vito Acconci from New York to lecture. He attended a number of teaching establishments, reading art history at Berkeley, and completing his MA at the San Diego State College, California. He also attended the Otis Art Institute, Los Angeles and Chouinard Art Institute, Los Angeles. He taught at CalArts from 1970 to 1988 and is currently a Professor of Interdisciplinary Art at University of California, Los Angeles. He has shown exhaustively both in America and abroad, participating in seminal exhibitions of conceptual art in the 1970s, as well as having numerous solo shows and retrospectives.

Selected Exhibitions
2001 *While Something is Happening Here, Something Else is Happening There: Works 1965–2001*, Reykjavik Art Museum, Reykjavik, Iceland
1996 *John Baldessari: National City*, Museum of Contemporary Art, San Diego, CA
1970 *Information*, Museum of Modern Art, New York, NY

Hillary Bleecker
Born 1969, Burbank, California

Before beginning her career in art Hillary Bleecker received her BA in Sociology from UCLA in 1992. She went on to earn her BFA from the San Francisco Art Institute in 1997 taking the Summer of 1996 to attend the New York Studio Program through the Association of Independent Colleges of Art and Design. Bleecker then moved back home to Los Angeles, completing her MFA at UCLA in 2001 where she studied under Lari Pittman. Her work has been shown internationally at venues including Kontainer Gallery in Los Angeles and f.a. Projects in London.

Selected Exhibitions
2004 *Let it Ride*, Kontainer Gallery, Los Angeles, CA
2003 *Rough Topography*, Vedanta Gallery, Chicago, IL
International Paper, UCLA Hammer Museum, Los Angeles, CA

David Bunn
Born 1950, Greensboro, North Carolina

David Bunn completed his MFA in Photography and New Genres at the University of California, Los Angeles in 1984. He acquired the complete card catalog of the Los Angeles Central Library in 1990 and since then his work has been dominated by explorations of the text, objects and stains found in these cards. Bunn has twice been awarded National Endowment for the Arts grants. He is currently a professor in the graduate program at UCLA. Bunn is represented by Angles Gallery in Los Angeles and Carolina Nitsch Contemporary Art in New York.

Selected Exhibitions
2005 *Double Monster*, Temple Gallery, Tyler School of Art, Philadelphia
Un art de lecteurs, University of Rennes Gallerie, Rennes

Mary Kelly
Born 1941, Fort Dodge, Iowa

Mary Kelly studied as an undergraduate at the College of Saint Teresa, Winona, MI between 1959 and 1963, before completing an MA in Florence, Italy. Between 1968 and 1970, Kelly studied at St. Martins School of Art in London, starting her career as an artist and as a writer against the background of conceptual art practices such as Art & Language, as well as feminist readings of psychoanalytic theory. Her writings on the representation of the female body, as well as the presentation of Lacanian theory within a feminist context, have become seminal texts in art history. She has taught in various institutions, most recently at the Whitney Independent Study Program between 1989 and 1996, before moving to Los Angeles to become a professor at UCLA.

Selected Exhibitions
2001–2002 *Ballad of Kastriot Rexhepi*, Santa Monica Museum of Art, Santa Monica, CA
1990 *Interim, The Complete Work 1984–1989*, New Museum of Contemporary Art, New York, NY
1976 *Post-Partum Document, I–III*, Institute of Contemporary Art, London, UK

Raymond Pettibon
Born 1957, Tucson, Arizona

Graduating from UCLA in 1977, Raymond Pettibon taught mathematics in the LA public school system before turning his attentions to artmaking. Famously associated with punk and hardcore culture, some of Pettibon's best-known images, notably the cover for Sonic Youth's 1990 classic *Goo*, have come out of collaboration with musicians and record labels. Gradually defining a simple but compelling mode of self-expression in a series of books distributed by SST Records, Pettibon began exhibiting work locally in California in 1985. In 2004, Pettibon received the prestigious Bucksbaum Award, a cash prize awarded to a promising American artist in the Whitney Biennial. He continues to show worldwide and retrospectives of his work have been held at The Museum of Contemporary Art in Los Angeles, the Philadelphia and the Santa Monica Museums of Art and the Whitechapel Art Gallery in London.

Selected Exhibitions
2005 *Raymond Pettibon*, Whitney Museum of American Art, New York, NY
2003 *Raymond Pettibon*, David Zwirner, New York, NY
2001 *Raymond Pettibon*, Whitechapel Gallery, London, UK

Ed Ruscha
Born 1937, Omaha, Nebraska

Ed Ruscha moved to Los Angeles from Oklahoma in 1956, intending to become a commercial artist. He studied at the Chouinard Art Institute, now CalArts, which at the time was a training center for Disney illustrators. In the early 1960s, under the influence of Jasper Johns and Robert Rauschenberg, he abandoned abstract expressionism in favor of a distinctive West Coast type of pop-minimalism, exemplified in his artist's books and *Liquid Word* drawings of that decade. Ruscha is considered one of the most important living American artists, and his work is held in numerous international collections. In 2001 he was elected a member of the Department of Art at The American Academy of Arts and Letters, and four years later he was selected to represent the United States at the 2005 Venice Biennale.

Selected Exhibitions
2005 *Course of Empire*, Venice Biennale, Venice, Italy
2004 *Ed Ruscha: The Drawings and Photographs*, Whitney Museum of American Art, New York, NY
2003 *Ed Ruscha Photographs*, Gagosian Gallery, Los Angeles, CA

Frances Stark
Born 1967, Newport Beach, California

Artist and writer Frances Stark received her BA in Humanities from San Francisco State University, San Francisco, in 1991 and went on to gain an MFA at the Art Center College of Design in Pasadena in 1993. Stark has had numerous solo exhibitions worldwide at venues including the UCLA Hammer Museum, LA; greengrassi, London; CRG, New York; Kunstverein Galerie, Munich; and Galerie Daniel Buchholz, Cologne. She has played in the rock band Palmetto and was featured in a Raymond Pettibon film as Yoko Ono. Her literary talents are evident in her published writings in numerous journals as well as in her books *Collected Writings 1993–2003*, 2004, and *The Architect and the Housewife*, 1999.

Selected Exhibitions
2005 *Frances Stark*, CRG Gallery, New York, NY
2004 *Destroy Date*, Galerie Daniel Buchholz, Cologne, Germany
2002 *The Unspeakable Compromise of the Portable Work of Art*, UCLA Hammer Museum, Los Angeles, CA

Wayne White
Born 1957, Chattanooga, Tennessee

Wayne White received his BFA from Middle Tennessee State University in 1979. He has won numerous awards for his accomplishments as a production designer and art director for film and television including five Emmy nominations. White is best known for his work on *Pee Wee's Playhouse*, 1986–1989, and his music videos for Peter Gabriel (*Big Time*, 1987) and The Smashing Pumpkins (*Tonight Tonight*, 1996). He has worked as a cartoonist and illustrator for *The New York Times*, *Village Voice*, *Rolling Stone*, and *High Times*. White is represented by Western Project in Los Angeles and Clementine Gallery in New York.

Selected Exhibitions
2004 *Wayne White,* Changing Role Gallery, Naples, Italy
 In-A-Gadda-Da-Vida, Western Project, Culver City, CA
2003 *Single Head Occupancy,* Mark Moore Gallery, Santa Monica, CA

Amy Adler
Born 1966, New York, New York

After graduating with a BFA from The Cooper Union in 1989, Adler went on to study for an MFA at UCLA, finishing in 1995. She has exhibited internationally, and when an artist in residence at Delfina Studios in London, 1999–2000, she undertook her photo shoot with Leonardo di Caprio. In 1999 she curated an exhibition of Joni Mitchell's paintings, *Amy Adler Curates Joni Mitchell*, Los Angeles Contemporary Exhibitions, further exploring the interface between celebrity, art and authorship. She is represented by ACME Gallery in Los Angeles and her work is in permanent collections including the Museum of Contemporary Art, Los Angeles.

Selected Exhibitions
2004 *Virgin Sacrifice*, Taka Ishii Gallery, Tokyo, Japan
2001 *Amy Adler Photographs Leonardo di Caprio*, Photographers' Gallery, London, UK
1997 *Once in Love With Amy*, Casey Kaplan, New York, NY

Delia Brown
Born 1969, Los Angeles, California

Delia Brown received her BFA from the University of California, Santa Cruz after a short stint studying at Goldsmiths College in London. She went on to earn her MFA from the University of California, Los Angeles in 2000. With paintings of herself and friends leading glamorous LA lifestyles, aimed at evoking jealousy in her viewer, she has earned a reputation in the artworld that is also to be envied. She is represented by Margo Leavin in Los Angeles and D'Amelio Terras in New York. Brown moved to New York in 2004 where she continues to live and work.

Selected Exhibitions
2005 *Il Capricorno*, Venice, Italy
2004 *Paintings*, D'Amelio Terras, New York, NY
2003 *Getting Hung Up at a Collector's Home En Route to the Museum*, Margo Leavin Gallery, Los Angeles, CA

Jeff Burton
Born 1963, Anaheim, California

Jeff Burton studied painting at the Texas Christian University, Fort Worth, Texas, graduating in 1985, and then went on to complete an MFA at CalArts in 1989. Starting his career in Los Angeles as a stills photographer for adult movies in 1989, Burton worked primarily outside the artworld until 1993. Since then he has exhibited internationally and his work is held in the collections of the Museum of Contemporary Art, Miami, Florida, and the Guggenheim Museum, New York. Jeff Burton is represented by Sadie Coles in London and by the Casey Kaplan Gallery in New York.

Selected Exhibitions
2003 *Kevin*, Casey Kaplan, New York, NY
2002 *Jeff Burton*, Galleria Franco Noero, Turin, Italy
2000 *Jeff Burton*, Sadie Coles HQ, London, UK

Sharon Lockhart
Born 1964, Norwood, Massachusetts

Lockhart studied at the San Francisco Art Institute, graduating with a BFA in 1991, followed by an MFA at Art Center College of Design, Pasadena in 1993. Lockhart has exhibited internationally, with her works in collections of the Tate Modern, London, and the Guggenheim Museum, New York. Her films have been screened in film festivals worldwide, with her recent project *No*, 2004, returning to Japan with a study of a man and woman farming, with their actions appearing almost as a minimalist painting.

Selected Exhibitions
2005 *Sharon Lockhart*, Fogg Art Museum, Cambridge, MA
1999 *Sharon Lockhart*, Museum Boijmans Van Beuningen, Rotterdam, The Netherlands
1998 *Goshogaoka Girls Basketball Team*, Blum & Poe, Santa Monica, CA

Daniel Marlos
Born 1957, Youngstown, Ohio

Daniel Marlos received his BFA from the Youngstown State University at his home town and went on to gain his MFA from Art Center College of Design in Pasadena. He is a self taught quilt maker and regularly contributes recipes to the American Homebody website where he also began his successful online column "What's That Bug?" He has designed the Metropolitan Transit Association's rapid bus line through San Fernando Valley's Woodman bus station, and also been awarded MetroLab's Individual Artist's Grant. He is currently Chair of Media Arts at the Los Angeles City College and is represented by Blum & Poe in Los Angeles.

Selected Exhibitions
2004 *Off on a Tangent*, Bliss Gallery, Pasadena, CA
1999 *Cold Drink*, Artists Space, New York, NY
1998 *Rudimentary Particles,* Unge Kunstneres Samfund, Oslo, Norway

Catherine Opie
Born 1961, Sandusky, Ohio

Catherine Opie trained as a photographer at San Francisco Art Institute, graduating in 1985, before studying for an MFA at CalArts, where she was immersed in the conceptual potential and politics of documentary photography. In the early 90s her series *Being and Having*, 1991, propelled her to international success, with her portraits of dykes sporting moustaches and beards against bright yellow backgrounds coinciding with widespread discussion on gender and performativity. Since this time Opie has exhibited internationally, combining residences in various locations across the US with her teaching on the art program at UCLA.

Selected Exhibitions
2000 *Catherine Opie*, Photographer's Gallery, London, UK
1999 *The Domestic Series*, Regen Projects, Los Angeles, CA
1997 *Catherine Opie*, Museum of Contemporary Art, Los Angeles, CA

Dean Sameshima
Born 1971, Torrance, California

Dean Sameshima received his BFA from CalArts, Valencia, in 1997 and his MFA from the Art Center College of Design, Pasadena, in 2001. He is well known for his photographic explorations of the changing status of the homosexual in contemporary society as well as his in-depth investigations of his personal desires which he calls "emotional conceptualism." Sameshima's work has been exhibited internationally at venues including the Pasadena Museum of Art and MOCA in Los Angeles, Kunstraum Innsbruck, and Kunstverein Hamburg, and Art 33 Basel, Switzerland. He is represented by Peres Projects, Los Angeles/Berlin, Taka Ishii Gallery, Tokyo and Alison Jaques Gallery, London.

Selected Exhibitions
2005 *Young Men at Play*, Taka Ishii Gallery, Tokyo, Japan
2002 *Art Statements*, Art 33 Basel, Basel, Switzerland
2002 *Bystander*, Andrea Rosen Gallery, New York, NY

Ed Templeton
Born 1972, Garden Grove, California

In his own words Ed Templeton "live[s] in Fountain Valley with my wife Deanna where I paint in my garage. I travel the world skateboarding and taking pictures." His artworld career began in the mid 90s when his combination of paintings and text for skateboard graphics began to get noticed. He has exhibited internationally, including solo shows at Roberts & Tilton Gallery in LA, Alleged Gallery in New York and Modern Art in London, with a series of self-published books and catalogues extending his audience, crossing the skate and art worlds.

Selected Exhibitions
2005 *The Judas Goat*, Modern Art, London, UK
2003 *The Prevailing Nothing*, Roberts & Tilton Gallery, Los Angeles, CA
2002 *The Essential Disturbance*, Palais de Tokyo, Paris, France

Kerry Tribe
Born 1973, Boston, Massachusetts

Kerry Tribe graduated from Brown University, Providence, Rhode Island in 1997 with a BA in Art and Semiotics. She then carried out the Whitney Independent Study Program from 1997–1998, before completing her MFA in 2002 at UCLA. Her video installations dealing with self-representation and intersubjectivity have earned her critical acclaim. She has shown internationally at venues including the New Museum for Contemporary Art in New York, LACE in Los Angeles and Lewis Glucksman Gallery in Cork.

Selected Exhibitions
2004 *Here and Elsewhere*, Lewis Glucksman Gallery, Cork, Ireland
How Can We Resist (LA Freewaves), Museum of Contemporary Art, Los Angeles, CA
2001 *Re: Duchamp*, Venice Biennale, Venice, Italy; Istanbul Biennial, Istanbul, Turkey

Liz Craft
Born 1970, Los Angeles, California

Liz Craft grew up in Mammoth, a Californian ski resort. She studied for her BFA and MFA at University of California, Los Angeles, graduating in 1997. Her large, fantastical sculptures have been exhibited extensively in Europe, as well as in her home country. She has undertaken a number of public sculpture commissions from the Public Art Trust, in New York, including a bronze sculpture for the 2004 Whitney Biennial. Craft is represented by Marianne Boesky Gallery in New York.

Selected Exhibitions
2004 Whitney Biennial, Whitney Museum of American Art, New York, NY
2002 *Liz Craft: A Real Mother for Ya*, Sadie Coles HQ, London, UK
2001 *The Americans: New Art*, Barbican Art Gallery, London, UK

Meg Cranston
Born 1960, Balwin, New York

Multi-media artist Meg Cranston received her MFA from CalArts, Valencia in 1986 after completing her BA in Anthropology at Kenyon College in 1982. She has shown internationally since 1988, shortly after completing a stint of scholarship in art at the Jan van Eyck Akademie, Maastricht. Cranston is an active writer in addition to creating sculpture, drawing, performance and installation work. In 2003 she co-curated the traveling exhibition *100 Artists See God* with fellow LA artist and mentor John Baldessari. She has received a John Simon Guggenheim Memorial Foundation Fellowship and a Penny McCall Foundation Artist Grant, among other honors. Cranston is a professor of art and art criticism at Otis College of Art and Design, Los Angeles.

Selected Exhibitions
2002 *Meg Cranston*, Rosamund Felsen Gallery, Los Angeles, CA
Meg Cranston: Recent Works, Happy Lion, Los Angeles, CA
2000 *Meg Cranston*, Galerie Kapinos, Berlin, Germany

Evan Holloway
Born 1967, La Mirada, California

Evan Holloway completed his BA at the University of California, Santa Cruz, in 1989 and his MFA from the University of California, Los Angeles in 1997. His constructions made from materials such as old batteries embedded in plaster, tree branches and Casio keyboards reflect his interest in kinetics, decay and perspective and have earned him an international reputation. Holloway is represented by Marc Foxx Gallery in Los Angeles, and The Approach in London.

Selected Exhibitions
2005 *Analog Counterrevolution*, The Approach, London, UK
2004 *I Don't Exist*, Marc Foxx Gallery, Los Angeles, CA
New Work, San Francisco Museum of Modern Art, San Francisco, CA

Terence Koh
Born 1977, Vancouver, Canada

Terence Koh rose to prominence in the mid 1990s under the *nom de plume* asianpunkboy, for his eponymous website and "art-porn" zines. His sprawling body of work, which includes paintings, photographs, sculptures, drawings and performances, quickly drew a large following in the queer-core underground and in the larger art world. A collaborator with artists such as Larry Clark and Bruce LaBruce, Koh's work has been exhibited internationally including participation in the 2004 Whitney Biennial. Since "killing off" asianpunkboy in 2003, he has concentrated on producing large, room-sized installations and performances, often utilizing everyday objects. His current website kohbunny.com is updated regularly with a mixture of his drawings, photographs, writing and art. Koh lives and works in New York and Los Angeles, and is represented by Peres Projects in LA.

Selected Exhibitions
2005 *The Voyage of Lady Midnight Snowdrops Through Double Star Death*, Peres Projects, Los Angeles, CA
2004 *Koh & 50 Most Beautiful Boy*, Peres Projects, Los Angeles, CA
2003 *The Whole Family*, Peres Projects, Los Angeles, CA

Liz Larner
Born 1960, Sacramento, California

Liz Larner received her BFA from the California Institute of Art, Valencia, in 1985. She gained critical recognition in the 1980s for her *Culture* series that involved growing bacteria in gelatine. Larner was awarded a Guggenheim Fellowship in 1999. She is considered one of the most important sculptors in California and has also been awarded the Lucelia Artist Award in 2002. Liz Larner is represented by Regen Projects in Los Angeles and currently teaches at the Art Center College of Design in Pasadena.

Selected Exhibitions
2005 *Liz Larner*, Regen Projects, Los Angeles, CA
The The, Modern Art, London, UK
2001 *Liz Larner,* Museum of Contemporary Art, Los Angeles, CA

Jennifer Pastor
Born 1966, Hartford, Connecticut

Jennifer Pastor graduated with a BFA from the School of Visual Arts in New York in 1988 and received an MFA in sculpture, from UCLA in 1992. She first received recognition in the mid 1990s when her installation titled *The Four Seasons*, 1992–1996, was featured in exhibitions in 1996 at the Museum of Contemporary Art, Chicago and the Museum of Contemporary Art, Los Angeles, and the Whitney Museum of American Art's 1997 Biennial. She contributed *The Perfect Ride* installation to the Venice Biennale in 2003 and drawings for this work were included in the 2003 group show, *Drawing Now: Eight Propositions* at the Museum of Modern Art, New York. She is currently Associate Professor of Visual Arts at the University of California at San Diego, and is represented by Regen Projects, Los Angeles.

Selected Exhibitions
2004 *The Perfect Ride*, Whitney Museum of American Art, New York, NY
2003 *Dreams and Conflicts:The Dictatorship of the Viewer,* Venice Biennale, Venice,Italy
1996 *Jennifer Pastor*, The Museum of Contemporary Art, Chicago, IL

Re-figuring Abstraction

Jon Pylypchuk
Born 1972, Winnipeg, Canada

Jon Pylypchuk, who has also gone by the name Rudy Bust, gained his BFA from the University of Manitoba in 1997, and an MFA from the University of California, Los Angeles in 2001. His work from 1996 to 2003 mirrored the whimsical cut-and-paste aesthetic of the Royal Art Lodge, a collective of like-minded Winnipeg artists that Pylypchuk formed along with Marcel Dzama, Neil Farber and others. His collages and mixed media paintings rapidly became known for their distinctive cast of anthropomorphic creatures, and were exhibited at various galleries and museums including the Drawing Center in New York in 2003. Following his relocation to LA, Pylypchuk began to produce sculptures and installations, often exploring similar themes and imagery.

Selected Exhibitions
2004 *You Won't Live Past 30*, China Art Objects, Los Angeles, CA
Erections Pointing at Stars and Angels, Alison Jacques, London, UK
2002 *Im From Orange County and I Drink Johnny Walker Red,* Galerie Julius Hummel, Vienna, Austria

Jason Rhoades
Born 1965, Newcastle, California

Jason Rhoades received his BFA from the San Francisco Art Institute in 1988 before spending the Summer at the Skowhegan School of Art in Maine. After completing his MFA at UCLA in 1993, Rhoades quickly came to prominence landing his first one-person exhibition at David Zwirner Gallery in New York as well as his first solo museum show the Kunsthalle Basel. His bizarre and complex room-size installations have been featured in many of the top art exhibitions, including the Venice Biennale, two Whitney Biennials and the Lyon Biennale. Rhoades is represented by Hauser & Wirth in London and David Zwirner in New York.

Selected Exhibitions
2005 *Black Pussy*, Hauser & Wirth, London, UK
2004 *Sheep Plug*, Kling & Bang Gallery, Reykjavik, Iceland
2003 *Meccatuna*, David Zwirner Gallery, New York, NY

Shirley Tse
Born 1968, Hong Kong

A native of Hong Kong, Shirley Tse studied fine art at the Chinese University of Hong Kong before leaving in 1990 to participate in the Education Abroad program at the University of California, Berkeley. She remained in California for her MFA, migrating south to Art Center College of Design in Pasadena, shortly thereafter gaining an international reputation for her commitment to working with plastics. She has been an artist in residence at the Skowhegan School of Art in Maine, Banff Center for the Arts in Alberta, Canada, and Capp Street Project in San Francisco. Tse is represented by Murray Guy in New York and Shoshana Wayne Gallery in Los Angeles where she teaches at CalArts.

Selected Exhibitions
2003 *Shelf Life*, Shoshana Wayne Gallery, Santa Monica, CA
2002 *Shelf Life*, Capp Street Project, Wattis Institute, California College of Arts and Crafts, Oakland, CA
Sprawl, Ben Maltz Gallery, Los Angeles, CA

Mark Bradford
Born 1961, Los Angeles, California

The painter Mark Bradford earned both his BFA and his MFA from the California Institute of the Arts in the late 90s. He has since gained critical attention for examining the complexity of black American representation within the formal framework of modernist abstraction. Having exhibited his work extensively in the US, Bradford is the recipient of a Louis Comfort Tiffany Foundation Award and a Joan Mitchell Foundation Award. He is represented by Brent Sikkema in New York.

Selected Exhibitions
2003 *Very Powerful Lords*, Whitney Museum of American Art at Philip Morris, New York, NY
2002 *Caught Up*, Suzanne Vielmetter Los Angeles Projects, Los Angeles, CA
2001 *I Don't Think You Ready For This Jelly*, Lombard-Freid Fine Arts, New York, NY

Jane Callister
Born 1963, Isle of Man, UK

Jane Callister grew up in Britain, and moved to the US to complete her training as an artist gaining her MFA at the University of Las Vegas, Nevada in 1994. She has since exhibited her paintings widely across the United States and internationally. She is well known for her *Liquid Landscapes*, candy colored abstract paintings and installations. Callister is represented by Susanne Vielmetter in Los Angeles and Peter Miller Gallery in Chicago.

Selected Exhibitions
2003 *Jane Callister*, Southfirst Art, Brooklyn, NY
Jane Callister, Suzanne Vielmetter, Los Angeles, CA
Liquid Landscapes: Jane Callister, Peter Miller Gallery, Chicago, IL

Kim Fisher
Born 1973, Hackensack, New Jersey

Kim Fisher received her MFA from the Otis College of Art and Design, Los Angeles in 1998. Her abstract paintings were featured in the 2004 Whitney Biennial and the 2004 California Biennial at the Orange County Museum of Art. Additionally, she has completed projects at fashion showrooms including the Shiseido Studio in Santa Monica and Anna Sui in New York and Los Angeles. Fisher is represented by China Art Objects in Los Angeles and John Connelly Presents in New York.

Selected Exhibitions
2005 *Kim Fisher*, Modern Institute, Glasgow, UK
2004 *Kim Fisher*, John Connelly Presents, New York, NY
2001 *Kim Fisher*, China Art Objects, Los Angeles, CA

Jeremy Gilbert-Rolfe
Born 1945, Turnbridge Wells, UK

Jeremy Gilbert-Rolfe, the critic, painter, and author of several books, was born in Southern England and educated in London before going to study for his MFA at Florida State University in 1968. Shortly thereafter he moved to New York where he had his first show in 1971, moving to Los Angeles in 1980 with an invitation by John Baldessari to teach at CalArts. He has been awarded two National Endowment for the Arts grants as well as a Guggenheim fellowship and was presented the 1998 Frank Jewett Mather Award for Art Criticism by the College Art Association. He has taught at Art Center College in Pasadena since 1987.

Selected Exhibitions
2005 *100 Artists See God*, The Contemporary Jewish Museum, San Francisco, CA; Laguna Art Museum, Laguna Beach, CA; Institute of Contemporary Art, London, UK; Contemporary Art Center of Virginia, Virginia Beach, VA; Albright College Freedman Art Gallery, Reading, PA; Cheekwood Museum of Art, Nashville, TN
2003 *Jeremy Gilbert-Rolfe*, Shoshana Wayne Gallery, Santa Monica, CA
1999 *Jeremy Gilbert-Rolfe, A 20 Year Survey*, Genovese-Sullivan Gallery, Boston, MA

Mark Grotjahn
Born 1968, Pasadena, California

Mark Grotjahn studied for his MFA at the Department of Art Practice, University of California, Berkeley, after completing his BFA at the University of Colorado, in Boulder. Grotjahn also attended the prestigious Summer painting program at Skowhegan School of Art in Maine. His conceptual approach to abstraction has brought him critical attention. In 2004 he participated in the 54th Carnegie International, Pittsburgh. Grotjahn is represented by the Anton Kern Gallery in New York and the Steven Friedman Gallery in London.

Selected Exhibitions
2005 *Mark Grotjahn*, Stephen Friedman Gallery, London, UK
2004 *Carnegie International*, Carnegie Museum of Art, Pittsburgh, PA
2003 *Mark Grotjahn*, Anton Kern Gallery, New York, NY

Sandeep Mukherjee
Born 1964, Pune, India

Sandeep Mukherjee originally trained as an engineer, completing a Bachelors degree in industrial engineering at the Manipal Institute of Technology in Bangalore, India, and then a Masters at the University of California, Berkeley. He then retrained as an artist attending the Summer School of Art at Yale University, Norfolk, Connecticut. He continued his studies in art at Otis College in Los Angeles in 1996, finally earning his MFA in 1999 at the UCLA. He has since gained a critical following for his ethereal painting and installation work including his signature pin-pricked sheets of duralene. Muhkerjee is represented by Margo Leavin Gallery in Los Angeles where he teaches at the USC School of Art.

Selected Exhibitions
2005 *Sandeep Mukherjee*, Sister Gallery, Los Angeles, CA
Works on Paper, Museum of Modern Art, New York, NY
2004 *Project 21*, Pomona College Museum of Art, Claremont, CA

Monique Prieto
Born 1962, Los Angeles, California

Monique Prieto was educated in Los Angeles, finishing two BFAs, the first at UCLA in 1987 and the second at CalArts, Valencia, in 1992. She continued on at CalArts completing her MFA in 1994. That summer she took a brief detour to Maine where she attended the Skowhegan School of Art. Her distinctly handmade, digitally inspired paintings have been featured in numerous solo exhibitions worldwide and are included in major public collections across California and in the Whitney Museum of American Art, New York. Prieto is represented by ACME Gallery in Los Angeles and Corvi Mora in London.

Selected Exhibitions
2003 *Monique Prieto*, Il Capricorno, Venice, Italy
2002 *Monique Prieto*, Cheim & Read, New York, NY
2001 *Hybrids*, Tate Liverpool, Liverpool, UK

James Welling
Born 1951, Hartford, Connecticut

James Welling studied from 1969–1971 at Carnegie Mellon University, Pittsburgh, and then moved to California where he continued his studies at CalArts, Valencia, gaining his BFA and MFA between 1971 and 1974. In recent years Welling's photographs have been featured in numerous solo and group exhibitions worldwide. His work is held in many private and public collections, including the Los Angeles County Museum of Art, the Metropolitan Museum of Art, New York, and the Whitney Museum of Art, New York. He is represented by Regen Projects in Los Angeles and Donald Young Gallery in Chicago.

Selected Exhibitions
2004 *James Welling New Photographs*, Wako Works of Art, Tokyo, Japan
2003 *James Welling*, Regen Projects, Los Angeles, LA
2002 *James Welling*, Palais de Beaux-Arts, Brussels, Belgium

Andrea Bowers
Born 1965, Wilmington, Ohio

Andrea Bowers earned her BFA at Bowling Green State University, Bowling Green, Ohio and graduated from the MFA program at the California Institute of the Arts, Valencia in 1992. Her concerns have developed from an interest in crowd mentality (the fan and the sports audience) to a conflation of current protest culture with a revisionist view of the social idealism and aesthetics of the 1960s. She has taught at the University of California, Irvine, the Art Center College of Design and CalArts. She has had numerous solo shows both in America and abroad.

Selected Exhibitions
2005 *Letters to an Army of Three*, Glassell School of Art, Houston, TX
2004 *Soft Blockades*, Mary Goldman Gallery, Los Angeles, CA
2002 *Virtual Arena*, Sara Meltzer Gallery, New York, NY

Sam Durant
Born 1961, Seattle, Washington

Sam Durant studied for his BFA at the Massachusetts College of Art, Boston and completed his MFA at the California Institute of the Arts, Valencia. He has shown extensively in America and abroad, with some notable mid-career museum exhibitions. Consistently reworking aspects of Robert Smithson's work, he has re-integrated the notion of entropy with other cultural entities as diverse as Public Enemy No. 1, The Rolling Stones's concert at Altamont and the social idealism of the 1960s. He is represented by Blum & Poe in Los Angeles, Tomio Koyama Gallery in Tokyo and Galerie Kapinos in Berlin.

Selected Exhibitions
2004 *Involved*, Blum & Poe, Los Angeles, CA
2002 *Sam Durant*, Museum of Contemporary Art, Los Angeles, CA
2001 *Consciousness Raising Historical Analysis, Pain plus Time Separated and Ordered with Emphasis on Reflection*, Kunsthof Zurich, Switzerland

Dave Muller
Born 1964, San Francisco, California

Dave Muller completed a double BA in chemistry and art at University of California, Davis, before moving to New York to continue his arts education at the School of the Visual Arts. The CalArts MFA program drew him back to the West Coast in 1991. Since graduation in 1993 he has lived and worked in Los Angeles, organizing his famed *Three Day Weekend* art parties worldwide. A cerebral artist with a marked interest in the hybrid notions that result when popular culture and the artworld collide, Muller was chosen in 2004 to participate in the Whitney Biennial. Muller is represented by The Approach in London and Blum & Poe in Los Angeles.

Selected Exhibitions
2004 *I Like your Music*, Blum & Poe, Los Angeles, CA
Three Day Weekend, The Arsenal Gallery, New York, NY (In association with the Public Art Fund and the Whitney Biennial)
2003 *Dave Muller: May I Please Speak with Mr. Murray Guy?*, Murray Guy Gallery, New York, NY

Kaz Oshiro
Born 1967, Okinawa, Japan

Born in occupied Okinawa, Oshiro moved to the US during the 1980s. He received both his BFA and MFA from California State University, Los Angeles in 1998 and 2002 respectively. Oshiro earned critical acclaim upon graduation for his painstakingly rendered three-dimensional amps, appliances, and trash bins that blur the line between painting and sculpture. He has had solo exhibitions at Rosamund Felsen in Los Angeles, and been included in group exhibitions at the UCLA Hammer Museum in Los Angeles and at Apex Art in New York.

Selected Exhibitions
2005 *Kaz Oshiro*, Pomona College of Art, Project Series, Claremont, CA
2004 *In and Out*, Rosamund Felsen Gallery, Santa Monica, CA
2003 *2003 Summer Program*, Apex Art, New York, NY

Mungo Thomson
Born 1969, Davis, California

Mungo Thomson received his MFA from UCLA in 2000 after completing an Independent Study Program at the Whitney Museum of American Art in 1994. He represented the United States at the Cuenca Bienal in Ecuador in 2004 and was included in the California Biennial at the Orange County Museum of Art, 2004–2005, and in the 2003 group exhibition *100 Artists See God* curated by John Baldessari and Meg Cranston. He has taught at USC in Los Angeles and the Art Center of Design in Pasadena. His work resides in the public collections of the Museum of Contemporary Art in Los Angeles and the New School University Art Collection in New York.

Selected Exhibitions
2005 *New York, New York, New York, New York*, John Connelly Presents, New York, NY
2004 *Mungo Thomson*, Margo Leavin Gallery, Los Angeles, CA
2004 *Mungo Thomson*, University Art Museum, Long Beach, CA

Shifting Scale

Chris Burden
Born 1946, Boston, Massachusetts

Chris Burden moved to LA in 1965 and received his BA from Pomona College, Claremont in 1969. He went on to take an MFA in architecture, physics and visual arts at the University of California, Irvine. During this time, he achieved notoriety for dangerous and violent performances that involved the use of his body. The son of an engineer, he has always had a fascination with technology and construction, and from the late 1970s onward his output has included sculptures and inventions that reflect his relationship to a mechanized and technological society. An internationally and critically recognized artist, his work has been exhibited widely around the world, and he is the recipient of numerous awards. He lives in Topanga Canyon, California, and teaches New Genres at UCLA.

Selected Exhibitions
2003 *Bridges and Bullets*, Gagosian Gallery, Beverley Hills, CA
2001 Venice Biennale, Venice, Italy
1998 *Out of Actions: Between Performance and the Object, 1949–1979*, Museum of Contemporary Art, Los Angeles, CA

Won Ju Lim
Born 1968, Kwangju, South Korea

Won Ju Lim received her MFA in 1998 from the Art Center College of Art, in Pasadena. She is known for sculptures and room-sized installations crafted out of foam core and plexiglas, that depict imaginary yet familiar cityscapes, illuminated in their interior and exterior spaces by dramatic lighting, slide projection and video montage. Lim has had solo exhibitions in Los Angeles, Madrid, London, Berlin, Salamanca, Korea, Basel and Vancouver. She is represented in Los Angeles by Patrick Painter, and currently works as a professor of art at UCLA.

Selected Exhibitions
2004 *Won Ju Lim*, Galerie Max Hetzler, Berlin, Germany
2004 *Won Ju Lim,* Emily Tsingou, London, UK
2002 *Sites of Korean Diaspora*, Guangju Biennale 2002, Guangju, Korea

Pauline Stella Sanchez
Born 1956, Albuquerque, New Mexico

Pauline Stella Sanchez studied political science at the University of New Mexico and art at the Corcoran Art School before graduating with a BFA in 1984. In 1987, she obtained her MFA from University of California in Los Angeles and staged her first solo show there at Ace Gallery. Since 1998 she has been a member of the undergraduate faculty at the Art Center College of Design, and in 2003 she won a John Simon Guggenheim Fellowship, awarded to further her work in sculpture and installation.

Selected Exhibitions
2005 *100 Artists See God*, The Contemporary Jewish Museum, San Francisco, CA; Laguna Art Museum, Laguna Beach, CA; Institute of Contemporary Art, London, UK; Contemporary Art Center of Virginia, Virginia Beach, VA; Albright College Freedman Art Gallery, Reading, PA; Cheekwood Museum of Art, Nashville, TN
It's Busted, Rosamund Felsen Gallery, Santa Monica, CA
2003 *Pauline Stella Sanchez*, Pomona College Museum of Art, Claremont, CA

Paul Sietsema
Born 1968, Los Angeles, California

An Angeleno born and bred, Paul Sietsema gained his BA from the University of California, Berkeley in 1992. He he studied under Charles Ray, an important formative influence, while completing his MFA at the University of California, Los Angeles. Sietsema has claimed that his earliest experience of art was drawing pictures of flowers to give to his mother, and he returned to this theme in his first exhibition, in 1998, with a 16mm film of meticulously crafted paper flowers. Sietsema is represented by Regen Projects, Los Angeles, and has also exhibited in New York, Paris and London. In 2005 he was the recipient of a John Simon Guggenheim Memorial Foundation Fellowship.

Selected Exhibitions
2005 *Hyperfocal Five from LA*, Galerie Nelson, Paris, France
2003 *Paul Sietsema: Empire,* Whitney Museum of American Art, New York, NY
2002 *Paul Sietsema,* Regen Projects, Los Angeles, CA

Deviant Rituals

Ron Athey
Born, 1961, Groton, Connecticut

Ron Athey began performing at underground venues in 1981 with Rozz Williams in a collaboration called "Premature Ejactualtion." From 1991 to 1999 Athey and Company toured his "torture" trilogy: *Martyrs and Saints, 4 Scenes in a Harsh Life*, and *Deliverance*. Since then he has traveled with subsequent stagings of his works *Incorruptable Flesh, Judas Cradle* and the solo work *The Solar Anus* at venues including the ICA in London, and The Walker Art Center in Minneapolis, MN, among countless others. A prolific and eloquent writer, Athey's texts have appeared in publications ranging from the *Village Voice* and *LA Weekly* to *Virus* and *Honcho*, as well as several anthologies including *Unnatural Disasters* and *Acting on AIDS*. Athey has lectured at the Tate Modern in London, The Art Institute of Chicago and The Australian Museum, Sydney. His gallery artwork is represented by Western Project in LA.

Selected Exhibitions
2002 *Joyce*, The Odeon Theater, Birmingham, UK
1998 *The Solar Anus,* Matthew Marks Gallery, New York, NY
1997 *Deliverance,* Inteatro XX: Festival of New Theater, Polverigi, Italy

Vaginal Davis
Born in Los Angeles, California

Vaginal Davis's drag performances, videos, short stories, club nights and fanzines have made her a queer icon. Davis's past is a mysterious muddle: exactly as she likes it. Some sources claim that she received a Ph.D in Psychology from Columbia University after a history of being expelled from Harvard University and other prestigious schools which she attended through scholarships. Vaginal Davis has lectured at the Cortauld Institute of Art in London, Yale University and New York University. Her work has been exhibited internationally and her writing has been included in *The Los Angeles Times*.

Selected Exhibitions
2005 *Orifice Descending*, New Moves Festival, Glasgow, UK
Vaginal Davis Film Retrospective, Northwest Film Forum, Seattle, WA
2004 *The Leopard Spots*, 18th Street Art Center, Santa Monica, CA

Julian Hoeber
Born 1974, Philadelphia, Pennsylvania

Julian Hoeber is a young artist who has made his mark with a number of slickly produced videos that reference contemporary art genre and film language (from horror pictures to natural realism). He has studied at a number of institutions, including Tufts University, Medford, the School of the Museum of Fine Arts, Boston and finally the Art Center College of Design, Pasadena where he received his MFA. He is represented by Blum & Poe in Los Angeles.

Selected Exhibitions
2005 *I wasn't joking. You were joking. I was serious*, Blum & Poe, Los Angeles, CA
2003 *Killing Friends*, Essor Gallery, London, UK
2002 *Killing Friends*, Blum & Poe, Los Angeles, CA

Mike Kelley
Born 1954, Detroit, Michigan

Mike Kelley is one the best known artists based in Los Angeles, whose career spans from the early 1980s to the present day. Hailing from Detroit, he moved to Ann Arbor where he studied at the University of Michigan School of Art until 1976. Kelley first moved to Los Angeles to study for his MFA at CalArts, which he completed in 1978. There he learnt to combine conceptual strategies with the influences of his youth—specifically those narco-libidinal revolutionaries, the MC-5, the cosmic rambling of Sun Ra and the provocations of Iggy Pop. A consistent collaborator he has worked with Jim Shaw in their band Destroy All Monsters, recreated his college collaboration with Tony Oursler, *The Poetics*, for Documenta X, and has worked on various projects with Paul McCarthy, including their apocryphal *Heidi* and *Fresh Acconci* video tapes. He has shown internationally for over 20 years and has had numerous writings published. He currently teaches at Art Center in Pasadena.

Selected Exhibitions
1999 *Framed and Framed, Test Room, Sublevel*, Magasin; Centre National d' Art Contemporain de Grenoble, Grenoble, France
1993 *Mike Kelley: Catholic Tastes*, Whitney Museum of American Art, New York, NY
1988 *Three Projects: Half a Man, From My Institution to Yours, Pay for Your Pleasure*, The Renaissance Society at the University of Chicago, Chicago, Illinois

Martin Kersels
Born 1960, Los Angeles, California

Martin Kersels has shown extensively in America and internationally. He studied for his BFA at University of California, Los Angeles, completing it in 1984, and returned to the same institution to complete his MFA in 1995. He worked with performance group the Shrimps between 1984 to 1993 before he began his gallery career, making work that utilized photography, mechanization and sound, among other things. Kersels currently teaches at the Cailfornia Institute of the Arts, Valencia. He is represented by ACME Gallery in Los Angeles.

Selected Exhibitions
2003 *Wishing Well*, ACME, Los Angeles, CA
2002 *The Americans: New Art*, Barbican Art Gallery, London, UK
2001 *Tumble Room*, Deitch Projects, New York, NY

Los Super Elegantes
Founded 1995, San Francisco, California

Los Super Elegantes are a fusion of the two artists Milena Marquiz and Martiniano Lopez Crozet. Working together as a poptastic duo this collective has performed throughout the West Coast and internationally. Looking ironically at the banality of global pop, their work both entertains and challenges preconceptions of global identity, life-branding and the controlled facade of cultural activity. They have shown in a number of venues; including galleries, old music halls, contemporary music venues and important art museums.

Selected Exhibitions
2004 Frieze Art Fair, London
 Mixed in Mexico, UCLA Hammer, Los Angeles
 Whitney Biennial, The Whitney Museum of American Art, New York

Paul McCarthy
Born 1945, Salt Lake City, Utah

Paul McCarthy studied at a variety of institutions, including University of Utah, San Francisco Art Institute and the University of Southern California, completing his studies in 1973. His interests ranged from the repetitious actions of Bruce Nauman, and the amateur theatrics of Jack Smith, to the experimental filmmaking of Bruce Conner. He has merged together a genre of symbolically loaded and desecrational social critique that has proved to be vastly influential—if not unavoidable—to a whole generation of artists. Working in a relative isolation until the 1990s he has since had a welter of international shows, including a retrospective at the Museum of Contemporary Art in Los Angeles in 2000. He was a professor at UCLA from 1984 until 2003. McCarthy is represented by Hauser & Wirth in Zurich/London and Luhring Augustine in New York.

Selected Exhibitions
2000 *Paul McCarthy*, Museum of Contemporary Art, Los Angeles, California
1999 *Dimensions of the Mind: The Desire and the Denial in the Spectacle: By Paul McCarthy*, Sammlung Hauser & Wirth, Gallen, Switzerland
1995 *Painter*, Projects Room, Museum of Modern Art, New York, New York

Marnie Weber
Born 1959, Bridgeport, Connecticut

Marnie Weber studied at the University of Southern California from 1977 to 1979 and at the University of California, Los Angeles, completing her studies in 1981. She has worked in many media, starting initially in song-based performance. More recently she has produced a number of darkly fantastical collages as well as openly poetic narrative videos. She has shown her work extensively, both within America and internationally and has released a number of albums, including *Cry for Happy* and *Songs Forgotten: The Best of Marnie 1987–2004*. Weber is represented by Rosamund Felsen Gallery in Los Angeles.

Selected Exhibitions
2005 *Songs That Never Die*, Rosamund Felsen Gallery, Los Angeles, CA
2001 *Who's The Most Forgotten of Them All?*, Fredericks Freiser Gallery, New York, NY
1997 *Destiny and Blow Up Friends*, Milwaukee Art Museum, University of Wisconsin, Milwaukee, WI

All images are courtesy the artist unless
otherwise stated.

Cover Images

Jeff Burton, *Untitled No. 202 (Hollywood first
morning)*, 2000, c-print, 27" × 40". Courtesy of Casey
Kaplan, New York and Sadie Coles HQ, London.

Hollywood, 2005, photo: M. Paige Taylor, courtesy the
photographer.

Designing Environments

Jorge Pardo
Images courtesy Haunch of Venison, London.

Jennifer Steinkamp
Images courtesy Lehmann Maupin, New York,
greengrassi, London, and ACME Gallery, Los Angeles.

Diana Thater
Images courtesy 1301 PE, Los Angeles and David
Zwirner, New York.

Pae White
Images courtesy greengrassi, London and 1301 PE,
Los Angeles.

Andrea Zittel
Images courtesy Andrea Rosen Gallery, New York.

Elaborate Fictions

Brian Calvin
Images courtesy Corvi Mora, London.

Carole Caroompas
Images courtesy Western Project, Los Angeles.

Carolyn Castaño
Image courtesy Kontainer Gallery, Los Angeles.

Russell Crotty
Image courtesy Shoshana Wayne Gallery,
Santa Monica.

Nick Lowe
Images courtesy Black Dragon Society,
Los Angeles.

Ivan Morley
Images courtesy Patrick Painter Inc., Santa Monica.

JP Munro
Images courtesy Sadie Coles HQ, London.

Laura Owens
Image courtesy Sadie Coles HQ, London.

Lari Pittman
Image courtesy greengrassi, London.

Jim Shaw
Images courtesy Patrick Painter Inc., Santa Monica.

Picture Credits

Text and Image

John Baldessari
Images courtesy Marian Goodman Gallery,
New York.

Hilary Bleeker
Images courtesy Kontainer Gallery, Los Angeles.

David Bunn
Image courtesy Angles Gallery, Santa Monica.

Mary Kelly
Images courtesy Santa Monica Museum of Art,
Santa Monica.

Raymond Pettibon
Images courtesy Regen Projects, Los Angeles and David
Zwirner, New York.

Ed Ruscha
Image courtesy North Carolina Museum of Art, Raleigh,
purchased with funds from the North Carolina Museum
of Art Foundation, Art Trust Fund.

Frances Stark
Image courtesy greengrassi, London and CRG,
New York.

Wayne White
Images courtesy Western Project, Los Angeles.

Constructing Identities

Amy Adler
Images courtesy ACME Gallery, Los Angeles.

Delia Brown
Images courtesy D'Amelio Terras, New York, and
Margo Leavin Gallery, Los Angeles

Jeff Burton
Images courtesy Casey Kaplan, New York and Sadie
Coles HQ, London.

Sharon Lockhart
Images courtesy Blum & Poe, Los Angeles.

Daniel Marlos
Images courtesy Blum & Poe, Los Angeles.

Catherine Opie
Images courtesy Regen Projects Los Angeles.

Dean Sameshima
Images courtesy Alison Jaques Gallery, London and Peres
Projects, Los Angeles

Ed Templeton
Images courtesy Modern Art, London.

Building the Absurd

Liz Craft
Images courtesy Marianne Boesky Gallery,
New York.

Meg Cranston
Images courtesy 1301PE Gallery and Happy Lion
Gallery, Los Angeles.

Evan Holloway
Images courtesy The Approach, London, and Marc
Foxx Gallery, Los Angeles.

Terence Koh
Images are part of the Deitch Collection, courtesy
Peres Projects, Los Angeles.

Liz Larner
Image courtesy Regen Projects, Los Angeles.

Jennifer Pastor
Courtesy of Regen Projects, Los Angeles.

John Pylypchuck
Images courtesy Alison Jacques Gallery, London.

Jason Rhoades
Images courtesy David Zwirner, New York and
Hauser & Wirth, London/Zurich.

Shirley Tse
Images courtesy Shoshana Wayne Gallery, Santa
Monica.

Re-figuring Abstraction

Mark Bradford
Image courtesy Brent Sikkema, New York.

Jane Callister
Images courtesy Susanne Vielmetter, Los Angeles.

Kim Fisher
Images courtesy John Connelly Presents, New York,
and China Arts Objects, Los Angeles.

Mark Grotjahn
Images courtesy Blum & Poe, Los Angeles.

Sandeep Mukherjee
Images courtesy Margo Leavin Gallery,
Los Angeles.

Monique Prieto
Image courtesy Corvi Mora, London.

James Welling
Images courtesy Regen Projects, Los Angeles.

The Popular is the Political

Andrea Bowers
Images courtesy Sara Metlzer Gallery, New York and
Mary Goldman Gallery, Los Angeles.

Sam Durant
Images courtesy Blum & Poe, Santa Monica.

Dave Muller
Images courtesy Blum & Poe, Santa Monica, and The
Approach, London.

Kaz Oshiro
Images courtesy the Rosamund Felsen Gallery,
Santa Monica.

Mungo Thomson
Images courtesy Margo Leavin Gallery,
Los Angeles.

Shifting Scale

Won Ju Lim
Images courtesy Galerie Max Hetzer, Berlin, and
Patrick Painter Inc., Santa Monica.

Pauline Stella Sanchez
Images courtesy Rosamund Felsen Gallery,
Santa Monica.

Paul Sietsema
Courtesy of Regen Projects, Los Angeles

Deviant Rituals

Ron Athey
Images courtesy Manuel Vason.

Vaginal Davis
Images courtesy AKSIOMA: Institute for
Contemporary Arts, Ljubjiana, and Manuel Vason.

Julian Hoeber
Images courtesy Blum & Poe, Los Angeles.

Martin Kersels
Images courtesy ACME Gallery, Los Angeles.

Los Super Elegantes
Image courtesy John Connelly Presents, New York.

Paul McCarthy
Images courtesy Hauser & Wirth, Zurich/London.

Marnie Weber
Images courtesy Rosamund Felsen Gallery,
Santa Monica.

This book has involved many people during its research, writing and design, without whom it would not have been possible. During the research phase Apolina Vargas put together a list of artists that made up the backbone of the book, followed by the indispensible work of Sophie Oliver and Sophie Ekwe-Bell in carrying out picture research with both dedication and organization. During the compilation of biographical materials and artist texts a number of researchers and writers contributed including: Charbel Ackermann, Juliana Amaral Leite, Yason Banal, Katie Beeson, Natalie Bell, Sophie Ekwe-Bell, Paul Flannery, Catherine Grant, Dominic Johnson, Ellen Lindner, Kathryn Main, Mitchell Marco, George South, Matthew Stromberg, Francis Summers, and Apolina Vargas. They all brought their individual perspectives on contemporary art, making the artist texts one of the book's greatest strengths as well as bringing order out of a vast amount of information.

The writers of the essays in this book, Chris Kraus, Jane McFadden and Jan Tumlir have given of their time and ideas with generosity and thoughtfulness, with each of their essays providing a unique take on the art of Los Angeles. Many thanks are due to M. Paige Taylor for taking all of the location photographs within the essay sections as well as one of the cover images. A thank you is also due to Jeff Burton for allowing the use of his photograph in such an unconventional way on the cover of this book. The designers Sean Murphy and Hazel Rattigan have spent many hours dealing with the large amount of material included in the book to create a strong design that allows the images to speak for themselves.

Most importantly, thanks are due to the artists who have so kindly allowed their work to be included in these pages. The staff at all the galleries and artist's studios that generously provided the images are also due thanks for making the numerous reproductions possible.

Oriana Fox

Acknowledge-ments

© 2005 Black Dog Publishing Limited,
the artists and authors
All rights reserved

Essays by Chris Kraus,
Jane McFadden and Jan Tumlir

Edited by Oriana Fox and
Catherine Grant

Picture Research by Sophie Ekwe Bell
and Sophie Oliver

Artist texts and additional research
by Charbel Ackermann, Juliana
Amaral Leite, Yason Banal, Katie
Beeson, Natalie Bell, Sophie
Ekwe-Bell, Paul Flannery, Oriana
Fox, Catherine Grant, Dominic
Johnson, Ellen Lindner, Kathryn
Main, Mitchell Marco, George
South, Matthew Stromberg, Francis
Summers and Apolina Vargas

Designed by Value and Service

Black Dog Publishing Limited
Unit 4.4 Tea Building
56 Shoreditch High Street
London E1 6JJ

Tel: +44 (0)20 7613 1922
Fax: +44 (0)20 7613 1944
Email:info@bdp.demon.co.uk

www.bdpworld.com

All opinions expressed within this
publication are those of the authors
and not necessarily of the publisher.

British Library Cataloguing-in-
Publication Data.

A CIP record for this book is available
from the British Library.

ISBN 1 904772 30 7